Grief Unseen

of related interest

The Inspiration of Hope in Bereavement Counselling
John R. Cutcliffe
Foreword by Ronna Jevne
ISBN 1 84310 082 7

Counsellors in Health Settings
Edited by Kim Etherington
Foreword by Tim Bond
ISBN 1 85302 938 6

Inner Journeying Through Art-Journaling
Learning to See and Record your Life as a Work of Art
Marianne Hieb
ISBN 1 84310 794 5

Gender Issues in Art Therapy
Edited by Susan Hogan
Foreword by Diane Waller
ISBN 1 85302 798 7

The Healing Flow: Artistic Expression in Therapy
Creative Arts and the Process of Healing: An Image/Word Approach Inquiry
Martina Schnetz
Forewords by Vivian Darroch-Lozowski and David C. Wright
ISBN 1 84310 205 6

Imagery and Symbolism in Counselling
William Stewart
ISBN 1 85302 350 7

The Therapeutic Potential of Creative Writing
Writing Myself
Gillie Bolton
Foreword by Sir Kenneth Calman
ISBN 1 85302 599 2 pb

Grief Unseen

Healing Pregnancy Loss Through the Arts

Laura Seftel

Foreword by Sherokee Ilse

Jessica Kingsley Publishers
London and Philadelphia

First published in 2006
by Jessica Kingsley Publishers
116 Pentonville Road
London N1 9JB, UK
and
400 Market Street, Suite 400
Philadelphia, PA 19106, USA

www.jkp.com

Library of Congress Cataloging in Publication Data
A CIP catalog record for this book is available from the Library of Congress

British Library Cataloguing in Publication Data
A CIP catalogue record for this book is available from the British Library

ISBN-13: 978 1 84310 805 4
ISBN-10: 1 84310 805 4

Printed and bound in Great Britain by
Athenaeum Press, Gateshead, Tyne and Wear

Dedicated to the many women and men
who carry a quiet loss, a loss that underlies
their daily affairs and permeates their dreams
with memories of children who were with
them too briefly.

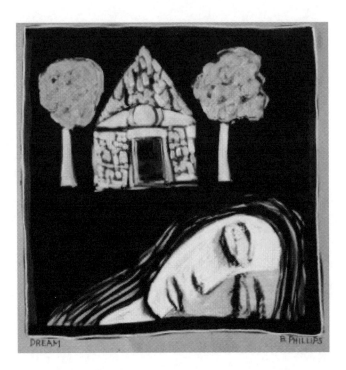

Dream, mixed media, Brenda Phillips

Contents

List of Figures

Foreword

Grief Unseen: Healing Pregnancy Loss Through the Arts is a genuine gift – one that can be especially understood and appreciated because the author, Laura Seftel, has personally lived through the loss of her own baby in miscarriage and over time has discovered some of the resulting gifts. Thankfully, she shares them with all of us through this new book.

The club that no one wants to join: The Secret Club. These are words I have used for years when speaking to families who have had a baby die in miscarriage, stillbirth or other infant death. I joined this club unwillingly in 1979 after our miscarriage and again in 1981 after the full-term stillbirth of our son. Sadly, the silence following each was deafening. The world, my family, my friends, and colleagues felt terrible for us but they had no words or experience to know how to talk with my husband David and me. Nor did we, at the time.

Our little treasures were gone. Poof. Outwardly we looked much the same; inwardly we were a mess, a disaster with no sense of how to cope or even begin to heal. First we had to feel it and grieve it: something foreign to both of us.

Over the many months that followed, I did discover the need to remember both Brennan, our stillborn son and Marama, our newly named miscarried baby. The process of remembering, expressing my feelings, and reaching out to others came out in the art form of writing. I had not found a book to read at the time, nor did I find one piece of expressive artwork that gave voice to my feelings. So I wrote my own.

As I look back, it is now clear that the early 1980s were the transition period from the "dark ages of perinatal bereavement" when little or no words were spoken beyond, "I'm so very sorry," if one was lucky enough to hear that. Miscarriage, stillbirth, and even the death of a baby who lived briefly were considered by most people as "non-events."

Thankfully, things began to change around that time and I was fortunate to be one of the handful of people who were inspired to be a part of that change. With Susan Erling and six other bereaved parents, we created a national nonprofit organization – the Pregnancy and Infant Loss Center in Minneapolis.

Sister Jane Marie Lamb had recently created the national organization SHARE at a hospital in Springfield, Illinois, Pat Schwiebert had just formed Perinatal Loss (now called Grief Loss) in Oregon, and RTS Bereavement Services was founded about that time by Rana Limbo and Sara Wheeler. With the needs of the bereaved parents in mind, we all worked in our own ways to improve the care and open the hearts of our community and country for this important issue and these anguished people. While the focus was often stillbirth, SIDS, or neonatal death, miscarriage is something I and others always included. As Sherry Jimenez, an early author on this subject wrote, "What is a miscarriage, but an early stillbirth." A baby is a baby, and the size or gestation should not matter when it comes to love, hopes, and dreams – along with the accompanying devastation – when that baby dies. While the losses seem small to some and even invisible, in fact these unborn already have life stories in the hearts of their parents. It ought to be understood that the universal drama of building plans for a most special future is dashed when the dreams are shattered and the pregnancy ends prematurely or the baby dies suddenly.

Slowly and with great effort, the climate did change. People began to see their babies, pictures were taken, mementos were offered, books were shared and support groups were created. Most recently the web has blossomed, offering support, memorial opportunities, and a multitude of resources.

Practical ideas on how to care for bereaved families were the focus of the books, the trainings, the articles and the studies for many years. It needed to be this way, so the care would improve and the regrets that had previously haunted mothers and fathers could be minimized. A number of organizations, groups, and individuals participated in changing this over the past 25 years. In most hospitals, there are now policies and protocols set forth for staff to follow as they care for families, especially those whose baby died at birth or soon after. Unfortunately, despite our best efforts and hopes, we still have much work to do to improve the care of families who have a miscarriage.

In *Grief Unseen*, Laura does an excellent job of documenting these changes and offers wonderful resources, authors, and references that will surely aid the reader of this magnificent book. She shares her own personal story of her losses, then defines the many types of losses that can and do occur. She guides the reader to better understand why expressing feelings through the arts is vital and how the bereaved can do this. I especially like how she explains that because of the "trailblazing of both the women and men before us, we have more freedom today to use the arts to sing out the truth of our experience." No doubt there is truth in this.

Only recently have a few people like Julie Fritsch, the sculpture and author of *The Anguish of Loss* and now Laura Seftel, the founder of the national arts

project the Secret Club and author of *Grief Unseen,* moved us from the practical "how to care for the basic needs" to a place where we are beginning to understand how to help people do their grief work through expressive arts, not just through talking in support groups. Finding meaning within and then moving those personal experiences into the world is much like a birth. The process has its moments of doubt, worry, fear, joy, love, hope and pain, but in the end the result has been worth it.

Whether the new creation is to teach or touch others or simply for personal healing, it has become a life unto itself that gives voice to those unspoken and often misunderstood inner struggles that all who have had a baby die can relate to in one way or another. Laura points out that:

> One of the benefits of the creative arts therapies is that they allow the client to be actively engaged and to express the sensations and emotions held in the body. When recovering from trauma, if we use only words we are distanced from our experience -- we are observers -- while expressive therapies engage the body, supporting "embodied resolution."

Throughout the ages, this creative process of finding meaning after such heart-ache following loss has been replayed over and over. Laura documents how this form of healing has occurred for centuries, whether accidentally, inadvertently, or purposefully. The imagery might be through words – fiction, nonfiction or poetry – through music, painting, photography, and various other art forms. They offer meaningful ways for each of us to move the unseen to a place of outward healing for ourselves as we reflect on our loss.

Laura writes, "Creative expression has always been a central part of how human beings make sense of their place in the world. In non-industrial societies the arts were usually seen as inseparable from ritual." The importance of rituals are emphasized and honored as means to healing and growth.

By presenting the grief of men, women and children, Laura invites the entire family and their care providers to feel included in this work. In my opinion, one of the greatest assets of this book, however, is the presentation of how people have brought their feelings —their pain, anguish, joy, hopes, dreams and growth through the arts — into the world. As she shares specific examples and pictures of the work of some, she inspires us all to believe that we, too, can reach inside and bring forth creations that will help us heal. Her practical suggestions and creative activities toward the end of the book are useful for all care providers and individuals. They inspire us to find our own way of expression.

This new project is more than a book to add to the now long list of resources for bereaved families and their care providers. It is a most unique and compelling gift. It has come through Laura's own struggles and the struggles of

others whose works she shares. It is not a given that each bereaved person *will* find such gifts, but through the creative arts and with open hearts, they *can* find amazing gifts from their tiny treasures, who died too early, but will always be remembered.

Sherokee Ilse, international speaker and author of
Empty Arms: Coping with Miscarriage,
Stillbirth and Infant Death

Acknowledgments

For help and encouragement with the book, I thank Caterina Cianciulli, Barbara Faith Cooper, Vicki Ritterband, Ann P. Lewis, Lucy Mueller White, and my long-time women's writing group for making me a writer through love and osmosis. I thank Madeleine Charney for contributing her limitless librarian skills to the project. Thanks also to Kara Jones for sharing her experience and her work so openly with me. My gratitude to all the poets who graciously allowed their work to be reprinted here. I also extend gratitude to clients who granted permission to use their stories and artwork.

Thanks to my father Dr Leroy A. Seftel, former Chief of Obstetrics and Gynecology at Ellis Hospital, for acting as medical consultant for this project and head cheerleader. Thanks to my husband, Glenn Siegel, who patiently read countless drafts, and to the rest of my family – nuclear and extended – for managing to survive my foray into publishing.

The Secret Club Project, the national art project about pregnancy loss on which much of this book is based, received generous grants from the following agencies: Northampton Arts Council/Massachusetts Cultural Council, The Puffin Foundation, and Money for Women/Barbara Deming Memorial Fund. I also want to acknowledge the Fund for Women Artists in Florence, MA, for their technical support and acting as our non-profit umbrella.

And finally, this book probably would not exist at all were it not for the many Secret Club artists who shared their imagery and stories. I offer special thanks to artists Melinda Ann Hill, Kathy Fleming, Kristine Sogn, and Beth Shadur for working to support the project's mission.

The author would like to thank the authors, artists and publishers who have kindly given permission to reproduce the following material:

Dream (p.xi), *Grief* (p.59), and *One Crow* (p.81) by Brenda Phillips. Used with permission from Brenda Phillips.

Extracts from "The Lost Child" (pp.15, 50, & 162) by Paul Petrie (1984). New York: Commonweal. Used with permission from the Commonweal Foundation.

Shattered (p.27) and *Corazon Materno* (p.82) by Sonia A. Key. Used with permission from Sonia A. Key

Visiting (p.31) and *Self-portrait (Anger)* (p.33) by Tammy L. Gross. Used with permission from Tammy L. Gross.

The Unexpected (p.31) by Marion K. Flanary. Used with permission from Marion K. Flanary.

"The Miscarriage" (p.34) by Richard Jones from *The Blessing: New and Selected Poems* (2000). Port Townsend, WA: Copper Canyon Press. Used with permission from Copper Canyon Press.

Tomorrow's Child (p.37) and *Maine Morning* (p.83) by Robin Freedenfeld, photographs by Stephen Petegorsky. Used with permission from Robin Freedenfeld and Stephen Petegorsky

Dream Trap (p.43) by Margaret Carver, and "Response to gallery installation" (p.119). Used with permission from Margaret Carver.

Poem (p.45) by Nancy Rich. Used with permission from Nancy Rich.

Extract (p.48) and poems (pp.62 & 80) from *Father, Son, Holy Ghost* (2000), "Anger I" (p.113) and excerpt (p.116) from *Flash of Life* (1999), and "His 6th Birthday" (p.144) from *A Different Kind of Parenting* (2005) by Kara Jones. Vashon, WA: KotaPress. Used with permission from Kara L. Jones.

Patient #1 (p.52) by Nancy Raen-Mendez. Used with permission from Nancy Raen-Mendez.

"Longer Days" (p.54) by Michael R. Berman. © Michael R. Berman, MD, 2005. All rights reserved. Used with permission from Michael R. Berman.

Six Hours (p.56) by Pamela Joy Trow-Johnson. Used with permission from Pamela Joy Trow-Johnson.

The Teapot (p.61) by Kristine Sogn. Used with permission from Kristine Sogn.

Pink (p.64) by Melinda Ann Hill. Used with permission from Melinda Ann Hill.

Birth Figure #4 (p.77) applique and fabrication by Judy Chicago (1982), photograph by Donald Woodman. © Judy Chicago. Used with permission from Through the Flower Archives.

Broken (p.78) by Jeannie Sharp. Used with permission from Jeannie Sharp.

Shattered Pieces (p.79) by Beth Shadur. Used with permission from Beth Shadur.

Beginning of the End (p.102) by Tabitha. Used with permission from the artist.

Extract (p.110) from Jen Primack's letter. Used with permission from Jen Primack.

Excerpt (p.110) from "Cartography" by Jennifer Jacobson. © Jennifer Jacobson 2005. Used with permission from Jennifer Jacobson.

Extract (p.111) from *Still as Rain* by Nancy White, produced at The Cherry Street Artisan in Colombia, MO, 2002. © Nancy White 1997. Used with permission from Nancy White.

Curtain Call (p.112) by Diane Savino. Used with permission from Diane Savino.

Womb Book (p.115) by Kara L. Jones, photograph by Hawk Jones/kotagraph.com. Used with permission from Hawk Jones and Kara L. Jones.

Christening Dresses (p.120) by Lieve van Stappen. Used with permission from Lieve van Stappen.

Womb (p.130) by Jennifer Shafer. Used with permission from Jennifer Shafer.

Heaven Bound (p.132) by Andrea Picard. Used with permission from Andrea Picard.

Found My Stars (p.144) by Sari Koppens. Used with permission from Sari Koppens.

Womb of Its Own Accord (p.145) by Gabrielle Strong. Used with permission from Gabrielle Strong.

"Knitting" (p.155) by Amy Olson Binder from *The Virago Book of Birth Poetry* (1992), edited by Charlotte Otten. London: Virago Press. Used with permission from Amy Olson Binder.

Excerpt (pp.158–9) from "Moon Knows" by Maya Charlton (2000). Used with permission from Maya Charlton.

"The Thing Is" (p.174) from *The Mules of Loves* by Ellen Bass (1998). Rochester, NY: BOA Editions. Used with permission from Ellen Bass.

Introduction: A Grief Without a Shape

A grief without a shape
is imageless.
Like a hidden fish it swims
under the sea, surfacing
at will,
or like a dark moon peers
through the window of any season
or any mood.
A grief without a shape
is endless...

P. Petrie, from "Lost Child" (1984)

Pregnancy loss is an invisible loss and so, for many, becomes an invisible grief. At least one in five pregnancies ends in loss, and yet miscarriage and other reproductive crises remain almost taboo. Surprisingly, an open and in-depth discussion of pregnancy loss is still culturally forbidden. A Canadian radio production, *Mothers of Miscarriage*, referred to this "dark little corner of women's fertility" as the "reluctant underground" (Burke 1999). Others have called the silence surrounding pregnancy loss the "hush syndrome." Following my own miscarriage, I found an all but hidden network of women who had endured miscarriages. Why hadn't I heard these stories before? British artist Simon Robertshaw, who explores pregnancy loss in his work, describes this wall of silence. "It was not until my wife had a miscarriage," he explains, "that my mother spoke of her experience of miscarriage. I can remember thinking at the time that an unspoken code of conduct seemed to dictate that you only spoke or heard about it when it happened to you or someone close to you."

Why is it that we still can't talk openly about pregnancy loss? Perhaps part of the difficulty in creating a meaningful dialogue is that words are not adequate to convey every human experience. Many women report that it is not easy for them to articulate the depth of emotions and physical sensations stirred up by a pregnancy loss. In some cultures, when the loss of a pregnancy occurs "there may not, quite literally, be the words to discuss and describe the event" (Cecil 1996, p.1). Artist Margaret Carver turned to the creative process to express her struggle with miscarriage and infertility, "Through art I am able to speak of an experience which is unspeakable, and therefore unknown."

With grief of any kind, we often rely too heavily on the intellect, believing we can ignore our emotions or think our way out of them. In *The Grief Recovery Handbook*, the authors acknowledge: "One of humanity's great gifts is our ability to show emotion. Yet society seems to place negative value on this gift" (James and Cherry 1988, p.32). Our modern culture has neglected to provide a framework to manage the disruption in our lives that can ensue following a significant loss. Grief is a normal process that will inevitably touch each of us, and yet most of us find ourselves ill-prepared and uneducated in this realm.

It is within this already stifled environment that we experience pregnancy loss, almost like a secret within a secret. When we stumble into this hidden region, we enter into what traditionally have been considered private female affairs: menstruation, fertility, birth, menopause, and the like. Women in many cultures are taught early on not to speak publicly of such things, and so pregnancy loss becomes just one more female experience to be demurely hidden and downplayed. As Kathleen Phalen puts it in her article about stillbirth, "Losing a baby is usually a secret that gets tied with a pink or blue ribbon and placed in the attic," (2000, p.16). Unfortunately, this societal censorship leaves women and their partners with few outlets to express their grief.

It is already well established that women who experience a miscarriage are twice as likely to develop depression, particularly in the initial six months after the loss (Neugebauer *et al.* 1997, p.383). A more recent study on miscarriage, conducted by Susan Speraw through the University of Tennessee-Knoxville, found that the absence of funeral rituals for a lost pregnancy can be highly distressing (Speraw 2004).

This small but noteworthy study found that often a couple has already psychologically attached to the fetus, assigning names or terms of endearment; however, friends and family typically are unable to relate to the couple's loss because there is no shared experience of a person whom all can mourn. "Emotional attachments are formed much earlier these days, as couples begin to invest their hopes and dreams in the expected child," notes Patti Hartigan, journalist and miscarriage survivor. "Those dreams are shattered when

pregnancy loss occurs, yet despite changes in medical technology, there are still no established rituals or ceremonies to memorialize the loss or numb the pain" (Hartigan 2002, p.19).

To cope, couples in the study reported that they developed their own "secret" rituals to memorialize a lost pregnancy. One family constructed a garden and assembled a memory box. Another family created and displayed a tapestry that held symbolic meaning for them. Each of the families seemed to be seeking a tangible outlet for their grief as well as a way to celebrate and acknowledge the brief existence of these pregnancies.

Such research highlights the seemingly innate urge to use creativity to address the grief of a reproductive loss. Malchiodi (1992, p.114) points out that the "desire to self-express through an art form is often heightened at times of mourning." This expression may manifest as a series of paintings, a soft scarf knit to comfort and soothe, or a special set of drawers built by a husband – with one for each pregnancy his wife lost. While families and pregnancy-loss support groups are discovering for themselves the benefits of creating art and rituals as part of the bereavement process, there is not much information available to guide their way.

I had much the same experience following my own miscarriage in 1993, as I blindly found my way through the grief. Painting and writing were essentially the only things that helped me manage the unexpected anguish. During the year following my miscarriage, I produced a number of pieces of visual art and writing reflecting my experience with this loss and my process of recovery. Following my own isolated art-making experiences, I wondered whether other women had turned to the creative process in order to heal their grief.

My search for a community of artists led to the founding of a national arts project called the Secret Club. The project began modestly as a grant-funded art exhibit in Massachusetts and has grown, almost as if it has a life of its own, to represent more than 40 artists from around the USA and abroad. Although miscarriage is the most common type of pregnancy-related loss represented, the Secret Club also has as members artists who have experienced failed fertility treatments, molar or ectopic pregnancies, loss in multiple gestation pregnancies, and stillbirth. The project gives voice to a group that previously has been muffled, if heard at all.

How difficult it is to fully grieve a loss we cannot see, and yet this is a real loss, a milestone that must be acknowledged. The artists' ability and courage to bring form to an experience that seems to defy words is relevant for us all. They teach us, whether we count ourselves as artists or not, that the creative process offers up a profound form of healing and helps us make meaning of unbearable losses. Creating meaningful responses to pregnancy loss challenges us to build

bridges between the worlds of mental health, medicine, and the arts in the search for new avenues for healing. Deepening our understanding of the links between making rituals and making art is a fascinating aspect of this work, leading from the world of modern art to ancient traditions.

This book is ideal for creative arts therapists, but it is also written with other professionals in mind. Many Secret Club artists expressed the hope that their message would find its way not only to other families who had suffered but also to the medical practitioners who are on the frontline of pregnancy loss: doctors, nurses, and midwives. This book can sensitize practitioners to the often overlooked aspects of reproductive crises and enhance their ability to aid families who face these unexpected disasters. What is not taught in training programs or acknowledged in our communities can be learned through the powerful words and images of pregnancy-loss survivors themselves.

Bereavement counselors, social workers, and other mental health practitioners who help families cope with loss can use and adapt the exercises and images presented here. One artist in the Secret Club Project, Melinda Ann Hill from Philadelphia, is an art therapist and bereavement counselor. Despite her familiarity with managing loss, she felt unprepared for the depth of emotional pain that followed her own miscarriage. Hill explains how creativity became pivotal to her healing: "There are not enough words to describe my feelings, so I draw… The process of drawing and reviewing the final images has helped me to acknowledge and work through my grief, loss and pain of having a miscarriage. It is this process which helps me grow and heal."

Hill believes that the field of grief counseling could benefit from more insight into the potentially devastating emotions related to miscarriage and other reproductive crises and a more creative approach to healing. Some counselors have begun to embrace the power of the arts in order to express grief and memorialize pregnancy loss, offering hands-on activities for bereaved families such as creating journals, scrapbooks and memory boxes.

The language we use to describe pregnancy loss is already emotionally loaded. The very term "miscarriage" implies that the mother did not carry the pregnancy well. Some bereaved parents also feel a subtle sense of blame in the phrase "lose a pregnancy", as if they somehow misplaced it or were careless. The words that physicians use to discuss pregnancy loss can stir up confusion or create an emotional disconnection from the patient. When we use language about this unique loss, our words reflect a perspective that may not perfectly match the viewpoints and feelings of others. It is my experience that through the arts we can sometimes bridge this gap.

Within this book you will find stories of creative acts performed in the face of daunting grief, sprouting up in a surprising range of settings from therapists'

offices to artists' studios to suburban backyards. You will also encounter responses to pregnancy loss from many cultures, both historical and modern. Unearthing these symbols and rites of passage helps us to make sense of childbearing loss in our own society. Contemporary Western culture has few communal rituals to move us through these private disasters, although this dilemma is now beginning to shift. Today, the arts hold important keys to unlocking the healing potential of symbols, rituals, self-expression, and community connections.

The creative exercises found in the last chapter help free the creative process and promote expression and healing. The exercises are designed for everyone. Whether you identify as an artist, just dabble in crafts, or feel hopelessly cut off from your creative self, you will find these exercises gentle, accessible, and supportive. These effective methods have been adapted from workshops facilitating the pregnancy-loss recovery process. By engaging with this book, you will glimpse reproductive loss as it has rarely been seen before and have opportunities to create your own expressive responses to pregnancy loss.

"When words are not enough, we turn to image and symbol to speak for us" (Malchiodi 2002, p.x). The arts establish a connection between our internal world and our external experience. The creative arts also connect the hands and the heart, moving us from a passive stance into one of life-affirming action. Embracing our innate creative process not only allows us to express authentically the depth of grief associated with loss but also helps us to re-establish a sense of vitality and wellbeing.

There are many excellent comprehensive guides available on the physical, emotional, and spiritual experiences of reproductive loss, both for children and for adults. You will find a list of these resources at the back of this book. You will also find listings of websites and organizations relevant to both pregnancy loss and the creative arts therapies. Most importantly, my hope is that you will find your own creative voice, your healing voice, and that you will learn to trust it. Samuels and Rockwood Lane (1998, p.2) say it beautifully in their book *Creative Healing*: "We are reminding you that what you know about art and healing is already deep inside of you. It is within all of us; it is our inheritance and birthright."

Permission to Heal

As you begin your own healing process, consider the following:

- You are not alone: approximately 500,000 women experience miscarriage each year in the USA, alongside those who encounter other childbearing losses such as ectopic pregnancy, molar pregnancy, failed in vitro fertilization, and stillbirth. Nearly one million American women are touched by reproductive crises each year.

- Approximately a quarter of a million pregnancies end in miscarriage each year in the UK.

- Pregnancy loss is a real loss: it deserves to be acknowledged and witnessed.

- The amount of time a woman is pregnant is not a valid measure of the depth of her grief. Losses occurring early in pregnancy – even failed fertility treatments – can be emotionally devastating.

- Turning attention away from a pregnancy loss may work for some people; however, others may need a more direct, active healing process.

- All authentic feelings associated with your loss are acceptable and need room for expression, including rage, guilt, shame, envy, and despair.

- Family members, friends, and employers may not understand your emotional needs. They may expect you to move on quickly, but the healing process cannot be rushed.

- Developing personal forms of expression, such as journal-writing, art-making, and creating rituals, can be profoundly helpful in identifying and healing your grief. No background in the arts is needed in order to engage in the creative process.

My Story

Like ink on a white blouse

Expecting

It is an indelible loss — like ink on a white blouse,
something ruined, irreversible.
Bright red swirls in the morning waters.
You stare silently, you think it might be a dream,
a dream just before waking.

You're losing something but you cannot stop it.
Your husband is running up the stairs.

Waiting for the doctor to phone
watching television blindly.
Not moving, so as not to stir things up, not to feel anything.
Thinking, perhaps this is the worst day of my life.

What they didn't tell you
is that it's not over in a minute, or even a half hour.
You will eat lunch in an Indian restaurant
and at an odd instant recall
you are having a miscarriage.

"It was never viable," the doctor explains.
You can't seem to hear her — you notice her kind eyebrows.
The nurses locate places for you to weep.
"Get my husband — I can't understand the doctor."
Tears springing, as if to wash away this wrong story.
Waiting for her to say there is still a baby somewhere.

I cannot find myself. Perhaps I have slipped out as well.
Perhaps something has broken open.
Something has been lost.
And now what to do with the prenatal vitamins?

The cherries on our tree, tiny hard miracles,
have quickly turned over-ripe.
Sitting in metal bowls they exude their sticky juices.
There seem to be always more of them.
How will it end? How many pies can I bake?
My hands are already stained
with the work of slitting each one and
pulling out the stone.

In 1993 I had a miscarriage. One particularly difficult night following my loss, I got out of bed and this poem spilled out of me.

The loss of my pregnancy took me completely by surprise. My husband Glenn and I had decided we were ready for parenthood. We had been married a little over two years and had always planned to have children – we chose the house we lived in because it was down the street from an elementary school. Every time I went through a department store I was magnetized by the baby clothes.

After a few months of trying, I suspected I was pregnant. But it was a strange pregnancy. I never really felt morning sickness. My first home pregnancy test was negative. The second one, not long after, gave me a positive result. Then a negative at the doctor's office, but it was still too early to know for sure. Finally, we received a valid test result that I was, indeed, pregnant. Two months into the pregnancy, just when I finally believed I was truly going to have a child, I began to bleed. I knew it was the end as soon as I saw the blood, although I prayed the pregnancy could somehow remain intact. It didn't. It was over.

My way through the grief was writing and making art. Imagery symbolic of my miscarriage emerged in my paintings and collages – some of it consciously, although the meaning of other images became clear to me only over time. The loss of my pregnancy reverberated intensely in my artwork for a long time after the miscarriage, just as an abortion had ten years before when I was studying painting in college. My male professors at that time seemed to have no idea what I was expressing and left me feeling isolated and out of sync with the program. Yet this lonely and awkward experience with art as a form of healing helped pave the way for my career in art therapy.

Without really planning it, art also become my primary outlet for healing from miscarriage. Images of bowls and teapots appeared first in my artwork –

vessels and containers that could be filled and emptied, as my womb had been (Figure 1.1). Later I learned that the Bamileke people of Cameroon pour water from a gourd to symbolically report a pregnancy loss. In this African tradition, miscarriages are referred to covertly so as not to attract "malevolent forces." Intuitively, it made sense to me that an emptied vessel be used as a metaphor for a lost pregnancy.

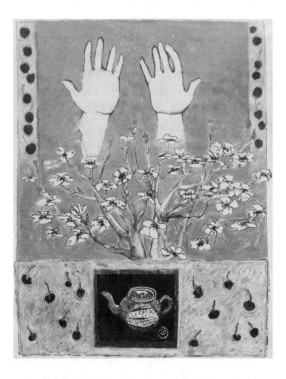

Figure 1.1: Prayer for a Healthy Child, mixed media, Laura Seftel

My artwork captured intense feelings about the miscarriage. Several of the pieces resonate with the pent-up anger and pain that I carried on a visceral level, like one painting with an angry scribble inside a jagged, womb-like image. The title of another painting, *Prayer for a Healthy Child*, reflected my fears about the future. When I became pregnant again, I never fully believed that I would come home from the hospital with a real baby in my arms. It didn't help that my Jewish tradition has its own superstitions about avoiding baby showers so as not to draw too much attention to a good thing. These beliefs are not taught officially but are passed on tacitly from mother to daughter. I have also heard that

many other cultures have similar fears about celebrating a pregnancy too soon or too joyously. I did finally relent and agree to a baby shower, but I was afraid to set up a crib or buy tiny undershirts and receiving blankets until the very last minute.

During this first pregnancy following my miscarriage, I lived with a host of uncomfortable symptoms, but the practitioners couldn't find a specific source of the problem. Three weeks early, I gave birth to a child – Henry Jacob – who weighed in at just four pounds. It was found that there had been an undiagnosed problem with the placenta, which was restricting the baby's nutritional intake, leaving him emaciated but essentially intact. Henry is now an eleven-year-old boy who collects comic books and loves soccer. But when we first took him home, I couldn't believe that he would survive. Even if he had been a full-term robust ten-pound baby, I probably would have felt just as fearful. Somehow, the miscarriage taught me to be wary. Everything seemed so fragile.

A little less than three years later, I gave birth to Arlo Frederick – everything went remarkably smoothly this time – and gradually I began to grasp that I was the mother of two boys who were, most likely, here to stay. Over time, my artwork and the everyday rituals of life with children helped me become more present and release some of my fears about their wellbeing.

Now, more than a decade after my loss, my miscarriage feels healed – a part of my story but no longer an incessant ache. I believe my relationship to my loss shifted not just because I eventually had babies to distract me from it but because I was blessed to find a transformational path through the arts.

Three generations

I wonder whether I was destined to embrace this topic, even before my own miscarriage. My family history, with three generations of pregnancy loss, unwittingly groomed me for this project. My grandparents Anna and Herman endured horrendous losses before they finally had a thriving baby – my father. My grandparents were Orthodox Jews whose parents emigrated from Eastern Europe at the turn of the twentieth century. They married just before the Great Depression. Anna was a remarkably tiny woman with a boyish figure and narrow hips. Her first pregnancy, in 1927, ended in the family physician's botched attempt to extract the baby from the birth canal with forceps. By the time he called in an obstetrician, it was too late. The baby boy did not survive the ordeal.

For her next pregnancy, Anna sought out an obstetrician from the beginning. The doctor delivered a baby girl, named Lila Barbara, by cesarian section. During the procedure, however, my grandmother began to

hemorrhage. Years before blood banks existed, her only chance for survival was a person-to-person transfusion. Her brother, who was a blood-type match, was brought in to provide the live transfusion that saved her life.

Although Anna survived, the baby was born "blue" as a result of an untreatable heart defect. She died 12 days after her birth. Today, both of the babies probably would have lived. But after two full-term pregnancies, Anna and Herman were left with empty arms. When my father was born a year later, the only surviving child, he was greeted as an answered prayer, a treasure.

With this family story, it is not surprising that my father became an obstetrician, symbolically rescuing his siblings and restoring babies to their mothers. However, when his own wife was five months pregnant, he could not prevent a miscarriage. My parents went on to have three healthy children, of which I am the oldest. I was aware that my mother had suffered a miscarriage, but I have learned only recently that this had not been the early-stage miscarriage I had always imagined it to be. It was something she never talked about. After I had my own miscarriage, I found out that my mother-in-law and my sister-in-law had also experienced pregnancy losses about which I had known nothing. I look at the generational grief that preceded the births in my family and I wonder how it taints us, changes us, perhaps even blesses us.

In the guestbook of our first Secret Club exhibit on pregnancy loss, a visitor shared how pregnancy loss had impacted on her life. Born after her mother had endured many miscarriages and the death of a newborn, the writer "grew up in the shadows of [her] almost siblings." She continues:

> I believe that I still carry grief that remains from the mourning that my mother was not permitted to express. I honor you for expressing, making visible, removing the shame, and allowing me permission to feel that my mother could have been, is, was, a member of your club.

Each personal story is literally just one of millions. I have encountered women who lost pregnancies while raising other children, women who have never been able to carry a pregnancy to full-term, women who have struggled with infertility, and women who have held stillborn babies in their arms. I have seen the anguish of women and their partners who, in their efforts to become parents, have endured one heart-rending disappointment after another. These are not the women who are satisfied, for the most part, with a decision to live child-free. I am thinking of the women who other writers have called "childless mothers" and "invisible mothers." And it is important for us to recognize that, on a deeper level, these women and their partners are parents – mothers and fathers who live with the shadow of a child who never fully arrived.

As I write, I find it ironic that I am often interrupted by my children. Here they are clamoring for my attention, a cup of juice, a fight to be refereed, and yet I am still struggling to write about the pregnancy I lost. I feel compelled to carry on this exploration. And as I move through my own personal loss, I am drawn again and again to the potential art holds as a healing force.

2

Losing a Dream

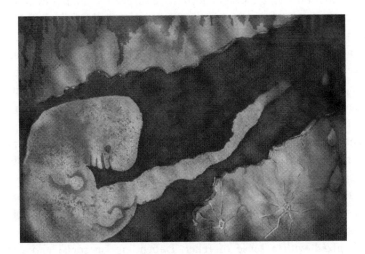

Figure 2.1: Shattered, watercolor and gouache, Sonia Key

What have we lost?

There are different kinds of pregnancy losses, including failed in vitro fertilization, molar pregnancy, ectopic pregnancy, loss in multiple-gestation pregnancy, abortion, miscarriage, stillbirth, and others that don't fall easily into one simple category. When the loss is not easily labeled, the family may be left with many unanswered questions. Jonathan Tropper describes it in this way: "It felt strange returning home the next day. We didn't know how to mourn, how to categorize what we'd lost. Certainly, it had been a traumatic event, but had we lost a baby or a pregnancy?" (2005, p.104).

What is lost? Most people have never given much thought to infertility or miscarriage because, for the most part, our society has been silent on the issue.

Pregnancy loss falls in a nebulous zone between birth and death. How do we talk about a life that ends just as it is beginning? Families can experience their lost pregnancies in profoundly divergent ways: a child, an angel, a cluster of cells, a spirit, a shadow.

In medical terms, there are specific phases of development: fertilized egg, embryo, fetus. Clinically, a miscarriage is defined as a pregnancy that ends spontaneously before 20 weeks, while a pregnancy ending after that point is termed a stillbirth. As the fields of medicine and law shift and develop, so too does our society's use of language. More than ever, a late-stage pregnancy is being referred to legally and in the media as an "unborn child."

No matter how long a pregnancy lasts, a surprising number of women and their partners seem to be connecting to the image of a baby, fully formed. Rarely do parents use the words "embryo" or "fetus;" they almost always refer to their pregnancy as a "baby." This intense attachment, which in fact is a normal part of the psychological preparation for parenthood, is what is shattered so painfully by a reproductive crisis. Describing her own miscarriage, journalist Peggy Orenstein points out: "What I'd experienced had not been a full life, nor was it a full death, but it was a real loss" (Orenstein 2002, p.41).

When contemplating the experience of pregnancy loss, it does not take long to rub up against the thorny question of when a life becomes viable, which leads us smack into the abortion debate that still rages, nowhere more so it seems than in the USA. "Pregnancy loss also touches upon the very question of what is human: when does life begin? What is human and what is not?" (Cecil 1996, p.1). Regardless of their politics, most women experience an abortion as a loss, even if mixed with a sense of relief. Depending on social and economic pressures, a pregnant woman may find herself in a situation that feels much less like a choice and more like an intractable dilemma.

Although abortion is not the main focus of this book, it bears mentioning alongside other reproductive crises and challenges us to stay open to women's real experiences. Each of us lives with our own personal truth, based on our own set of stories and our cultural legacy. It is through these experiences that we form our ethics and beliefs about when it is that a pregnancy attains its personhood and where souls reside when they are not obviously present.

As a lifelong supporter of women's rights to make their own reproductive decisions, I never thought of my own early pregnancies as fully formed babies. However, in organizing and researching this project, I made alliances with women who couldn't be further from my own particular beliefs. My hope is that the creative process, which allows us to depict the uncertainties and paradoxes of our lives, makes room for people of all backgrounds to speak for themselves about their intimate experiences on the border of birth and death. Radio

producer Kelley Jo Burke expresses feelings close to my own when she asks: "Can both the pro-choice and pro-life movements accept the idea that life begins and ends when the woman carrying the fetus believes it begins and ends?" (Burke 1999).

Families who endure reproductive crises often find that the experiences do not fall into neatly proscribed categories. Just this week, a close friend learned that her much-desired pregnancy of ten weeks was not viable. Through a sonogram, she saw that the embryo was malformed and had an intermittent weak heartbeat. She had also begun to spot, and within days the flow of blood and discharge increased. Her physician discussed a dilation and curettage (D&C) with her. Some of the doctors in the practice would not perform a D&C if there was still a heartbeat; others would. My friend wondered whether she was having a miscarriage, an abortion, or a sad blend of the two.

To deconstruct the barrier that has developed between those who experience abortion and those who experience miscarriage, a group of artists affiliated with Sun Crumbs Gallery in Pittsburgh collaborated on an art exhibit called *Womb Journeys: Beyond Regret, Joy and Shame*. The exhibit examined miscarriage, birth, and abortion through the eyes of four artists. The gallery purposely avoided making a strong distinction between this range of reproductive-related experiences; instead it allowed the artists' words and images to speak for themselves, to help us see these experiences as part of a spectrum. One of the show's organizers, Gabrielle Strong, writes in the exhibit brochure: "Although childbirth, miscarriage and abortion are events which occur frequently within the span of our lives, they are often assumed to be separate events, having no crossover of associated feelings…this assumption not only isolates women from each other, but from ourselves."

In my own history, there is emotional crossover in my reproductive lifeline. Having personally experienced pregnancy, abortion, miscarriage, and giving birth, I found that all of these events are indeed multilayered and interwoven one with another. Christina Springer, another artist who developed the exhibit in Pittsburgh, challenges stereotypes about reproduction and loss: "Miscarriage doesn't happen to nice women, does it? Childbirth is supposed to be an avalanche of roses, a whirlwind of candy kisses. Abortion seems to be a dirty word, a secret… Share another vision. We are taking one step on the journey toward wholeness."

Returning to the question of what is lost, we find no simple answers. There is a tremendous range of reactions to the experience of pregnancy loss, based on the unique circumstances and on one's longstanding personal and cultural beliefs. In one family, a miscarriage may be an upsetting but ultimately manageable experience – a pregnancy may be seen not as a child but as a group

of cells with the potential for personhood. In another family, a miscarriage is viewed as the loss of a beloved child who has already been named.

It is important to acknowledge that a pregnancy loss is not always a traumatic event. "Everything depends on the context of the loss and how the loss is eventually interpreted," explains Kim Kluger-Bell. "It is not abnormal to be able to brush off an early miscarriage, or even to see it as a *positive* sign: depending on her life circumstances, a woman may well regard an early loss as either a blessed escape from an undesired responsibility or even a positive sign that she and her partner are fertile" (Kluger-Bell 1998, p.47).

If we tour artwork created by pregnancy-loss survivors, we can actually see these different perspectives translated into form. The arts provide a powerful way to express stories that are otherwise hidden or whitewashed. Rather than seeking out simplified and sanitized points of view, the arts offers a range of experiences – as messy, contrary, and unpredictable as they need to be in order to capture authentic reactions to these emotionally complex losses.

Some people who have experienced pregnancy loss produce images reminiscent of embryos, curled-up forms residing in the uterine waters, such as the painting by Sonia Key (Figure 2.1). Others envision their babies as spirits sent to this world only for a short time but who might still hover about them or communicate with them. Pictures of dark figures or hooded thieves making off with a precious package also emerge, revealing the artist's sense that their pregnancy was somehow stolen. Many artists depict the lost baby, looking like a small but fully developed infant being held tenderly in the hands of God, or they picture themselves reunited with their child in a heavenly setting. Tammy L. Gross created a series of computer-enhanced works of art about her experience of pregnancy loss. Her piece, *Visiting*, poignantly depicts a reunification scene between mother and child (Figure 2.2).

Keeping in mind that each individual, each family, and each culture holds its own ideas of what is lost, it may be helpful to have an overview of different types of pregnancy losses and common reactions. Life is rarely simple; in her lifetime, a woman may encounter more than one of these reproductive losses, creating a complex reproductive history. Below, I give a brief explanation of many of the childbearing crises that families endure.

Miscarriage

"Miscarriage is a ripping away – of excitement, of dreams, of joy," writes Marion Flanary, an artist from Syracuse, New York state. "A senseless emptiness remains, accompanied by profound grief." In her painting *The Unexpected*, Flanary depicts the helpless chaotic state she experienced after her pregnancy loss

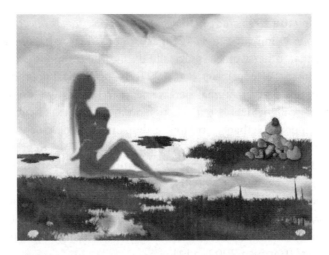

Figure 2.2: Visiting, computer art, Tammy L. Gross

Figure 2.3: The Unexpected, oil, Marion K. Flanary

(Figure 2.3). "My painting attempts to convey the intense, out of control state of losing a pregnancy and all the unfulfilled hopes." This overwhelming grief is too often misunderstood by friends and family, leaving the woman and her partner emotionally stranded. Terri Campeau of Olympia, Washington state, shares in an interview in her local newspaper, "One minute, you're pregnant; the next minute, you're not. You have nothing to show for the experience to the public, to your support system, to your family" (Gilmore-Baldwin 2004).

According to a 1997 study in the *Journal of the American Medical Association*, a woman who has a miscarriage is more than twice as likely to experience clinical depression than other women, especially during the six months immediately following the loss (Neugebauer *et al.* 1997). Is this clinical depression, or are these symptoms part of normal bereavement? Where do we draw the line? Whether one calls it depression or grief, women may experience insomnia, changes in appetite, lethargy, irritability, despair, and repetitive thoughts. On rare occasions, they may even become suicidal. This depressive state, heightened by a profound sense of isolation, is too often ignored or underplayed – women are tacitly expected to recover quickly from a reproductive crisis, almost as if nothing had happened. "You're not supposed to crumble or break down, the way you might after the death of any other loved one, so most women carry the grief internally while trying to go on with their 'normal' lives" (Hartigan 2002, p.11).

Karen, who lives in Washington state, describes her experience: "My husband Doug and I, over a six-year period, sought treatment for infertility, had a miscarriage, lost a baby at birth, and had three more miscarriages. While we had attention and support when we lost a full-term baby, the other losses were barely or not even acknowledged by others, though deeply grieved by us." Women, like Karen, who endure more than one miscarriage may experience a cumulative effect. "Recurrent miscarriage is one of the most horrendous problems any woman can face... The death of a hoped-for child in utero is as real as any other death, and as the losses accumulate the grief can seem intolerable" (Domar and Dreher 2000, p.270). Some couples feel so traumatized by recurrent miscarriage or failed in vitro fertilization treatments that they give up their quest rather than subject themselves to another loss.

It is common to feel profound rage following a reproductive crisis. Artist Tammy Gross portrays her overwhelming anger and fragmentation in her artwork *Self-Portrait (Anger)* (Figure 2.4). These unexpected feelings may leave bereaved parents feeling even more ashamed and isolated.

In her novel *The Wholeness of a Broken Heart*, Katie Singer presents a Jewish woman newly immigrated to America who loses her first pregnancy (Singer 1999). When she is finally released from her prescribed confinement after the miscarriage, the woman walks to the river and her emotions begin to bubble up, expressed in her broken English: "I can't sit. I feel thunder, thunder what has turned in my heavy heart all week, and I stand up." She hears herself shouting at her unborn child: "What nerve you have! What nerve you have to leave me before you sit on my lap! Before you taste my *kuchen*! You take all the love words I give to my belly and then you leave me! How could you do such a thing to me? Tell me – *mayn ziskeyt*, my sweetheart – what do I do with this love?" In a

Figure 2.4: Self-portrait (Anger), computer art, Tammy L. Gross

fascinating twist, the author develops a compelling voice for Vitl, the miscarried child who speaks from the Other World. Throughout the years, this unborn child, possessing an unlikely wisdom, becomes an invisible companion to her mother and a guardian angel to subsequent generations of the family.

It's not unusual for a woman or her partner to also harbor a sense of guilt of having done something wrong or a sense that they are being punished. I worked with a client who believed on some level that her arguments with her husband caused her miscarriage. Tammy Gross, who experienced an ectopic pregnancy, shares her relationship to guilt:

> The guilt is experienced on many levels, first with "what did I do wrong?" Then the guilt goes to a completely different level, where we have guilt that we shouldn't be grieving like we do. Where we should be "forgetting" about our loss and getting on with our lives like nothing has ever happened. These feelings are usually brought on by the closest people in our lives, including our mates/husbands. It is also brought on by the uncaringness of the medical professionals, who shuffle us through as just another number.

Many myths persist around what causes a miscarriage. Pregnant women are often cautioned against certain activities by well-meaning relatives, and this advice may lead women to blame themselves when a pregnancy is lost. Although the cause of most miscarriages is unknown, the scientific community is fairly certain about what does *not* cause a miscarriage: eating spicy foods, exercising moderately, lifting an object or carrying a small child, having sex, and

sustaining a minor fall. This list of common myths is not comprehensive and does not cover all the ideas held by various cultures. For instance, several cultures believe that "scaring the baby" through some shock or unexpected event can cause a miscarriage. In Hindu communities, there was until recently a widespread concern that the bubbles in carbonated beverages could dislodge a pregnancy. None of these myths, however, takes into account the durability of a healthy pregnancy.

Another common root of guilt is the belief that "I didn't want the baby enough." Some women may believe that their ambivalence or fears about parenthood, although completely normal, led to their pregnancy's demise. Rarely do we hear about the typical feelings that expectant parents experience alongside their joy: worries, fears, and doubts. "Ambivalence – intense anxiety along with exhilaration – is characteristic of the early months of pregnancy" (Kluger-Bell 1998, p.31). This common phase of preliminary anxiety may lead a woman and her partner to harbor guilty feelings that they did not want or deserve the pregnancy enough.

In his poem "The Miscarriage" Richard Jones (1986, p.168) beautifully captures a general sense of miscarriage as punishment:

> *As I held you,*
> *I felt I had been caught.*
> *The brief light of our souls –*
> *child too sad to show its face –*
> *shone upon my life, revealing*
> *all the things I'd done*
> *that can and will be used*
> *as evidence against me.*

Sharon Olds, another highly regarded American poet, echoes these feelings of self-recrimination in her piece *Miscarriage*: "I never went back to mourn the one who came as far as the sill with its information: that we could botch something, you and I" (Olds 1984, p.25).

One of the emotions that women and their partners often feel most ashamed of is their burning envy that others seem to have children so effortlessly. Writer Leslie Dick calls it "a stony, poisonous envy that burst out in the dark cry of why her not me?" (Dick 1988, p.192). Following a reproductive crisis, the world may seem awash with babies. Leeah Joo, an artist living in Kansas, relates her reactions following multiple miscarriages: "After having experienced this kind of loss, one can't help noticing every woman with a swollen belly and every child in a stroller. In fact, suddenly the immediate world is overfilled with women who can and have. You can't help feeling: why her and

not me?" Her painting *Sixteen* quietly portrays the sense of isolation and longing of a bereaved parent, as the viewer looks through a curtained window at the outside world.

One woman from Massachusetts vividly recalls a post-miscarriage visit to her nurse midwife and feeling enraged that the bulletin board near the examining room was plastered with photos of babies. All these beaming faces: exhausted mothers holding swaddled newborns, babies dressed in their best and held by older siblings or grandmothers. "It all felt like a personal affront to me, a woman freshly bereaved, coming back to this medical office, now un-pregnant."

In her novel *A Thousand Acres*, Jane Smiley weaves the theme of pregnancy loss and infertility throughout the story of a family of American farmers. Her protagonist, who has been unable to have children, recalls her difficulty coping with the birth of her sister Rose's second child. After her first miscarriage, just seeing the two babies felt toxic. Although she loved them and cared for them, her "tissues hurt" at the sight of them, as if her jealousy were physically poisoning her. Her envy was so strong and fresh each time she was with them, she found she couldn't be kind to her sister. On some deep level she blamed her for having what she could not. This experience of poisonous unacceptable jealousy and rage is understandably difficult for women to share openly and can become a constant but silent companion.

Parents who lose a pregnancy may also come to believe that the world is an extremely hazardous place or that whatever is given will soon be taken away. A mother may become inordinately fearful that she will lose subsequent pregnancies or become suddenly concerned for the safety of her remaining children. Following a full-term stillbirth, one woman shared her heightened fears: "At first I was afraid whenever someone left the house that they would die, both children and husband. I felt overprotective. It was a real struggle to let my son even ride his bike to school" (Kohn and Moffitt 2000, p.12).

In his essay on his wife's pregnancy, which ended due to severe abnormalities, Jonathan Tropper beautifully articulates the fears that accompany another try at a baby:

> ...this pregnancy was not accompanied by the innocent wonder of our ill-fated one. There were high-risk screenings and amnio, and I had recurring dreams in which the doctor handed me a baby with shocking deformities. The first time around, it hadn't occurred to me that something might go wrong. Now, even after we were assured at our midterm screening that the baby was perfect, I couldn't fathom the reality of a normal baby. The spell had been broken, and from here on out, I would always be afraid. (Tropper 2005, p.104)

Kluger-Bell (1998) observes that without outlets to work through these toxic forms of fear and self-blame, women and their partners can remain frozen in this emotional state for decades. These unexamined feelings may go underground and remain unresolved unless they are recognized, shared, and processed.

What makes it particularly challenging to share these unexpected feelings – this stew of anger, guilt, fear, and despair simmering just below the surface – is the almost universal experience of deep isolation that so often accompanies pregnancy loss. Women may feel profoundly alone with their grief, separated even from partners and family.

Nancy, a 22-year-old unmarried college student, lived through this bleak experience of aloneness following the loss of a wanted pregnancy:

> Though I was three-and-a-half months into my pregnancy, I had not publicly revealed my situation. Thus when I had my miscarriage, there were few to tell. I was unable to speak with my parents who would have been unsympathetic and could not have understood the complex web of feelings that I was experiencing. The "health care" providers were not helpful and in fact left me more traumatized because of their unsupportive actions and unsympathetic attitude. My friends felt uncomfortable with the subject. If not for my sisters and a woman named Claudia, I would have been hopelessly alone through the entire ordeal. I learned quickly most people are unwilling to speak about miscarriage.

Nona Hatay, an artist who now resides in Massachusetts, had a similar experience of isolation. "My miscarriage was long ago but I can still feel the physical fear and pain," she writes. "Feeling as if I was going to bleed to death, knowing my hopes and dreams were dead, feeling so helpless and alone in the bathroom all night long. Afterwards, no one really understood how bad it was." Hatay mentions the bleeding. In her artwork, she even smears a baby shower invitation with red paint.

Although almost every woman who experiences a miscarriage faces the red saturation of bloodied clothes or sheets, it is seldom spoken of. In reality, pregnancy loss can be a bloody, traumatic experience. The line "I woke in a wave of blood" penned by poet Nancy Willard (1993, p.163) reminds us that miscarriage is not a theoretical concept but a visceral event. Describing a miscarriage, Patricia McCarthy in her poem "D and C" writes: "Analgesics could not deaden the pain / of loss. My bloodprints on the floor / of the ward lead only one way" (McCarthy 1993a, p.178). The profound physicality of carrying a pregnancy and then enduring the often painful and messy draining away of that life separates the experience of women from that of their partners.

Finally, one of the universal experiences following pregnancy loss or infertility is the sense of emptiness or of something missing. Robin Freedenfeld created a series of haunting paintings after a miscarriage. The pieces, which at first appear decorative, soon reveal themselves to be barren and somehow too quiet. Her painting *Tomorrow's Child* captures the feeling of emptiness when an expected baby never arrives (Figure 2.5).

Tubal/ectopic pregnancy

Figure 2.5: Tomorrow's Child, oil on canvas, Robin Freedenfeld (photograph by Stephen Petegorsky)

An ectopic pregnancy occurs when a fertilized egg is implanted outside the uterus, usually settling in the fallopian tubes – hence the common term "tubal pregnancy." In rare instances, the ectopic pregnancy may occur in the ovary, cervix, or other area of the abdominal cavity. These pregnancies not only are destined to fail but also place the life of the mother at great risk, particularly if the misplaced pregnancy results in a life-threatening rupture of the surrounding

site. The diagnosis of an ectopic pregnancy usually requires immediate surgical intervention.

Friedman and Gradstein (1992, p.83) capture the experience: "Ectopic pregnancy. Before you had one you probably never heard of it. While you were in the middle of it you were probably stunned. You may have recently found out or not even have known you were pregnant. Then, suddenly, you were being rushed into the operating room. You woke up and learned that you had lost a baby and a fallopian tube." Imagine the shock that an expectant couple experiences when a routine ultrasound scan transforms into emergency surgery. To complicate matters further, the woman learns that her chances of a healthy pregnancy in the future have just plummeted.

The incidence of ectopic pregnancy is on the rise, in part due to untreated infections such as chlamydia that can result in scarring of the reproductive tubes. "In 1970 there were 17,800 ectopic pregnancies in the United States alone. By 1992 (the latest year figures were available) the number of women who endured the emotional and physical anguish of ectopic pregnancy had reached 108,800" (Kohn and Moffitt 2000, p.57). In the UK, the incidence of ectopic pregnancy is currently 70,000 cases annually – about 1 in 250 pregnancies.

Despite the prevalence of this type of pregnancy loss, there seems to be little understanding of the parents' grief. One woman reports that her medical providers "told me to go home, saying, 'you were never really pregnant.'" To make matters worse, during a woman's postoperative recovery, she may find herself in the unbearable setting of a maternity ward. "I was on the obstetrics floor after my ectopic for five days," shares one woman, "surrounded by happy mothers and fathers and their babies. I was particularly sensitive to seeing them because I had lost a baby and a tube" (Friedman and Gradstein 1992, p.89). Couples who experience an ectopic pregnancy need acknowledgment from their medical care providers and reassurance that they have every right to grieve their loss.

Molar pregnancy

Women who endure a molar pregnancy often feel as if nature has played a cruel trick, promising a baby and delivering only heartache. This rare category of pregnancy loss (1–2% of pregnancies), also called a hydatidiform mole, mimics a healthy pregnancy. Usually there is no fetus but a mass that begins to fill the uterus with an overgrowth of the placental tissue.

With few symptoms to alert her, a woman experiences the growing abdomen and morning sickness she would expect with a typical pregnancy. The shocking news that there is no baby can be psychologically devastating. But

that's not the end of potential problems – she also faces a potential health risk: a molar pregnancy may be the harbinger of a rare form of cancer. Fortunately, this kind of cancer is considered generally to be curable. The woman's physician will carefully monitor her following a molar pregnancy to detect any signs of malignancy. Doctors can also reassure a couple that molar pregnancies are extremely unlikely to reoccur (Kohn and Moffitt 2000, p.61).

Jenn, from the US midwest, began a website (www.mymolarpregnancy.com) in 2001 dedicated to supporting women in recovery from a molar pregnancy. She initiated her site just six weeks after her own loss, having been unable to locate helpful pre-existing sites. Jenn says, "Pregnancy sites offered little more than a blurb about molar pregnancies, and finding women on those sites who had had or were having the same experience was too difficult, because it meant wading through messages from countless happy moms-to-be." Her site features the personal stories of women who have experienced the pain of this confusing loss. Sharing their narratives about molar pregnancies and related losses affords the writers a chance to make sense of their experience and find a sympathetic audience. On her website, Jenn explains: "Writing my story, sharing it with others, providing a place for women with molar pregnancies to meet and talk…all of these things have been very therapeutic for me."

Infertility

In an interview in *People* magazine, actress Brooke Shields openly discusses her struggle with miscarriage and infertility. She shares the feelings many women encounter when their well-laid plans for parenthood turn out to be not so straightforward. "Being a type A personality, I've always believed that if I did my homework, if I worked hard enough, I'd get the results I wanted," she says. "But you can't ensure success unless you're God – and you're not. Neither are the doctors" (Smolowe and Gold 2003). In these times of medical miracles, we are often surprised and disappointed when technology fails to grant our wishes, as if the birth of a child were no longer a blessing but a right.

Approximately nine million American couples struggle with infertility each year. Another way to understand the numbers is that 15 percent of couples encounter infertility. Infertility is diagnosed after a woman has experienced several miscarriages or when a couple is unable to conceive after trying for one year. Generally speaking, the physiological factors causing infertility are divided fairly evenly between the sexes. There is a real lack of sound knowledge about the psychological impact of infertility; and yet, as psychotherapist Pam Peterson points out, "infertility can be one of the most distressing life experiences a couple faces" (Peterson 2004, p.9).

The primary causes of male infertility are impaired sperm production, impaired sperm delivery, and testosterone deficiency. A man may be infertile as a result of genetic or developmental conditions, hormonal dysfunction, injury, illness or infection, or the use of some medications or chemotherapy. As recently as the 1990s, treatment for infertility in men was limited to inseminations or in vitro fertilization using donor sperm. Today, advances in the treatment of male infertility have introduced therapeutic options offering men greatly improved chances to conceive their own biological offspring.

The underlying causes of female infertility are also numerous. The inability to conceive or sustain a pregnancy may be the result of any of the following conditions:

- *Endometriosis:* in this disease, tissue that normally lines the inside of the uterus spreads to other organs, such as the fallopian tubes, intestines, and ovaries. This disease affects 10–15 percent of women of reproductive age. The severity of the condition varies greatly among women, from no symptoms at all to severe pelvic pain and bleeding. A significant number of women with endometriosis suffer from infertility (Berstein 1995, p.56).

- *Fibroid tumors:* these benign growths in the uterus often cause no problems but occasionally they may be associated with infertility, miscarriage, and premature labor. It is not uncommon for a woman over the age of 40 years to develop fibroids. In terms of fertility, the presence of fibroids may interfere with implantation of the fertilized egg. They can also reduce blood flow to the placenta and compete for space with the developing baby. In mild cases, a physician may choose simply to monitor the condition or to remove the tumors surgically. In severe cases, a full or partial hysterectomy may be necessary, effectively ending the woman's reproductive capacity. Fibroids are more common in older women and in women of West Indian or African origin (Kohner and Henley 1995, p.187).

- *Other tumors:* some women develop uterine polyps (small growths) or cysts in the wall of the uterus. Both can be removed surgically. Rarely, malignant tumors such as sarcoma may develop.

- *Pelvic inflammatory disease (PID):* this condition is caused most commonly by chlamydia, but it can also result from gonorrhea and other sexually transmitted infections. Untreated chlamydia can spread to the uterus and fallopian tubes and cause PID in up to 40 percent of infected women. In the past, PID was also associated with intrauterine devices (IUDs) used for birth control. This

problem has for the most part been corrected by a new generation of safer devices. Whatever its initial cause, PID can lead to permanent damage to the fallopian tubes, uterus, and surrounding tissues, which can result in infertility. Chlamydia infection is often described as a "silent disease," doing its damage quietly without obvious symptoms.

- *Cervical stenosis:* this is closure or narrowing of the cervical canal, usually caused by untreated infection, multiple D&Cs, or surgical procedures on the cervix.

- *Anatomical conditions:* developmental defects in the structure of the uterus, such as a bicornuate uterus or septate uterus, can interfere with fertility. These structural problems can be detected through a hystogram (dye and X-rays). In rare cases, the fallopian tubes may fail to develop or may be underdeveloped (hypoplasia).

- *Thyroid disease:* both hypothyroid and hyperthyroid conditions can affect fertility.

- *Luteal phase deficiency:* this condition is marked by a lack of the hormone progesterone in the later part of the menstrual cycle. Without this crucial hormone at the correct time, the fertilized egg cannot thrive. This imbalance can be treated with synthetic progesterone after ovulations.

- *Polycystic ovary syndrome (PCOS):* this condition can affect a woman's menstrual cycle, fertility, hormones, insulin production, cardiovascular system, and appearance. PCOS is the most common hormonal reproductive problem in women of childbearing age. Women with PCOS have elevated levels of androgens (male hormones), often resulting in increased growth of hair on the face and body, acne and oily skin, thinning hair, type 2 diabetes, pelvic pain, and menstrual cycles that are irregular or non-existent. Although we do not understand fully the causes and cures of PCOS, it can be managed successfully in many cases.

- *Ovarian failure:* primary ovarian failure is diagnosed when a woman has never ovulated; however, sometimes ovulation can be induced with proper hormonal treatment. Secondary ovarian failure is diagnosed when a woman initially has been able to ovulate but then stops. This is not an uncommon condition in women who are long-distance runners or who have eating disorders, dramatic

weight loss, or a serious chronic illness such as congestive heart failure or kidney disease.

- *Hysterectomy:* different types of hysterectomy may be performed, based on the particular health concerns of the patient. The surgeon may remove only part of the uterus or the entire uterus and cervix. In some cases, the ovaries and tubes must also be removed, which has major implications for the woman's hormonal balance, inducing "surgical menopause."

- *Other medical conditions* that may influence infertility or increase the risk of miscarriage or premature birth include lupus, diabetes, sickle cell disease, pre-existing high blood pressure, pregnancy-induced hypertension and eclampsia, and infections in the mother.

Emotional reactions to infertility

How do women and their families respond to the dilemma of infertility? In traditional cultures, fertility is the basis of society, and the woman's primary role is to bear children. A woman struggling with infertility may be pitied or shunned – even divorced – and she may find herself without a real niche in society. Even in today's modern societies, women almost always feel a sense of responsibility: "It is her body that does not get pregnant or that fails to carry the pregnancy to term" (Peterson 2004, p.9).

Yet, with many more roles besides mothering available to women, the inability to carry a pregnancy to fruition may be emotionally underplayed. Friends and relatives may say, "Oh well, what's the big deal – isn't it alright for a woman to live child-free?" These statements, masquerading as comfort, can ring hollow. Women's roles are far from clear, leaving many torn between conflicting pressures to succeed on the work front and the home front – and for many women, that still means having children. Jeannie Sharp, who uses images of dolls in her photography about pregnancy loss, writes: "As little girls, we are gifted with small plastic imitations of ourselves which thrust us into the willing role of pretend motherhood. Through vivid imaginations we create real children that we hope to someday bear. For myself, there was never a question of if, but when, I would have children."

When infertility enters her life, a woman often experiences her body and spirit as defective or damaged. Margaret Carver, an artist from Northampton, MA, created a gallery installation reflecting her struggle with infertility and pregnancy loss. In her found-object sculpture *Dream Trap* (Figure 2.6), she assembled discarded pieces of blackened machinery and car parts from

Figure 2.6: Dream Trap, assemblage, Margaret Carver

junkyards to capture her experience of betrayal by a malfunctioning reproductive system.

In response to this intense focus on the body and simultaneous disconnection from it, many couples find that their sex life suffers. Psychologist and fertility guru Alice Domar observes: "After months or years of scheduled sex, in which lovemaking loses its spontaneity, partners readily lose their passion for each other" (Domar and Dreher 2000, p.107). Some couples find that they can reclaim their sexual connection through practicing what Domar terms "mindful sex," which includes deep breathing and taking time to give and receive pleasure.

More women coping with infertility are choosing to participate in programs designed to provide psychosocial support. Domar heads one of the best-known programs in affiliation with Harvard Medical School. She advocates integrating yoga, guided imagery, journaling, and other stress-reduction techniques into treatment for infertility and cites statistics that these types of programs do get remarkable results.

Yet a woman struggling with infertility may get the message that her problems are purely psychological: she is blocking the pregnancy with unresolved

issues or lifestyle choices. Receiving advice to change her attitude in some way – open up, soften up, slow down – perpetuates the belief that her infertility is the manifestation of a character flaw or poor lifestyle choices. Caught between her internal critic and external advice, she may be left with chronic feelings of failure and guilt.

If a woman requires a hysterectomy, even though it may be a relief in terms of health concerns, she may find it to be an intensely painful emotional experience – with the loss of her womb, a woman is faced with the finality that she can no longer bear a child. Women who have undergone hysterectomy may experience depression, heightened emotions, a sense of emptiness or uselessness, or an overwhelming desire to have a baby. This may be surprisingly true even for women who feel comfortable with their decision to have a hysterectomy, for women who already have children, and for women who consider themselves emotionally resilient.

A quick glance online reveals a world of women who are grieving the loss of their childbearing capacity and their symbolic womanhood. Some of these sites, with catchy names like HysterSister and HysterCity, feature electronic bulletin boards, where visitors share information and lend an empathetic ear.

Some cultural observers feel that infertility may be easier on a man's psyche – in many societies, he can be accepted as complete and functional regardless of whether he fathers children. But in some societies, male infertility can be an even more taboo topic than it is for women, as a man's virility may be seen as the hallmark of his very manhood. And how many of us take the time to comfort the male partner of an infertile couple and ask how he is coping emotionally?

Infertile couples, and increasing numbers of single women, must decide whether to wrestle with insurance companies or stake huge sums of money and emotional energy on procedures such as in vitro fertilization (IVF), which may have a success rate of less than one in four. These procedures can involve months of injections, discomfort, hormone swings, and the agonizing wait for results. It is also important to note that assisted technologies such as IVF are not accepted practices by all religions, and some couples may have to choose between their religious beliefs and the desire to utilize these new procedures.

As more families, including those headed by two women, avail themselves of scientific breakthroughs in their bid for pregnancy, a previously unheard of category of loss is born: the failed IVF. This loss is just one of the new kinds of bereavement that we now encounter in the quest for fertility. Kluger-Bell (1988, p.33) reports that many of the couples she counsels are "shocked by how much emotional weight an IVF failure carries." In "Elegy, the Fertility Specialist," Canadian poet Sharon Thesen writes of how infertility offers one

disappointment after another, with "Doors closing in swift silent succession" (1995, Thesen 1995, p.115).

The loss of one's dreams of having a child in a particular way, or of having a child at all, is perhaps the most invisible in the range of reproductive crises, and yet it can be the most consuming of time and emotional energy. Studies have shown that the stress levels of people struggling with infertility are equal to the stress experienced by patients suffering from AIDS or cancer. The need for the acknowledgment and release of this stress, as promoted by Domar and her colleagues, is becoming a more recognized part of the treatment of infertility. Creative expression of the ongoing experience of infertility and its accompanying feelings can provide a powerful outlet for this hidden loss. Nancy Rich, who endured several miscarriages and was finally unable to have a baby, wrote:

> *It is empty.*
> *I am empty.*
> *My hands are empty.*
> *I come to the altar without gifts.*
> *How do I approach with my head high*
> *And my eyes without tears?*

In her poem, Rich reveals the emptiness and grief that pervaded her experience. In writing a series of spare and elegant poems, she made room for her dark imagery and began the process of healing and acceptance. Infertile couples may "have endured heartache, frustration and anxiety-ridden pregnancies, sometimes over a period of years" (Kohn and Moffitt 2000, p.196). Moving through the bereavement process of miscarriage combined with infertility – what has been called a "two-fold sorrow" – can be a crucial part of a couple's preparations for their evolving identity, whether it means ultimately coming to terms with their childless status or, by working through their grief over the loss of their genetic legacy, opening up to the possibility of becoming adoptive parents.

Abortion

The bitter ongoing abortion debate, particularly in the USA, adds a layer of confusion to how we regard this category of loss. In the black-and-white politics of abortion, there is little room for gray. Our personal experiences don't always line up neatly with our political beliefs, and some women feel as if they have fallen between the cracks, with no safe place to express their experience.

Technically, medical practitioners distinguish between two ways that pregnancies end – both are called "abortions," but the terms are not used in the

colloquial sense. Physicians define a miscarriage as a "spontaneous abortion" – in other words, the unexpected loss of a pregnancy. In medical parlance, an "elective abortion" defines the decision to terminate a pregnancy.

Women who experience an elective abortion have the extra burden of knowing they made a choice to end their pregnancy. Kluger-Bell (1998, p.20) points out: "There is often shame and a desire to forget, and, especially with the chosen loss of abortion, a fear of condemnation, of being blamed for a deep parental failure." Their grief may feel disenfranchised, as if they have no right to grieve.

Women who are pro-choice may even subdue or hide their sorrow over a miscarriage "for fear that they could provide ammunition for the antiabortion movement, even though these women feel there is a distinct difference between the unexpected loss of a planned pregnancy and a woman's right to make a choice about an unplanned one" (Hartigan 2002).

Gwendolyn Brooks' poem "The Mother" begins with the thought that abortions are never forgotten (Brooks 1991, p.183). Just because a woman chooses to end a pregnancy does not mean she does so lightly or without sorrow. In her practice as a psychotherapist, Kluger-Bell (1998, p.96) has found that for many women who have an abortion, "the fact that their pregnancy losses were chosen did not make their grief over them any less real or less potent." Poet Judith Minty ends her poem about abortion "The Babies," with the reminder that we may mourn a previous pregnancy even when nursing our last child (1974, p.192). (Minty 1974, p.192).

A woman who has an abortion may find her experience complicated by the political maelstrom surrounding the issue. She may encounter a counselor who is barred by agency policies from discussing abortion as an option. She may have difficulty locating a doctor who will perform the procedure. When she arrives at the clinic, she may have to wade through protesters praying and screaming at her to not "kill her baby." At her place of worship, she may no longer feel comfortable, knowing that her actions are not acceptable to her community of faith. These factors can make the recovery process following the termination of a pregnancy confusing and painful.

Termination due to severe abnormalities or multi-fetal pregnancies

A more recent and increasingly common loss involves terminating a pregnancy in the face of severe fetal abnormalities. Families confronted with this heart-wrenching decision are truly in uncharted waters, with little information about this reproductive crisis or support to deal with their conflicted feelings and

intense grief. Often, they experience the anguish of abortion and miscarriage simultaneously, as they are forced into a position in which they must make a deliberate choice.

Writer Jane Brody quotes the dreams of a woman who elected to terminate a severely abnormal pregnancy: "I had already pictured her birth, pool parties, mother/daughter shopping escapades, graduation day, and her wedding. I planned my entire life with her in it" (Brody 2003, p.F6). No one can imagine that it was an easy decision for this woman to terminate her pregnancy. In fact, the sourcebook *Surviving Pregnancy Loss* (Friedman and Gradstein 1992, p.117) points out that few individuals can predict accurately how they will react when given the news that their fetus carries a serious genetic or developmental flaw.

Writer Jonathan Tropper was faced with the devastating news that the fetus his wife was carrying had a rare mutation and was significantly malformed. "You know you've arrived in a different universe," he admits, "when the word 'fatal' comes as a relief" (Tropper 2005, p.104). Even families stationed in the pro-life camp may be surprised to find themselves choosing to terminate such a pregnancy.

And what of those situations in which the diagnosis is not so clear-cut, presenting the couple with a set of harrowing statistics and risk factors? Given this predicament, a couple's tolerance for taking risks and living with the unknown will play a large part in the resolution they choose. The history of the family before the abnormal pregnancy sets the tone for the decision they ultimately make. "Whether a couple has other children, whether or not the pregnancy was planned, and how attached the parents are to the pregnancy may all have an influence on what decision is made" (Friedman and Gradstein 1992, p.118).

The emotional challenges of a loss stemming from the diagnosis of an abnormal pregnancy may include simultaneous feelings of guilt and relief, as well as the need to keep the decision secret from family, friends, and co-workers. A woman may feel herself to be abnormal for conceiving an abnormal pregnancy. One member of the couple may feel somehow responsible for passing on a faulty gene to the baby. Poet Patricia McCarthy paints the scene of a pregnant woman just learning that her baby has Down syndrome. In the clinic, she watches the "other mothers to be / waddle knowledgeably, bellies ripe as fruits, / through an assured future for each pregnancy." Her isolation is palpable: "they can't see the deformities / in my tiny ration of hope that I happened to conceive" (McCarthy 1993b, p.20).

Families may also have to make tough decisions in multiple pregnancies. "The dilemma they face is a difficult one: the decision to continue without intervention means bringing a child with major problems into their lives, and

the decision to selectively terminate means taking the risk that the unaffected fetus or fetuses may not survive the trauma of the termination procedure" (Friedman and Gradstein 1992, p.119). With more infertility treatments occurring today, there is also a rise in the number of pregnancies with three or more fetuses, which again requires a decision to be made. Should the parents elect to terminate some of the fetuses to ensure the healthy development and delivery of the others? "Ironically, many of those facing a decision about multifetal pregnancy reduction have spent a significant amount of time, money and energy trying to conceive" (Kluger-Bell 1998, p.92).

These kinds of loss present a special challenge for families: amidst the preparations and celebrations welcoming a new baby or babies, the parents are also mourning the infant who did not survive. The joy and anguish become intertwined, with little time or space to process the impact of these milestones on the emotional life of the family. Parents may also wonder how much of the history of the pregnancy should be shared with the surviving twin. One woman relates her experience of losing a twin and caring for the surviving child. Although she wanted to protect her son from her grief, "she was constantly reminded of the death of the other baby by his presence" (Hogan 1997, p.243).

Friedman and Gradstein (1992, p.108) remind us: "Not so very long ago pregnancy was a mysterious process." The gifts conferred by genetic testing on today's potential parents are accompanied by a new set of agonizing decisions if their pregnancy is the one in a hundred or a thousand that results in the dreaded conference with the doctor. Their emotional recovery from this loss usually requires a willingness to communicate about the almost inevitable divergence in feelings and perspectives that partners experience and to find ways to tolerate the contradictory feelings that are so often stirred up.

Stillbirth and neonatal loss

It's hard to imagine anything sadder than a nursery that must be dismantled because there is no baby to bring home. When death meets birth, the collision leaves families stunned and disoriented. In one of many poems produced after her stillbirth, Kara Jones (2000, p.28) writes:

> *I seemed to circle round*
> *and round the same room*
> *constantly looking at the*
> *same empty spaces where*
> *my son should have lived*

Stillbirth is defined as the death of the fetus between the twentieth week of pregnancy and birth. In the USA, approximately 29,000 babies are stillborn each year. In the UK in 2001, about 6000 babies were stillborn or died shortly after birth. In other words, in one year in the UK, "5 babies in every thousand are stillborn, and 5 more die within the first four weeks of life" (Kohner and Henley 1995, p.174). In almost half of stillbirth cases, no cause of death is found.

Although stillbirth may be diagnosed while the baby is still in the womb, some women may endure a full course of labor before they learn that their child has not survived. Although her arms are empty, a woman's body will still produce breast milk and go through other postpartum transitions, such as after-pains and hormonal shifts. "For women who have lost their babies, this period is exceptionally stressful, both physically and emotionally" (Friedman and Gradstein 2000, p.67)

Stillbirth and neonatal death are unique in the spectrum of reproductive crises, because in these cases parents often do have a glimpse of their baby. It is an agonizing greeting and bidding farewell at once. Words truly cannot express the loss of a full-term baby. As performance artist David Hansen laments in his solo drama *I Hate This: A Play Without the Baby*, there is no word in English for the parent of a dead child (Zinoman 2004, p.B1).

Neonatal death, the loss of an infant within 28 days of birth, is technically not a pregnancy loss. The baby survives birth and the parents have had a chance to interact with their son or daughter. However, in the case of a baby who is premature, is severely ill, or has life-threatening birth defects, the parents may spend most of that time navigating medical settings. "Facing major decisions about surgery, removal of life support systems, and other interventions in an infant's care can cause additional anguish to already overburdened parents" (Kohn and Moffitt 2000, p.87).

In the UK, approximately 7 out of 100 pregnancies end in premature birth (before 37 weeks' gestation). Although our ability to help these babies survive has increased dramatically, there are still cases in which the baby either is too small or has congenital malformations that make life outside the womb impossible (Kohner and Henley 1995, p.225).

The death of an ill infant can bring a combination of unbearable sorrow mixed with relief. Some families may feel guilty about having any sense of relief in their infant's passing or may question the medical choices they made. For those who lose a newborn without warning, the shock can be even more intense; they have had no time to digest the anticipated loss of their child. Families who suddenly lose a healthy infant are likely to feel traumatized, as if the rug has literally been pulled out from under them. "To bereaved parents, it seems at first that they will be destroyed by their grief. It seems impossible to feel so much and to survive" (Kohner and Henley 1995, p.43).

What helps many couples heal after the tragedy of stillbirth or newborn death is the authentic acknowledgment of the reality of their loss, to have others understand that their taste of parenthood, however brief, has changed their lives profoundly. Parents often feel that the response of their medical providers cannot match the agony they are experiencing. The doctors and nurses may in fact be in shock, or they may have learned to shut down emotionally as a form of self-protection. Fortunately, many hospitals have put into place bereavement teams that are ready to respond compassionately and effectively. "The response of health care professionals to the emotional needs of couples who have experienced a stillbirth has improved dramatically in the last decade" (Glass 1992, p.vii).

Years ago, stillborn infants were removed quickly from the mother in order to "protect" the fragile woman, as described in these lines from a poem by Paul Petrie: "But born still-born she was bustled / faceless away / to save a mother's / grief" (Petrie 1984, p.173). Now it is understood that the parents can benefit profoundly from an opportunity to see and touch their stillborn baby. Couples who are not given the opportunity to view and hold their infant may feel later that they are left with an invisible loss. One woman who did not have the chance to see her baby said: "Even though the baby was very tiny, I would have liked to have seen it at some point. I grieved so long for a baby with no face" (Friedman and Gradstein 1992, p.62).

"While many hospitals now recognize the value of memory-making, it wasn't too long ago that hospitals cut a clear line between the living and the dead," writes Kathleen Phalen in the *Washington Post*. "Mothers were sedated with scopolamine, the baby whisked away before she woke. Fathers stayed on the periphery. The baby's birth was often not acknowledged, an announcement never placed in the local paper" (Phalen 2000, p.14).

Now, many hospitals encourage parents to have photographs taken, make ceramic molds of the baby's feet, and save mementos from the birth. Mindy Gough (1999), in her chapter about "remembrance photographs," considers these images a special gift from the caregiver to the bereaved family. These may be the only tangible memories the family will have of their child to carry them through the years. In coping with this loss, a loss beyond words, couples can use these mementos as part of their healing rituals. A bereaved mother describes the solace she gets from the impressions of her daughter's feet: "When I am missing her immensely, I kiss the feet. Rub the rim. I think I have all the little lines worn off" (Phalen 2000, p.13).

Pregnancy loss and medical care

One of the most common complaints of women who have experienced a pregnancy loss is dissatisfaction with the way they were treated by the healthcare system. The experience of Beth Shadur, from Illinois, captures the feelings of many women who have felt emotionally abandoned by medical practitioners:

> I had my miscarriage in late 1989, after going through many years of infertility work, and finally achieving a pregnancy with some gymnastic medical means. I was thrilled to be pregnant, but very, very sick, and finally at 14 weeks had a miscarriage. The baby had apparently died at around nine weeks, but I had few signs, because I had been so sick anyhow. I was told while alone in an examining room, with my female (!) gynecologist telling me simply she was sorry, but the pregnancy was no longer viable, and that I should go home to try to let the fetus pass. She would perform a D&C in several days, if nothing happened on its own…and then she left the room and left me alone. I remember calling my husband, feeling shock, and somehow made it home on rubber legs. Not only did I have the D&C but she didn't get it all, and so I ended up in the emergency room several days later with an infection and much bleeding. A sympathetic resident helped me through that.

Nancy Raen-Mendez of Stoughton, MA, captures her experience of pregnancy loss in her series of paintings (Figure 2.7). Her *Patient* series depicts the isolation and the vulnerability she felt when she encountered the unsympathetic attitude of her medical providers. Beth and Nancy are not alone in their perception that medical care could be tailored better to the physical and emotional needs of women enduring pregnancy loss.

According to the website of the Miscarriage Association in the UK, recent research among a sample of over 300 women who had experienced loss in pregnancy showed:

- nearly half (45%) of them did not feel well informed about what was happening to them

- only 29 percent felt well cared for emotionally

- nearly four out of five (79%) received no aftercare.

Usually, it is not a matter of misconduct on the part of care providers but a lack of communication or sensitivity that leaves women feeling so inadequately cared for.

Hartigan (2002) describes her own experience when she was pregnant with twins: "After trying to conceive for some time, my husband and I were ecstatic. But nobody told us that I might lose the babies before we saw a heartbeat; they left that part out. We were totally unprepared for the day when the ultrasound

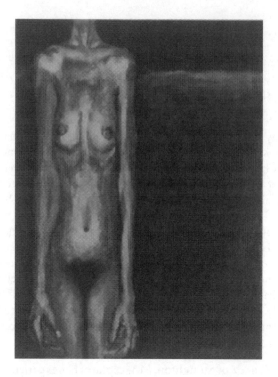

Figure 2.7: Patient #1, oil paint, Nancy Raen-Mendez

revealed two embryos that didn't make it; the technician left me lying on the exam table, legs propped in the stirrups, while she ran to consult the doctor." Hartigan is not alone in her complaint that someone should have told her how fragile a pregnancy could be and how high the chances of miscarriage really are. The dilemma for practitioners is deciding whether and when there is a right time to warn a couple that they could lose their pregnancy.

Other families point out the inadequacy of care offered to women after they lose a baby. Jean and Michael Morrisey of Lexington, Massachussetts, have campaigned tirelessly on behalf of grieving parents' rights to receive compassionate care. One bill they introduced would ensure that women who suffer a stillbirth receive quality postpartum care. They have also called for families to have more say in the disposition of the fetus or baby. In essence, the Morriseys and other pregnancy-loss advocates are simply asking that women who lose a pregnancy be recognized, empowered, and cared for.

Physicians would be the first to admit that our healthcare system is not designed to allow time for discussion and reflection about loss. Some physicians may feel that it is not their role to offer counseling or emotional support. Dr Robert H. Glass observes: "Unfortunately, the physician's focus on the physical

problems associated with the loss of the pregnancy can interfere with his or her ability to recognize and deal with the emotional needs of the couple" (Glass 1992, p.vii). On a personal level, medical providers may also doubt their own ability to cope with the intense feelings that arise for both themselves and the grieving patient in the face of unbearable loss.

In many practices, the nurses and midwives are designated unofficially the emotional caretakers of patients. However, whether they have the training and background to offer a sensitive response to a patient's loss is often hit or miss. The experience of Jay, an Australian woman who lost one of her twins and later joined an art therapy group as part of her recovery, remembers this dreadful moment: "Jay describes the member of the nursing staff who performed the ultrasound as 'not interested in me at all'... It was this person, with whom she had no rapport, who broke the news that one of her babies was dead" (Hogan 1997, p.240).

Writer Nancy Willard captures the surreal and disconnected sensations of a 4 a.m. trip to the hospital in her poem "For You, Who Didn't Know." Although it has a happy ending, the poem palpably lays out the trauma of this episode, when a pregnant woman wakes up bleeding: "There are rooms on this earth for emergencies / A sleepy attendant steals my clothes and my name / And leaves me among the sinks on an altar of fear" (Willard 1993, p.163).

Maryse, a nurse practicing in Canada, shares the doubts she had about her ability to respond to a stillbirth she witnessed: "I was afraid that I couldn't help the patient because I was so emotional myself. I felt totally helpless" (Kohn and Moffitt 2000, p.121). After she attended a two-day training program focusing on bereavement intervention skills, Maryse felt more empowered to remain emotionally present with families coping with a reproductive crisis.

Overall, medical care is evolving to provide improved emotional support to families faced with pregnancy loss. Dr Michael Berman, an instructor of obstetrics and gynecology affiliated with Yale University School of Medicine and author of *Parenthood Lost* (Berman 2001), gives his patients a rare gift. Faced with wrenching losses such as miscarriage and stillbirth, most physicians have learned to shut down emotionally. Dr Berman, however, channels his personal responses into poems that he shares with the bereaved families. "I have been writing poetry for many years and have used it in my practice to help my patients heal. I have read these poems at funeral services, at families' homes, and at memorial events." He also uses his poetry to reach medical students, in the hope that they too will embrace their emotional lives as tools for healing rather than seeing feelings as an encumbrance.

Berman penned this poem for a patient who lost a long-planned pregnancy in the thirteenth week. Prenatal testing revealed a rare and fatal chromosome abnormality.

Longer Days

Today, my senses are paralyzed

In frozen chambers of dismay
As in solitude I chant
Silent notes of prayer.

Like a leafless tree writhing,
I long for blossoms
At spring's first dawn

When the brightest days
Are longer than
The darkest nights,

When the breezes are warm,
And the air is fresh
With the scent of laurel,

When climbs of roses
Bring new hopes to bear
And tears of time
Drown my despair...

...when oblivion is home
To all my dismay.

As part of his outreach, Berman founded the Hygeia website (www.hygeia.org). Since its inception, Hygeia has grown into an international forum offering an unusual blend of medical information and creative expression related to pregnancy loss, neonatal death, and infant illness. Berman writes: "As caregivers and as members of the human family we must be able to offer comfort and solace to bereaved parents of the fetus and stillborn." The website also offers a special section for medical practitioners who may be suffering vicarious traumatization as a result of the pregnancy losses and early infant deaths they are too often confronted with in their work.

It is becoming more common for hospitals to have available on staff a bereavement counselor or a team of nurses specializing in pregnancy loss to respond to stunned women and their partners who were expecting to go home with babies. Medical centers are also beginning to sponsor ongoing support

groups dealing with infertility and pregnancy loss from a variety of angles. Some of these programs are affiliates of national peer-support organizations, such as SHARE (for miscarriage) and RESOLVE (for infertility). Other groups are being founded on a grassroots level, with women and their partners directing their grief into supporting and reaching out to other families. An example of such a pregnancy loss group, After the Tears – Another Chance, is offered at Bellevue Woman's Hospital, Schenectady, New York state, for people dealing with a new pregnancy or the demands of parenting after a pregnancy loss.

The arts in healthcare movement may also provide a fresh approach to humanizing our healthcare settings. Organizations such as the Society for the Arts in Healthcare have had some success in helping hospitals to create healing environments that replace the traditionally cold, hard-edged atmosphere we usually associate with medical care. From cultivating healing gardens to empowering patients to create tile murals, artists-in-residence and art therapists, alongside doctors, nurses, and social workers, are bringing new life to hospital corridors and treatment rooms. As patients, we long to be treated as whole people with unique cultural, spiritual, and emotional needs. Physicians, like Dr Berman, who are not afraid to use their own creativity to touch their patients' lives point the way to the many possibilities that the arts in healthcare movement offers.

We often underestimate the impact of the environment on our memories of loss. The art of British artist Simon Robertshaw, developed after his wife's miscarriage, speaks about how our experience as patients shapes our grief. His work, developed as part of the exhibit Before Birth: the Art and Science of Life in the Womb, was comprised of clinical, almost eerie, photographs of physicians' examining tables. Robertshaw describes this work as exploring "miscarriage and the interface between the body and medicine." The sounds and smells of the examining room, the equipment, the sonogram images – these things form the memories on which one's trauma and healing are built. For Robertshaw and his wife, "the table came to represent a sense of loss and grief."

It is important to remember that when a woman receives traumatic news, she may associate that trauma with her surroundings and the individuals who bear the bad news, despite the sensitivity they offer in the process. Pamela Joy Trow-Johnson, of Bend, Oregon, captures her nightmarish experience in her digital artwork Six Hours (Figure 2.8). "I was at the beginning of my second trimester and at my first doctor's appointment. All I could hear was, 'There's no heartbeat.' I couldn't believe it," she recalls. "The doctor and nurses had seen this before. They were delicate with me. 'We'll need to do a D&C. We can do it this evening.' This evening was six hours away. For those six hours my womb became a coffin for my child and my dreams."

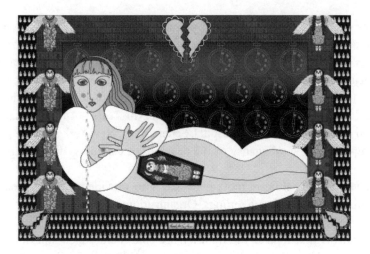

Figure 2.8: Six Hours, digital art, Pamela Joy Trow-Johnson

As the authors of *A Silent Sorrow* observe, "You will probably remember forever the way you learned about your pregnancy loss" (Kohn and Moffitt 2000, p.109). The behavior of your medical care providers is most likely a substantial part of that memory. Most families are no longer willing to accept insensitive care. Today's patients are looking for healthcare providers with a more sophisticated psychological understanding of pregnancy loss; however, more education and dialogue are needed before all medical practitioners can develop a truly compassionate protocol for patients grappling with this crisis.

Some of this important work is going on at conferences where caregivers are calling for effective partnerships between providers, patients, and communities. Researchers and educators have pioneered a deeper understanding of the psychological impact of childbearing losses. It is hoped that this well-documented information will begin to inform the care received in medical settings in a more comprehensive way. A new emphasis on cultural proficiency is also emerging, helping healthcare providers to better understand and respect families beliefs and customs. But perhaps the greatest potential for deep changes in the tone of the medical care we receive lies in the willingness of medical practitioners to ask questions and then take the time to actually listen to their patients' stories.

Some families who feel disappointed or traumatized by the nature of the treatment they received opt to voice their concerns. One of the most effective ways to be heard is to contact your hospital's patient representative, social work department, or director of obstetrical nursing and share your experience.

3

Griefwork

Living with loss

The work of bereavement specialist Kenneth Doka (1988) on "disenfranchised grief" provides a helpful prism through which to view pregnancy loss. Grief can become disenfranchised when a loss is not openly acknowledged, socially accepted or publicly mourned. In these situations, the relationship is not recognized, the loss is not recognized or the griever is not recognized. Artist Kathy Fleming of Minnesota, still affected by miscarriage decades later, says: "I remember life going on around me, whizzing by, but never engaging me. I felt held apart, invisible to people around me. I felt as if I were on the edge between being and nothingness, existing on the boundary line."

In normal grief resolution, feelings subside gradually. However, when grief is not acknowledged or accepted, grief resolution cannot occur and the griever is left stranded in a kind of emotional limbo. Formal studies and anecdotal evidence reveal that pregnancy loss can remain a longstanding grief if it is not addressed. We can begin to shift miscarriage and other reproductive losses out of the disenfranchised realm by validating that these are real losses and then developing meaningful responses.

But what does typical or normal grief look like? What does it mean to "accept" loss, let alone to "move on?" How do we move from numbness or drowning in sorrow to some kind of peace and acceptance? For years I have held on to a quote whose author I have long since forgotten: "Bereavement is not a state which one enters and departs; nor is it an illness from which one can be cured. It is a gradual evolving process that irrevocably changes the mourner." These words remind me that there are no quick magic bullets for grief – not therapy, not art, not religion, although these are some of the best tools we have – but there is a process that can be navigated.

Kluger-Bell (1998, p.24) gives us an overview of the grief process: "working through grief involves learning to withstand the certainty and the finality of the loss, uncovering the personal significance of what has been lost, and neither holding on to nor pushing away the sorrow, anger, guilt, shame, despair and envy that arise in response to it." The classic work of Elisabeth Kübler-Ross offers one way of understanding the stages that we encounter when facing our own mortality and the similar route we travel in facing the loss of a loved one (Kübler-Ross 1969). In the case of pregnancy loss, it is the loss of one we have just begun to love or have imagined loving.

Kübler-Ross's well-known stages of grief are denial and isolation, anger, bargaining, depression, and, finally, acceptance. To arrive at some kind of acceptance, it is usually necessary to wend our way through the other steps first. Some bereavement counselors question whether we really move through these stages in the order that Kübler-Ross outlined or whether we find ourselves jumping back and forth to different aspects of mourning. One should also note that some families who suffer a pregnancy loss do not necessarily experience the "bargaining" stage. However the process unfolds, we are striving for a return of the presence of hope and vitality.

Phyllis Silverman's "stages of transition" offer another way to view the journey through grief (Silverman 2000). She calls the first stage "impact": facing the unthinkable, often with denial or numbness. In a similar way, Worden (1991) sees accepting the reality of the loss – that the loved one is truly gone – as the initial stage of grief.

Following this stage in Silverman's framework is "recoil," which many people experience as an intense, sometimes overwhelming flood of feelings. Silverman emphasizes that grief work is not about "finishing" a feeling (for instance, working on anger and expecting to be done with that feeling) but about the ability to shift with the flow of feelings that inevitably arise. Her last stage, "accomodation," is the ongoing search for meaning and purpose, despite the loss, and an evolving relationship with oneself, the family, the community, and the memory of the deceased.

During the "recoil" stage, it is important for the griever to have a safe haven in which to identify and express authentic feelings. This is the phase of grief during which someone is most likely to seek out a therapist or support group. It is important to acknowledge that individuals have different styles of grieving: some are more feelings-focused while others are more action-focused. Expressive therapy can be a very useful modality for the safe expression of intense emotions at this time.

The feelings following a pregnancy loss may seem unbearable at times. The sorrow that hits may be pervasive and entirely unexpected. Intense feelings of

rage or guilt may sweep over you. It is not unusual to be preoccupied with thoughts of the loss. You may have vivid dreams of your baby or imagine you hear him or her crying, especially if you have experienced a stillbirth. Coping with normal day-to-day living may seem unmanageable, and interactions with your spouse or children may be tense. You may feel irritable, empty, lonely. All of these responses can be part of the grieving process (Figure 3.1).

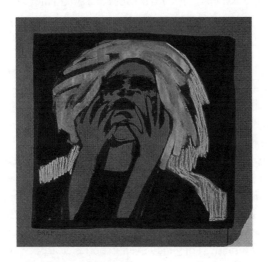

Figure 3.1: Grief, mixed media, Brenda Phillips

It is also important to note some of the physical reactions that can accompany loss, such as tightness in your throat or chest, lack of appetite, fatigue, and insomnia. Hogan (1997, p.237) mentions other possible sensory experiences, such as a heightened sense of reality, breathlessness, and oversensitivity to noise. She also points to research on parents who have lost a child at birth – it is common for them to be preoccupied with the image of their baby and to have a strong desire to hold their dead baby. Because of the ways in which grief can be manifested physically, creative modalities that allow for the release of grief held in the body can be a vital part of the healing process.

One crucial aspect of grief work is the recognition of cultural differences. A common mistake is to assume that there is only one "proper" way to grieve. Grief counselors and others who hope to accompany bereaved parents on their journey must set aside their own personal beliefs and cultural biases. Zucker (2005) shares the story of a psychiatrist who mistakenly hospitalized a native American patient when, following the death of a loved one, she dramatically cropped her long hair and began talking about knives around her doorway. Both of these "symptoms" were appropriate when viewed through the lens

of her culture. It is a tradition of her culture to shear one's hair during the mourning period. The knives around the door turned out to be a common way in which her community held broken doors in place. A stance of non-judgment and openness to the griever's experience can help one to avoid such misunderstandings and false assumptions that impede the healing process.

It is also important to understand the griever's personal concept of what was lost. We have many associations with the loss of a pregnancy and the dreams and hopes associated with it. Occasionally, the bereaved have very specific images associated with a lost pregnancy. "Although I have a wonderful son (Micah, 17 months) now, I still often think about the losses," shares Jen Primack of Pennsylvania. "I have an image of the baby I lost during my second miscarriage. I still see her in my dreams with a long brown ponytail and a fuzzy purple sweater. I love Micah and I love being a mother, but I still carry the loss of my little girl with me." Acknowledgement of these dreams – and their longevity – is crucial to understanding the mourner's experience.

Every loss is likely to have some level of trauma associated with it, even if it is an anticipated death. Pregnancy loss is prone to leave the griever dealing with traumatic memories, particularly as it may involve copious amounts of bleeding, unexpected medical procedures, and other shocking events. But even in cases when the pregnancy loss is ostensibly more low-key, the bereaved parents may experience it as traumatic. They may even experience aspects of post-traumatic stress, such as intrusive thoughts, dissociation, flashbacks, and hyperarousal.

There are two common reactions to traumatic loss: (1) a complete avoidance of the memories and feelings associated with the loss and (2) an obsessive kind of focus on some horrible aspect of the loss. Both of these grieving styles may leave the individual in a place where he or she cannot begin to reminisce about the lost loved one and accommodate the loss (Rynearson 2001).

To cope with the fallout of traumatic loss, Rynearson uses typical treatment techniques such as relaxation methods, thought-stopping, and guided imagery. He also adds what he calls a more "shamanic" approach, in which he invites the spirit of the deceased into the treatment. Whether one believes that the spirit is actually engaged in the process or that it is a projection of the griever's psychological needs is irrelevant to the effectiveness of the method. Rynearson may ask clients what their loved ones would think about their feelings and the way in which they have interpreted the story of their loss. Gestalt role-playing techniques can help access the wisdom of the deceased through dialogue. Rynearson also supports the use of clients drawing their memories and feelings as a way in which to process their trauma and make sense of their relationship to and loss of the loved one.

We come up against the question again: Is the grief process about letting go? In his "Tasks of Grieving", J. William Worden (1991) offers one way of answering this question. The final task of grieving, Task 4, is to emotionally relocate the lost child and re-engage with life. This task does not mean giving up the relationship with the missing child; instead, it means finding an appropriate place for the child in our lives – a place that will enable us to go on living effectively in the world. Silverman refers to this attachment as a "continuing bond."

Stillbirth survivor Kara Jones explains: "There was a time when I thought I would have to set my child aside, put him away, be 'over' his life and death before I could ever hold or love another child." As her process unfolded, she learned that healing derived not from forgetting her son but from integrating his presence into her life. Likewise, bereavement specialists today are less likely to urge families to "move on" and put the loss behind them. Healthy grieving is now seen as incorporating a productive ongoing relationship with the lost loved one – an attachment that does not interfere with the family's ability to adapt to their lives in the here and now.

Artist Kristine Sogn, living in Olympia, WA, depicts this idea beautifully in her piece *The Teapot* (Figure 3.2). What at first glance appears to be a chunk of a tree is actually a functional teapot, hand-built from porcelain. Sogn explains the connection to her pregnancy losses: "I enjoy living among the large old trees and considering the range of changes they have witnessed in their long lifetimes. The maples seem to record their every thought in their bark, their rings, their branches." She continues: "I have had three miscarriages over the past 12 years and realize that, like births, they are all different, effect me deeply and

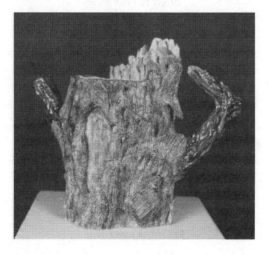

Figure 3.2: The Teapot, hand-built ceramic, Kristine Sogn

are never forgotten...the tree's losses are incorporated into the tree as a part of its whole."

Modern society does not prepare us very well to be grievers. "We are not allowed this. We are allowed to be deeply into basketball, or Buddhism, or *Star Trek*, or jazz, but we are not allowed to be deeply sad. Grief is a thing that we are encouraged to 'let go of,' to 'move on from' and we are told specifically how this should be done" (Strayed 2002, p.40). As a culture, we strive to insulate ourselves from the realities of illness and death. To accept that life is full of unexpected losses is entirely un-modern. We navigate our busy lives as if we have full control of our destinies, right down to whether or when we will have a baby. Too often we believe that advances in medicine will protect us from loss, but this belief couldn't be further from the truth, particularly when it comes to pregnancy loss.

"Women today...are caught in a unique historical moment: technology encourages them to form emotional attachments to their pregnancies, but society has not developed traditions to cushion the shock when those attachments are shattered" (Hartigan 2002, p.19).

Pregnancy loss is not on the decline. Despite technological advances in fertility treatment, we still do not always get to decide what fate has in store for us. The only thing we truly get to choose – and even this has something to do with luck and our own histories – is how we will make sense of these losses. We open to the possibility of learning something if we can; often, we are just grateful that, physically and emotionally, we survived.

Two poems, from *Father, Son, Holy Ghost* by Kara Jones (2000, p.18), in the Japanese *tanka* form provide a glimpse into one woman's ongoing healing:

> *Before you can move*
> *on, you must remember that*
> *it was your son who*
>
> *died*
>
> *not you.*
>
> *We go on to live*
> *full lives, empty of our son.*
> *The waters gather*
>
> *deep and cold in the well*
> *carved*
> *carefully*
> *by Grief's own hands.*

Men and women: grieving styles

One factor contributing to women feeling emotionally adrift after pregnancy loss is the difference in the way men and women tend to show their feelings. Psychologists have learned what most of us already know intuitively: men and women demonstrate differences in the way they cope with and express grief following a miscarriage (Beutel *et al.* 1994). According to one study, men tend to cry less than women and feel less of a need to talk about their grief and sadness following a miscarriage. In turn, the man's coping style inadvertently leaves the woman feeling alone in her bereavement.

At first glance, it seems fair to posit that women are more expressive about loss and more likely to seek support from others, while men are more action-oriented, tend to gather facts and problem-solve, and often choose not to participate in support networks focused on sharing feelings. Yet Doka and Martin (2000), in their book *Men Don't Cry... Women Do*, urge us to transcend these gender stereotypes of grief. Instead, they recommend looking at particular grieving styles, regardless of whether the bereaved is male or female. One may ask, for instance, "Does this individual feel comfortable expressing emotions directly or would he or she benefit more from developing a hands-on ritual?"

One factor that impacts the grief experience is the physical reality of carrying a pregnancy. The parent who does not carry the pregnancy has a different physical and emotional experience. Hormones may play an important role in a pregnant woman's emotional attachment to the fetus, as well as heightening her reaction to a reproductive crisis. In a series of colored-pencil drawings, Melinda Ann Hill explores her experiences after a miscarriage (Figure 3.3). Through her semi-abstract figure drawings, she is able to communicate the visceral sensations that would be difficult to articulate with words.

James and Cherry (1988, p.111) observe that the non-pregnant partner's emotional relationship with the baby typically begins when he feels the first kick. No matter how invested he may be in the pregnancy, he does not experience it internally. "While a prospective father may share his wife's desire for the child, the fact that the pregnancy is not part of his physical self makes the experience less immediate, and often less real, for him" (Friedman and Gradstein 1992, p.9). In same-sex couples, the woman who carried the pregnancy may feel that her partner cannot really understand the depth of her loss and her physical connection to the baby. Lesbian couples occasionally experience tensions over which of them will carry their child, and their feelings about this issue may surface again if they endure a pregnancy loss.

Loss and the lack of communication around the loss can create a schism within a family, sometimes irreparably. Jhumpa Lahiri, in a short story from her Pulitzer Prize-winning collection *Interpreter of Maladies*, depicts the quiet

Figure 3.3: Pink, colored pencil, Melinda Ann Hill

unraveling of a marriage after a stillbirth (Lahiri 1999). In her piece "A Temporary Matter," a young Indian-American couple slowly lose the capacity to speak of their feelings and inexorably drift apart, while their Boston neighborhood mirrors their emotional shutdown with nightly blackouts. In this story, it is the woman who cannot begin to find the words to express her grief and repair the rift in the marriage.

Nancy Rich, an educator at a college art museum in Massachusetts, turned to poetry when pregnancy loss and infertility touched her life. Her poems were written over a period of several years, when she had first one miscarriage, and then a second, and finally she was unable to have children. Rich says: "The sorrow never leaves, but things did change over time and it became possible again to live." She finally gave a copy of her poems to her husband. "Several years later, he told me he had cried every time he read them and had finally thrown them away. He felt he had to in order to put the experience behind him. I shook my head and sort of laughed. A relationship that survives encompasses such incongruities."

On the other hand, are men really encouraged to express their grief openly and authentically? A man from Edinburgh, UK, explains the situation following

his wife's miscarriage: "Afterwards, I was asked how my wife was. Never was I asked how I was." From a man's point of view, he may feel constrained in expressing his grief, as he struggles to appear emotionally intact following a pregnancy loss. "The husband too suffers and he is under the added burden of societal expectations that he will keep a stiff upper lip" (Glass 1992, p.viii). There is unspoken pressure on the man to be the strong one, to be there for his partner, but this arrangement leaves little room for the man's own bereavement.

Within the relationship of a grieving couple, much may go unsaid or be misconstrued. Men often feel excluded from the pregnancy experience and left without a map when that pregnancy ends. Robert Frost's poem "Home Burial" (1914) centers on a couple's loss of their child, addressing this sense of being an outsider to a woman's emotional landscape. The husband implores his wife to include him in her grief, to give him a chance to be included.

The myth that men do not respond deeply to pregnancy loss may just be the next taboo to be shattered. How to overcome this gender divide? When possible, it is helpful for both members of a couple to attend support groups or counseling together in order to bridge the communication gap that can develop following a family loss. Creating a family ritual that allows each person's style of grieving to be honored can diminish the distance between partners. The American Pregnancy Association offers basic survival tactics for couples who have experienced a miscarriage: be respectful and sensitive to each other's needs and feelings, share your thoughts and emotions, accept differences, and acknowledge each other's coping styles. Kluger-Bell (1998, p.117) adds: "...men, like women, need to seek out opportunities to remember, honor and speak about the pregnancy losses and abortions they are party to. And we all need to listen."

Children and pregnancy loss

The loss of an expected sibling will be experienced in different ways by children of different ages. The capacity to understand the concept of this invisible loss depends on the child's psychological and cognitive development. Children below the age of six or seven years may not yet understand the meaning of death and its finality. Before a fuller grasp of cause and effect emerges, a child may have "magical thinking" about the events. Some children even blame themselves for the loss, much as we have seen parents shoulder guilt for miscarriage or still-birth. It is important to reassure children that the loss of the baby was not anyone's fault.

Most bereavement counselors believe that children are quite adept at tuning into adult "secrets" about death. "Even very young children are aware when their

parents are upset, even when attempts are made to conceal distress" (Kohner and Henley 1995, p.99). The idea of protecting children from the realities of death and grief is considered passé. Today it is recommended that young members of the family be offered the truth about loss, but in a way that does not overwhelm them with details or leave them floundering for facts. This stance requires a bit of a balancing act on the part of adults.

For instance, simply stating "the baby went to Heaven" may not be enough to help a sibling understand what happened. On the other hand, parents should avoid flooding a young child with complex medical terms and traumatic images that they are too young to digest. A helpful approach is to give the basic facts. Kohn and Moffitt (2000, pp.160–1) suggest frank explanations; for example, "The baby's body did not grow properly from the very beginning, so he died" or "We think the cord wrapped around the baby's neck a week before she was born." It can also be useful to plant the idea that you are open to talking more about the situation and answering any questions that arise.

Giving the child an opportunity to tell the story of the loss as they understand it can give caring adults a window into the child's feelings and beliefs. Many children respond well to creating a short book about the pregnancy and its unexpected outcome. They can draw pictures to illustrate their narrative, which allows them not only to express their feelings visually but also to create a keepsake.

Young children also use play as a natural form of expression and to work through their feelings and ideas. "Playing at doctors and nurses, at being pregnant and having a baby die, and similar games can help them, though they may be upsetting or irritating for their parents" (Kohner and Henley 1995, p.100). Children can be included in family rituals acknowledging the loss and help in setting up memorials such as gardens or shrines.

Some children may need very little support following the loss, but others may feel quite troubled. Rather then expressing their distress through words, they may show it in changes in behavior, sleep patterns, or nightmares. When working with bereaved children, it is recommended to let them take the lead and to address their grief in small, manageable doses. Several books geared for bereaved siblings are available to help parents explain a sister or brother who never arrives or whose stay is tragically short.

One couple, who lost their pregnancy in the sixth month, share their story in *Rituals for Our Times* (Imber-Black and Roberts 1992). Grieving deeply, they planted a flowering plum tree to remember this lost pregnancy. "They created their own special ritual, making this tree the symbol of both their loss and ongoing life." As their other children grew, they explained to them the meaning of the tree. The mother shares: "Last year, my children planted flowers all around it to surprise me. Now the tree is not alone – they're all connected" (1992, p.131).

Counseling the bereaved

Grief counseling can be difficult work. It stirs up our own past traumas and losses. It reminds us of our own fears. It brings up questions that we would rather not think about. Yet it can also be life-affirming work, offering opportunities to deepen our understanding of life and death and our own choices and values.

There is a particular stance that is helpful for those who want to help the bereaved. The essential quality of this stance, empathy, requires the ability to tolerate intense emotions – both the counselor's and the clients' – without rushing to "fix" or resolve those feelings. The urge to fix is a natural one, but generally it is not as useful as a willingness to sit with clients' anguish, letting them know they are not alone and providing a holding space for them to have this experience. Zucker (2005) talks about our fears that the clients' affect will be overwhelming and accompanied by the urge to "shut off the valve" of feelings. How much more helpful to say "I can handle it if you want to tell me more about it." Ultimately, empathy asks of us the willingness to be touched by our clients' stories and to use our own histories and vulnerabilities to bring a human-ness to our work.

An additional skill needed by the counselor is awareness of one's own judgments. Are you feeling aggravated with your clients' need to talk over and over about the same small detail? Do you label a client "delusional" because she hears her baby crying? Counselors who are unable or unwilling to reflect on their own background and experiences are more likely to mistakenly pathologize a family's reactions to loss.

Instead of judgment, bring a curiosity and openness to the work – ask clients to initiate you into their experience and their understanding of loss. In a sense, they become the guides on this journey. This stance may mean setting aside one's own beliefs and spiritual teachings in order to learn about the clients' communities and worldviews.

It is also tempting to squeeze a client's experiences into neat stages of grief, such as denial, anger, guilt, etc. It is the grief counselor's job to be up to date on theoretical frameworks but to apply this information sensitively. When we rely solely on theories, we risk devaluing each person's unique struggles and solutions. Rather than judge a woman's inability to let go of guilt and move on, one might ask her: "How is this guilt important? How does it serve you?" We must also strive to understand this person's particular grieving style – is it active or passive, emotive or action-oriented, solitary or group-focused – and then design our interventions based on this understanding.

Zucker (2005) observes that the grief counselor requires patience, compassion, and persistence. As we are educating families about the bereavement and healing, they are also educating us. We are in the business not of fixing grief but of accompanying families on journeys they never wanted to take, reminding them that they are not alone, and working alongside them to honor their suffering while holding out hope. The creative output of individuals who have experienced pregnancy loss provides a unique window for those who are called to witness their pain and comfort them; the stories, the paintings, the songs and the poems serve to sensitize us all to the realities of this hidden grief.

Singing the Silence

Hidden history

Creative women today owe a debt to those who broke the rules before many of us were even born. Poet Muriel Rukeyser's often-quoted question asks: "What would happen if one woman told the truth about her life? The world would split open" (Rukeyser 1968). Today, with talk shows and memoirs that bare all, we take for granted the airing of our private lives. But when artists like Frida Kahlo and, later, Judy Chicago, created their groundbreaking artwork, there was scant encouragement for women to have creative careers, let alone make art about their authentic experiences. Roseanne Cecil, in her book *The Anthropology of Miscarriage*, reminds us that "the lives of ordinary women have been largely hidden from history" (1996, p.179).

Against the background of these challenges, we search for clues of how the arts have been employed to express (or obscure) the realities of infertility and pregnancy loss. How does unearthing the history of the creative expression of pregnancy loss instruct us today? By understanding the ways in which women's real experiences have been muffled and misconstrued, we derive a clearer understanding of where we stand now and what needs to be reclaimed. Cecil (1996, p.3) points out: "…the significance which a pregnancy loss has for a culture can be gleaned from considering how miscarriages and other losses are dealt with in its literature and poetry." The arts provide a mirror of the society in which they are produced, allowing us a glimpse of the unspoken attitudes and beliefs of the times. In rediscovering this body of work and placing it in context, we also lay claim to the potent symbols and images found therein, making them available to new generations of women and men. With this knowledge, one can see symbols found in ancient cultural practices reverberating in today's artwork, whether by coincidence or by design.

Visual art

The conundrum facing any visual artist grappling with pregnancy loss is this: how does one depict an invisible loss? Infertility and miscarriage essentially are about something that is not there, something longed for but missing. Capturing this experience in a visual format was particularly challenging until modern art presented new approaches. To understand the ways in which pregnancy loss has been portrayed over time, we often have to rely on the more obvious images of fertility, pregnancy, and birth. Even these experiences are largely hidden and, at times, co-opted by a predominantly male point of view. "Like depictions of pregnancy, images of giving birth are rare in the history of art, and an air of secrecy and taboo clings to this intimate, essential process" (Tobey 1991, p.32).

Early petroglyphs and sculptures of figures that are pregnant or giving birth have been discovered in most regions of the world, including pre-Columbian North and South America and pre-historic Greece. "By far, the greatest number of images of pregnant women come from preindustrialized cultures" (Tobey 1991, p.32). For instance, a stone sculpture from the Aztec culture depicts a woman squatting as her baby emerges. These fertility figures convey a deep sense of the magic and mystery that ancient people associated with reproduction. The image of a female figure, re-drawn by the author, is shown in Figure 4.1. The original was probably made by Algonkian-speaking people, and was found among copious rock carvings in Peterborough, Ontario (Corbin 1988, p.107).

Some mythologists and anthropologists believe that before the current Indo-European culture, Neolithic Europe was home to a goddess-worshipping culture. From England to Russia, artifacts point to peaceful, egalitarian, earth-centered societies with women at the center of the circle of life. These cultures worshipped the cycles of birth and death that they experienced in nature and regarded the goddess as both life-giver and destroyer.

Nature, the earth, and the goddess were all experienced as one. The moon, powerfully linked to the lunar menstrual cycle, often represented female qualities. Mounds and hills were also symbols for fertility, almost as if the earth itself was pregnant, and caves, metaphors for a woman's internal reproductive space, were sacred sites. The symbol of the cave, "nestled in the belly of the earth, had female associations and thus was made part of the general conceptual domain of fertility" (Biedermann 1994, p.61).

After this period, which the controversial anthropologist Marija Gimbutas (2001) called the civilization of the goddess, the central role of the mother-goddess and frank images directly depicting female fertility and pregnancy all but disappeared in Western culture for thousands of years. Some have suggested that the role of the mother-goddess of Neolithic times has been transposed on to

Figure 4.1: Pre-European petroglyph: female figure, Ontario, Canada

the Christian Madonna. Paintings of Jesus in the manger, often called the *Adoration of the Magi*, speak to Mary's role as a fertile, yet chaste, goddess figure. However, far from depicting the actual experience of birth, the artists place an alert Christ child on the lap of the placid, demure Virgin, as if there was no labor.

Christian tradition also features paintings of the Annunciation, a biblical scene in which the Angel Gabriel visits the Virgin Mary to tell her she has conceived. In the passage describing the Annunciation, Mary also learns of the miraculous pregnancy of her older cousin Elizabeth, who was considered barren. The angel announces that Elizabeth is six months pregnant with St John. These two women, one a virgin and the other infertile, are miraculously given the gift of procreation by a higher power.

In the Buddhist tradition, we find a birth story with many parallels to Mary's. The beautiful Queen Maya conceives and gives birth to Buddha in miraculous ways, which, as in the story of the Virgin Mary, preserve her virtue and make birth seem no more difficult than lifting one's arm. In this story, Maya dreams of a wondrous white elephant that merges with her. Upon waking, the queen feels great joy and wellbeing. A wise man interprets her dream to mean

that she will bear a son of great importance to the world. On her way to her parents' home, her birthing time comes near. In a scene often depicted in Buddhist art, she grabs on to a tree limb with her right hand and her son is born, almost effortlessly, from her side. In Buddhist theology, Queen Maya's role is fairly limited, unlike that of Mary in Christian traditions.

Images of more mundane and realistic birth scenes do exist. In the European medieval period, births are shown taking place in women's private chambers, where the woman is often attended by a midwife and other female figures. The visual material that has survived from 1300–1500, usually from manuscript illuminations, provides us with a peek at the real medieval woman. Some of these manuscript illuminations were created by women, usually nuns in convents, and the perspective and details included hint at a feminine viewpoint. However, these book illustrations, often anonymous, were certainly not regarded at the time as great art. As Tobey (1991, p.9) points out: "It is surprising that the subject of maternity in art has received so little attention."

During the Renaissance, Leonardo Da Vinci devoted himself to studying and describing the natural form of things. Beginning in 1509, Leonardo created anatomical diagrams, including studies of fetuses in the womb (Rosci 1976, p.148). These drawings were not based on dissections but were the result of his knowledge of human and animal anatomy. The sketches, made for scientific advancement, omit entirely the woman's emotional experience of pregnancy, but they are important as rare visual representations of the realities of reproduction.

One more thing about Leonardo: his *Mona Lisa*, perhaps the most famous painting ever made, is surrounded by the popular conjecture that the sitter is secretly pregnant – hence her mysterious smile. This rumor has been difficult to prove or disprove. We do know that at the time she posed for the artist, beginning in 1503, she had birthed one girl, already deceased, and two healthy boys.

It was fashionable for Renaissance painters to depict young married women with swelled abdomens, as seen in van Eyck's *Arnolfini Wedding*, now housed in the National Gallery in London. Modern viewers may mistake these women as being pregnant; in fact, such paintings are only highlighting the sitter's potential to conceive a child. This aesthetic convention tells us something of how women were regarded during those times: their role was tied inextricably to their ability to bear children. It is fair to say that paintings and sculptures of this period were created almost entirely from a male point of view.

In some medieval and Renaissance paintings, women are entirely removed as the conduit for birth: Botticelli's *Birth of Venus* shows the lovely goddess emerging fully formed from a seashell, and the biblical birth of Adam, who, in a

twist of nature, lends a rib towards the creation of Eve, is frequently depicted. These birth scenarios, which conveniently dispense with the role of women altogether, can be traced all the way back to the ancient Greeks, who developed myths such as the birth of Athena from her father's head, in which she leaps into the air with a war whoop, fully armored. One version of the story has Zeus swallowing his consort, the goddess Metis, after which Athena is eventually born. Some have pointed out how this arrangement gave males authority and power over birth, something that previously had been a strictly female realm.

Despite this mythology, the birth experiences of real women were fraught with discomfort and danger. "Throughout Renaissance Italy the infant survival rate hovered at fifty percent and giving birth was itself not without risks for the mothers as well" (Tobey 1991, p.17). Very few paintings of pregnant everyday women emerged from this time period. The great Renaissance painter Raphael made *La Gravida*, a portrait of an anonymous woman who is clearly well into a pregnancy, while a century later the Dutch painter Johannes Vermeer painted the contemplative *Woman Holding a Balance* in 1664.

Diane Savino, an artist and professor, explores the whitewashing of real birth experiences:

> Women throughout history have had very little control over their bodies, even in the process that they are most dominant in: giving birth. Instead, women have been presented with such maternal figures as the Virgin Mary or the "happy mother" of 18th century France. Birthing has always been portrayed as a joyous event or a painful one, endured because of Eve's curse. Women were never encouraged to speak about their real labor experiences, especially the ones that were messy or life-threatening. The concept of "the immaculate birth" prevailed, along with the "good mother."

If birth is depicted in a painting, then it is usually the moment following the actual birth, as we saw in the many Adoration of the Magi paintings in the Christian tradition. With artwork revealing women's authentic pregnancy and birth experiences almost non-existent in Western art, the possibility of depicting a miscarriage or stillbirth would have been even more unthinkable.

The example of artist Élisabeth Louise Vigée Le Brun illustrates that even when the brush was wielded by a woman, personal experiences were not portrayed directly in artwork (Sterling 1995, p.59). Vigée Le Brun, born in 1755, is documented to have had a miscarriage after the birth of her first child. An accomplished painter and independent thinker who worked during the French Revolution, Vigée Le Brun was successful enough to be commissioned to paint portraits of such luminaries as Queen Marie Antoinette and the sister of Napoleon. In her tumultuous life, riddled with trumped-up scandals, she

resided in various European cities and associated with aristocrats, and yet even this recognized and privileged artist did not allude on canvas to her experience of miscarriage. Her times afforded few personal or private revelations on the canvas, for men or women.

It was not until the early 1900s that societal upheaval and its accompanying modern art movements allowed artists and writers to grapple directly with issues such as pregnancy, birth, and miscarriage. These art movements were influenced in part by a new appreciation of art from traditional societies. Traditional cultures had for millenia created sculptures and symbols that captured the essence of the natural and spiritual worlds. Rather than relying on a more and more realistic approach to art, these societies let elaborate decorations or powerful symbols, masks, and altars tell the story of their connection to life and death.

Borrowing from and transforming this aesthetic, artistic approaches such as expressionism, surrealism, and abstraction offered modern artists new ways with which to capture hidden psychological realms and experiences. Expressionism in particular was concerned with portraying the artist's emotional truth, while surrealism was driven by the idea of the unconscious and the world of dream imagery.

In 1913, French painter Marc Chagall, influenced by both expressionism and surrealism, created a beguiling image called *Pregnant Woman* of his friend's wife (Tobey 1991, p.19). In the fanciful dream-like painting, one can view a child within the woman's torso, as if through a round window. What today may seem like a decorative and slightly odd depiction of a pregnant woman was considered quite new in its time. Almost a century later, today's artists pay homage in their own artwork, directly or indirectly, to artists like Chagall. They employ similar creative techniques in order to allow the viewer to see within a pregnant woman's body and psyche, to convey a more visceral sense of her experience of pregnancy and, at times, the subsequent loss of it.

In the 1930s, the celebrated Mexican painter Frida Kahlo was perhaps the first artist who dared to depict pregnancy loss in her artwork. She broke the tacit societal rules that dictated what was appropriate fare for the arts. A catastrophic trolley accident had left Kahlo physically shattered, with a traumatic injury to her pelvis. "As a result of the accident, she would never be able to carry a baby, and the doctors warned her not to attempt to conceive" (Rivera and March 1960, p.201). Despite these warnings, Kahlo became pregnant repeatedly, resulting in three miscarriages and two therapeutic abortions.

Through a combination of brutally forthright and surreal imagery, she conveyed the intense emotional and physical pain of pregnancy loss. In works like *Frida and the Miscarriage* (1932), Kahlo unflinchingly explores her losses.

She captures the cold, clinical experience of her hospitalization and her physical anguish following a miscarriage that occurred during a visit to Detroit. In *Henry Ford Hospital* (1932), Kahlo paints herself in a hospital bed. Unclothed, the figure lies on bloody sheets and a large tear falls from her left eye. Her husband, the muralist Diego Rivera, also included the image of a fetus in the painting he was completing during one of her miscarriages. In his autobiography, Rivera writes: "Frida's tragedy – for such she felt her experience to be – inspired her to paint a canvas depicting a miscarriage and expressing the sensations and emotions it gives rise to." He adds: "Never before had a woman put such agonized poetry on canvas as Frida did at this time in Detroit" (Rivera and March 1960, p.202).

In his autobiography, Rivera writes that Kahlo had been obsessed with having his child since she met him when she was just a 12-year-old schoolgirl (Rivera and March 1960, p.201). Her husband, wrapped up in his artistic work and his own emotional needs, was opposed to – or at least ambivalent about – the idea of becoming a father. Kahlo's feelings about having a baby were also conflicting. She was terrified of carrying and delivering a baby, believing that it would mean her death, and yet on several occasions she tried to bring her pregnancies to term.

In 1937, Kahlo painted an image of herself entitled *Me and My Doll*. In this disturbing painting, the artist is seated in a barren room next to a ceramic baby doll. The artist does not look at the doll; rather, she regards the viewer dispassionately as she holds a cigarette in one hand. "Many things prevented me from fulfilling the desires which everyone considers normal," Kahlo said in a interview, "and to me nothing seemed more normal than to paint what had not been fulfilled" (Herrera 1991, p.75). In paintings by Kahlo and more recent artists, these images of dolls – babies only half real – become haunting reminders of loss.

Kahlo's approach to painting combines modern sensibilities with old traditions, especially Mexican folk art. She was very familiar with small devotional paintings, *retablos*, which continue to be a popular form of expression in Mexico. These paintings, usually created by unschooled artists using oil paint on tin, are commissioned to tell a story of divine cure or intercession, usually by the Virgin of Guadalupe. Typically, they depict a medical crisis, accident, or other unfortunate situation from which, miraculously, the petitioner escaped. *Retablos* can be offered in regard to a reproductive problem as well, such as an averted miscarriage or a good outcome to a difficult birth. The artists did not shy away from grim, gory, or sexually loaded imagery, and these *retablos* empowered Kahlo to paint candidly about her own traumatic experiences with pregnancy loss.

Another artist who broke through the walls of silence surrounding miscarriage is Judy Chicago, best known for her monumental 1970s feminist art

project, *The Dinner Party*. Her work contributed new images of experiences and viewpoints that are explicitly female. In her book *The Birth Project*, Chicago brought to light the glaring lack of birth imagery in Western art. She observed: "When one views art, one sees it – consciously or not – in the context of art history; however, there was almost no art historical context for creating birth images" (Chicago 1985, p.143).

Chicago was not a mother herself, but she was intent on unearthing the primacy and power of women's reproductive experiences and creating a new iconography. Her innovative solution included enlisting hundreds of volunteers to use traditional needlework techniques to flesh out her stylized designs of the birthing process. By commandeering what had been considered a domestic craft and using it to make art, these artists challenged the notion of a woman's place in the art world.

Raw and direct, the tapestries that Chicago designed included vaginal forms and semi-abstracted images of women in the powerful throes of giving life. As the project progressed, Chicago discovered that many pregnant women felt a profound discomfort and ambivalence about the dramatic changes they experienced in their bodies. In response, she developed a large fabric mural, *The Birth Figures*, which was constructed by Sally Babson. This mural depicts four female forms discomforted by their bodies' transformations: one is looking down at her rounded belly in dismay; another gazes at milk spouting from her breasts; the third fears a "monster" is growing in her womb. The last of these figures (Figure 4.2) stares down at "the miscarriage that is carrying away the child she wants to bear" (Chicago 1985, p.77).

Chicago writes of her puzzlement over how, during interviews she conducted, women blamed themselves for problems occurring during pregnancies. "Although it was obvious that all these occurrences were outside their control, I had sat with them and heard each of these intelligent, educated women say the same thing: 'I felt that it was somehow my fault'" (Chicago 1985, p.78).

At a time when the art scene was still run by men, Chicago's *The Birth Project* was considered subversive and radical, giving voice to women and breaking their isolation. Another feminist artist, Joan Snyder, touched on pregnancy loss in her 1983 painting *Mourning/Oh, Morning*. She describes this piece as a narration of her personal history of loss: a failed marriage, an abortion, and a miscarriage. Snyder's work is intensely expressive and brazenly autobiographical. Like Chicago, she often exalts processes and materials that she thinks of as feminine – she sews, stuffs, and darns her paintings, adding collage elements such as sequins, fabrics, and wallpaper. In the 1970s, many feminist artists used fabric and other materials associated with "women's work" to challenge the art establishment's tendency to honor certain materials and demean others (Chadwick 1990, p.332).

Figure 4.2: Birth Figure #4, from The Birth Project, tapestry, Judy Chicago (constructed by Sally Babson, photograph by Donald Woodman)

Common themes in art

Current artistic work exploring pregnancy loss encompasses such a broad range of media and styles that it is hard to make easy generalizations about unifying themes and imagery being used by artists today. However, one form does stand out: the circle. The earth is round, a woman's pregnant belly is round, and the cycle of life and death is sometimes referred to as "the great round." In many books on symbolism, the circle is seen as representing the feminine aspect.

Over and over, one sees in artwork about pregnancy loss the recurring motif of rounded forms: circles, ovals, and soft organic shapes that speak to us of being held, contained, and centered. Often, these womb-like images contain embryonic forms. And because this artwork expresses the loss of a pregnancy, sometimes we see circles that are bent and shattered, gourds that are broken, rounded wombs full of angry scribbles, eggs that are vulnerable or cracked (Figure 4.3). As their creative process unfolds, some artists celebrate the meaning that the pregnancy held for them, and these pieces sing out from the center of a circle with a renewed sense of wholeness.

Figure 4.3: Broken, photograph, Jeannie Sharp

Many cultures around the world utilize the circular form in their sacred imagery. This ancient and universal form – found everywhere, from Tibetan temples to European cathedrals – is referred to as a "mandala."

Another recurring image is the bowl or container. Earlier in this book, I mentioned how bowls, teapots, and urns emerged in my own artwork after my miscarriage. Several years later, I read a case study by art therapist Susan Hogan, presenting similar imagery created by a woman who had suffered the death of one of her twin babies. In the study, Hogan (1997, p.258) points out a drawing of a chalice representing to the client blood, fecundity, and the womb. Towards the end of her healing process, the client depicts the chalice being filled by a teapot. These images are seen not simply as metaphors for the uterus but also as images of a spiritual nature.

If there is a classic symbol of a lost pregnancy, it would have to be the image of the empty crib. Robin Freedenfeld offers a version of this idea with her painting of an unoccupied rocking horse, titled *Tomorrow's Child.* (Figure 2.5) The symbolism of the emptiness left where there should be the playfulness and cooing of a baby seems an obvious one, and yet Freedenfeld says that she was not conscious that she was grappling with her miscarriage when she painted this series. Making art allowed her to express her profound feelings and at the same time protected her from them.

Beth Shadur, in her watercolor *Shattered Pieces,* also includes the image of the empty waiting crib (Figure 4.4). This elaborately detailed painting, created within six months of her miscarriage, offers many other symbols that speak to her grief:

Figure 4.4: Shattered Pieces, watercolor, Beth Shadur

The work combines symbols of growth and fertility (the gardener, flowers and foliage) with symbols of loss. The figure in the center is definitely autobiographical, as the woman on the steps of her home sits with head in hands. There is a nursery presented, which is empty, and depicts

an open window with an image of an angel flying out. There are also symbols of motherhood presented, with a black and white photo of a mother and child, and a wall of hands, based on ancient Native-American pictographs. Below that, the hand of fate and karma is offered but bound by a ribbon. Next to that is a well of water, with the center draining out. (Beth Shadur, unpublished artist's statement)

Although barely visible, a black bird seems to be shadowing the angel in Shadur's watercolor. Images of black birds seem to find their way mysteriously into the artwork of pregnancy loss. In cultures around the world, birds in general represent the soul or are seen as celestial messengers. Ravens, crows, and blackbirds can carry a slightly more ominous interpretation – the raven is considered in many traditions to be a bird of ill-omen, while in others it is an image of foresight and divine providence. Kara Jones writes in one of her poems, "A black bird flies past / winging on cool summer air / I call out to him: 'Black Bird! Do you ever see / my son's old soul in Heaven?'" (Jones 2000, p.16). In Greek mythology, a white crow watched over Apollo's pregnant lover. One day, the crow brought bad news to Apollo and was turned black when the bird informed him of the unfaithfulness of his lover Coronis.

In my research, I found this haunting traditional rhyme:

> *One crow for sorrow,*
> *Two crows for mirth,*
> *Three crows a wedding,*
> *Four crows a birth,*
> *Five crows silver,*
> *Six crows gold,*
> *Seven crows a secret,*
> *Never to be told.*

Secret Club artist Brenda Phillips alludes to this rhyme in her ink drawing *One Crow* (Figure 4.5), part of a series she created about her pregnancy loss. Donna Estabrooks, who worked for several years on paintings and prints following her miscarriage, found that a "raven kept showing itself in my artwork." She regarded the image as a mystical one, helping her to validate her grief, pointing the way towards healing and acceptance, and ultimately, to the birth of a healthy son.

When women create artwork about pregnancy loss, they are able to capture internal experiences that are almost impossible to convey verbally. In the process of translating their sensations, artists take liberties with anatomy, relying instead

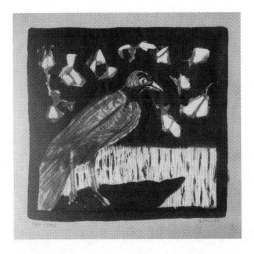

Figure 4.5: One Crow, mixed media, Brenda Phillips

on more surreal, dream-like depictions. In her painting *Corazon Materno – Duro y Tierno (Mother Heart – Hard and Soft)*, artist Sonia Key reveals not just one but three exposed and bleeding hearts (Figure 4.6).

Kathy Ann Fleming's work also visually juggles her internal organs and, in the process, creates a mysterious and moving portrait of her experience. She says: "My paintings deal with feminine grief. It is a function of the body. It lives and breathes in every fiber." Occasionally, images alluding to labial and vaginal forms emerge in pregnancy loss artwork. These representations often appear vulnerable, angry, or damaged in some way.

Finally, images of dolls are common symbols in work centering on pregnancy loss. Frida Kahlo depicted a doll in "Me and My Doll" her post-miscarriage piece, and we find a similar usage in paintings and photographs by later artists. Jeannie Sharp uses silhouettes of dolls to haunting effect in her photographs. She explains: "My images convey the fragility of dreams and the reality of children that were for a moment alive and real, now shadows of our broken hearts." Robin Freedenfeld's hyper-realistic paintings also incorporate dolls to create a disquieting mood. In one of the pieces she created after her miscarriage, the artist's reflection appears in the mirror as we gaze at an oddly animated but lifeless doll (Figure 4.7). Unlike the dolls used in traditional cultures as ritualized surrogate babies, these images of modern dolls seem more ironic, cold, and disconnected; and yet the process of creating these pieces proved to have an important healing function for the artists.

Figure 4.6: Corazon Materno, mixed media, Sonia Key

Figure 4.7: Maine Morning, oil on canvas, Robin Freedenfeld (photograph by Stephen Petegorsky)

Literature and poetry

> *Give sorrow words.*
> *The grief that does not speak*
> *Whispers the oer-fraught heart*
> *And bids it break.*
>
> William Shakespeare, *Macbeth*, Act IV, Scene 3

Aaron Kramer, in *The Journal of Poetry Therapy,* reminds us: "Literature is flooded with lamentations intended to unburden the poet's heart at the death of a beloved" (Kramer 1992, p.153). However, until as recently as the 1960s, the publishing world – like the art world – was primarily the domain of men. Women were, in many ways, silenced on the page as well as on canvas. As far back as the early 1400s, Christine de Pisan, a French author who was the first professional woman writer in Western history, pointedly asked: "How can women's lives be known when men write all the books?" (Chadwick 1990, p.30).

Published works about pregnancy and motherhood speaking from a woman's perspective barely existed, and publications on pregnancy loss were even more taboo. When miscarriage did make a rare appearance in literature, it was often mentioned only in passing. In George Eliot's classic novel *Middlemarch*, the character Rosamond – a rather unlikable former beauty – suffers a pregnancy loss (Eliot [1879] 2003). The event carries little significance for the narrative and the author does not provide much of a window into Rosamond's emotional response. Lest we be tempted to blame this approach on a male writer, we should recall that George Eliot was the pseudonym of Mary Ann Evans Cross, a freethinking, proto-feminist English writer.

In an effort to unearth women's authentic experiences, scholar Janet Sha researched the history of pregnancy loss around the world. She was motivated to reclaim the real story of pregnancy loss after enduring six years of infertility and three pregnancy losses of her own. She conducted her research in part by reading diaries written by women in the past. Sha found that women of the Victorian era "treated the subject of childbearing so delicately in their journals that it is nearly impossible to find out whether a woman had children, much less whether she had infertility or pregnancy problems" (Sha 1990, p.x).

However, there did exist in Victorian times a tradition of novels and paintings tenderly depicting dead or dying children, reflecting the harsh realities of high infant mortality and the vulnerability of young children to illness and accidents (Cooper 2001, p.24). One wonders whether the more visible losses of older children distracted families from the quieter miscarriages that also occurred with great frequency. Surely the secrecy around pregnancy loss was also influenced by its association with a woman's body, making it a private, almost shameful, affair. In the USA in the eighteenth and nineteenth centuries, and even to some extent in the early part of the twentieth century, the pregnant woman's modesty left her essentially housebound. As Judy Chicago reminds us, "women had been ashamed to appear in public while pregnant less than one hundred years ago" (Chicago 1985, p.120).

One writer who broke the silence, embracing her sexuality and baring her authentic psychological life, was Anaïs Nin. Born in Paris in 1903, Nin was a modernist whose output included novels, short stories, and erotica. Nin entered the public eye when seven volumes of her diaries – kept since 1931 – began to be published in 1966. In her first volume, she journals about the experience of losing a pregnancy at six months: "As I looked at the dead child, for a moment I hated it for all the pain it had caused me, and it was only later that this flare of anger turned into great sadness... Regrets, long dreams of what this little girl might have been. A dead creation, my creation, my first dead creation" (Nin 1969, p.344).

The taboo on making pregnancy – and, by extension, miscarriage – too public persisted until quite recently. Most novels, short stories, and self-help books about miscarriage appeared only in the 1970s and early 1980s. Old notions about women were beginning to be dismantled and a generation of "articulate, concerned women was beginning to educate society about what women's health needs really were" (Friedman and Gradstein 1992, p.xi). Even today, with scores of books published on pregnancy loss, it can still be challenging to find information readily. Kluger-Bell (1998, p.14), a psychotherapist and author who experienced several of her own pregnancy losses, describes her experience in a bookstore: "The many shelves of books on pregnancy, childbirth and childrearing did not contain a single volume on the topic of pregnancy loss. When I finally found the courage to inquire at the front counter, I was directed to a dark corner in the back of the bookstore."

As artists and writers began to dismantle the wall of silence, a smattering of gorgeous poems about miscarriage and stillbirth were written in the 1970s. Surprisingly (or perhaps not so surprisingly, given the times), a majority of the poems that made it into print were authored by men. Many are found in the collection *The Virago Book of Birth Poetry* (Otten 1993).

Anne Sexton, one of the first female poets working in the "confessional" style in the 1960s, paved the way for others to write the truth about their sexual and reproductive experiences. She made the experience of being a woman central to her poetry and was both celebrated and criticized for bringing subjects such as menstruation, birth, and abortion into her work. In "Celebration of My Uterus" (Sexton 1967), a poem she appears to have penned in opposition to the suggestion that she have a hysterectomy, is an example of the brash and unapologetic nature of Sexton's work: "Sweet weight / in celebration of the woman I am / and the soul of the woman I am / and the central creature and its delight / I sing for you. I dare to live." Although Sexton committed suicide at 46 years of age, many consider her writing to be the therapeutic modality that allowed her to survive her severe and debilitating depression for as long as she did.

A contemporary of Sexton, poet Sylvia Plath also directly addressed women's reproductive experiences and losses. In her 1961 poem "Parliament Hill Fields," she writes of a lost pregnancy and how no one can see what is missing. A longer poem "Three Women" (1968) first written for radio in 1962, reveals the reproductive realities and constraints that women faced at that time. The poem follows a married woman who successfully gives birth, a secretary who miscarries (not for the first time), and a college student who gives up her baby for adoption. With its convincing images, the poem conveys the complicated ways in which birth, infertility, and unwanted pregnancy are felt.

Like Frida Kahlo and Judy Chicago, Plath forges a new, courageous form of creative expression.

In non-fiction works, a few pioneering authors also began to speak out about the specific needs of women and their families who had experienced miscarriage. Italian writer Oriana Fallaci broke new ground with her book *Letter to a Child Never Born* (Fallaci 1977). Sherokee Ilse, who survived a miscarriage in 1979, a stillbirth in 1981, and an ectopic pregnancy in 1987, was inspired to create a simple brochure about miscarriage which eventually evolved into the classic book *Empty Arms* (Ilse 1982), with over 250,000 copies now in print. She went on to become an international speaker on bereavement and created her own publishing house, Wintergreen Press, based in Minnesota.

One of the authors that Wintergreen Press has published is Julie Fritsch, who, after the death of her infant son, created a series of sculptures capturing her heart-rending experience. Her book *The Anguish of Loss: Visual Expressions of Grief and Sorrow* (Fritsch 1992) compiles photographs of these sculptures. With few words, it relies on the power of imagery to capture the raw universal drama of loss. Another author who shares her experience of stillbirth is Beth Powning. In her memoir *Shadow Child: An Apprenticeship in Love and Loss* (Powning 1999), she offers us a beautifully wrought poetic exploration of her recovery from the loss of her son Tate.

The theme of pregnancy loss has also blossomed more recently in fiction writing. "Envy," a short story by Dick (1988), presents the complex inner landscape of a feminist writer grappling with thoughts of pregnancy, infertility, and loss. This piece could in some ways be titled more accurately "Ambivalence." Dick's protagonist Jeanie is gripped by a fierce and visceral longing for a baby: "The extremity of her desire for a child was a dark, heart-clenching secret, and though she joked about it, no one knew how completely it had come to shape her days" (Dick 1988, p.168). Yet, at the same time, Jeanie is absolutely terrified of the prospect of having a baby and all the psychological baggage that she believes accompanies such a choice. Pushing sentimentality aside, Jeanie articulates her reluctance to step into the role of motherhood and some semblance of a settled life, her fear of being so vulnerable to loss, and her disdain for the way parents sometimes satisfy their own narcissistic needs through their children.

Jane Smiley's novel *A Thousand Acres* explores the life of an American woman raised in a small farming town in Iowa (Smiley 1991). Readers familiar with Shakespeare will recognize echoes of his tragedy *The Tempest*. In Smiley's novel, the main character Ginny loses pregnancy after pregnancy and is regarded as "barren" by her domineering and abusive father. Her husband cannot bear to keep trying for a baby, and so she keeps her last two miscarriages

a secret, burying her soiled nightgown under the floor of the barn. Although Ginny's infertility is not the pivotal storyline, it weaves in and out of the tragic events that result in her ultimate alienation from the family. Smiley paints a portrait of a world where married women on the farm have babies and keep an orderly home. Those who cannot will suffer not only the loss of motherhood but also their role in the community.

These days, women who want to write and read about infertility and miscarriage don't wait for the green light from a publisher: they simply start their own websites or Web logs (affectionately called "blogs"). A quick scan of the Internet reveals dozens of blogs with creative names like Babyfruit: The Miscarriage Diaries, The Naked Ovary, Chez Miscarriage, and Uterine Wars. The authors of these Web diaries espouse a kind of independent do-it-yourself approach, often with a dose of sardonic humor to sustain them. Blogs offer the kind of intimacy that electronic anonymity provides but, at the same time, create a widespread grassroots movement. Many bloggers point readers to like-minded Web authors, weaving an informal Internet community that provides the information and support that women often lack in their home communities.

Music and theater

Around the world, songs, drumming, chanting, and movement are essential parts of the traditional healer's repertoire. Cultures have used dance and music to tell stories, communicate with the spirits, and treat maladies from time immemorial. What we call the "performing arts" were once employed not as entertainment but as healing rituals.

Today, popular culture has packaged and marketed music and theater as commodities, but some artists stubbornly maintain a level of authenticity in their work. Many mainstream performers shy away from touching on intensely personal material about taboo subjects, but songwriter and performer Tori Amos gives us a front-row view of the angst of pregnancy loss. Amos has a fervent following, all of whom are probably aware that her album *From the Choirgirl Hotel* is in large part a response to her 1996 miscarriage. In "Spark" (1998), which, like much of her work, is somehow both polished and harrowing, Amos sings of her inability to save her baby. Her frankness in interviews with the media adds an articulate, offbeat voice to our understanding of pregnancy loss and the creative process.

Although Amos' work is fairly cryptic – you'd be hard pressed to find the lyrics where she states directly that she lost a pregnancy – she weaves her experience into the construction of the songs. She says: "I had to find some

primal feminine place inside myself to really understand that the earth has both birth and loss every day. As I felt all the different rhythms that the earth produces, I started to see rhythm in a way I really hadn't before. As I went to the piano, I knew now that it had to be written and built into the structure" (Gatta 1999). For many artists, regardless of the medium, it is not only the imagery or stories they create; it is also the immersion in the creative process itself that heals. In this process, the artist has the power to add and subtract, to cover over and to reveal. The rhythms of songwriting or the strokes of painting – these acts somehow shift our consciousness and change our relationship to the loss.

Another musical reference to pregnancy loss is performed by French-Canadian singer Ariane Moffatt. In her song "Angel Dust (Poussiere d'ange)" on her debut recording *Aquanaut* (2002) she soothes a friend with the reassurance that the spirit of a lost pregnancy returns to the same mother in her next pregnancy, and so is not truly lost.

One of the few songs I uncovered in the country/folk/blues tradition is called "Marie." One of the last songs that Townes Van Zandt penned before his death in 1997, it tells the melancholy story of a homeless couple. Bereft of employment, money, shelter, and warm clothes, the protagonist and his pregnant girlfriend roam the streets looking for a break; but as autumn approaches, time runs out. One morning Marie does not wake up – the man loses both his girlfriend and his unborn baby.

"Mountain Angel," Dolly Parton's song on her album *Little Sparrow* (2001) sounds like a classic English folk ballad transposed to hillbilly country. Parton weaves the story of a lovely but naive young woman who loses her virginity to a mysterious stranger. When he abandons her, pregnant and alone, he leaves her to a life of isolation and ruin. Hiding atop a mountain, she becomes a haunting and deranged figure. Rumor has it that her baby died and the bereaved mother now sits alone beside the small grave, unable to put the fragments of her broken life back in place.

Although they both touch on pregnancy loss, neither of these country songs tells a story familiar to most families. In the world of opera – which seems to me like the perfect setting for a story of pregnancy loss – there is also a glaring lack of relevant work. Scottish composer James MacMillan touches more directly on infertility and pregnancy loss in his tragedy *Inés de Castro*. This opera, which premiered in 1996, provides a modern reworking of an old story – the real Inés de Castro, on who's life several operas are based, was a noblewoman in the 1300s and mistress to Pedro, the crown prince of Portugal. Inés, a Spaniard, is in a dangerous position at a time when Portugal is at war with Spain. Blanca, Pedro's spurned wife, considers Inés her rival and relishes her downfall. Unable to have children of her own, Blanca sings a captivating aria about marital rape,

torture, and miscarriage. Although she comes to the aid of Inés towards the end of the opera, she cannot help but express her bitter envy of Inés's motherhood.

Like opera, traditional theater offers little on pregnancy loss, but a number of cutting-edge dramatic works centering on infertility, miscarriage, and stillbirth have been seen at progressive festivals. One example is the one-man drama *I Hate This: A Play Without the Baby* by performance artist David Hansen. In this piece, Hansen matter-of-factly invites the audience into his experience of being the father of a stillborn child. By elucidating such mundane moments as his futile attempts to be removed from a baby-food company mailing list, Hansen gives us a glimpse into day-to-day life after a baby dies.

Chris and Amy Neuner, creators of *Infertility: The Musical That's Hard to Conceive*, use songs and humor – a rare commodity in the field of pregnancy loss – to tell a tale of infertile folks searching for parenthood (Sweeney 2004, p.B6). Based on their "six-year infertility odyssey," the musical features a spectrum of characters reflecting today's visitors to a fertility clinic: a heterosexual couple from middle America, a lesbian couple seeking a sperm donor, and a single female executive who may have waited too long to fit a baby into her life. Within the comedic exploration of their tribulations is a poignancy that speaks to those who have faced infertility and educates those who have not.

Pregnancy also crops up in performance pieces as one of several other thematic threads. Performance artist Dawn Akemi Saito weaves her struggle with infertility into her work *Blood Cherries*. Skillfully integrating spoken word, music, projected visual imagery, and the Japanese art of Butoh dance, Saito explores her father's death, her relationship with her husband, the legacy of war, and her repeated miscarriages. In this surreal piece – part fantasy, part memory – the artist creates a disjointed but compelling story of love and loss.

Film

In cinema, difficult as it is to believe, very few mainstream films have been made that reflect the true experience of pregnancy loss. The brilliant Swedish director Ingmar Bergman presented us with an exception to this rule with his 1957 film *Brink of Life*. Following the experiences of three women awaiting delivery in a hospital maternity ward, the movie explores the drama of birth, death, and motherhood. Eschewing the typical superficial depiction of pregnancy and birth, Bergman allows his characters the rich range of emotions and ambivalence that real women feel in the face of these life-changing experiences.

The first woman in the film has a miscarriage, which she attributes to pressure from her husband who does not want to be a father. The second woman's baby dies in a harrowing childbirth scene. The last woman, unwed and bitter because the baby's father has no interest in her plight, is moved by the

suffering of the others to accept her baby and abandon her thoughts of abortion. Although some of the material in the film is now dated, it still represents a departure from the usual film fare.

In contrast, mainstream films too often introduce pregnancy loss as a minor plot twist or a thoroughly unbelievable device. As one anonymous online critic observes sagely: "Pregnant women only befall tragedy in movies. Hollywood or Indie, it doesn't matter. Pregnancy is always treated as a device for tragedy." The same holds true for television. "Soap opera babies usually don't stand a chance," writes Dr Gerard M. DiLeo. "An actress falls and she has a miscarriage. A character discovers that her husband is having an affair with her best friend's Tupperware distributor, and the stress causes her to lose the pregnancy" (DiLeo 2005). While pregnancy loss makes for dramatic storytelling on the soaps, DiLeo goes on to reassure women that they are less vulnerable to miscarriage than their favorite characters appear to be.

As far back as 1945, the noir-flavored film *Leave Her to Heaven* depicts miscarriage as a melodramatic plot device. The lead character Ellen, played by the beautiful Gene Tierney, is a woman whose pathological version of possessive love drives her, among other dastardly acts, to plan her own miscarriage in order to have her husband all to herself. In a scene between the pregnant Ellen and her sister, she looks glumly in the mirror and says, "Look at me…I hate the little beast. I wish it would die!" At this moment, we can almost see the lightbulb go off over her head as she works out her plan. So calculating is she that she even pauses to refresh her lipstick before throwing herself down the flight of stairs. Right after she is released from the hospital, we see her happily frolicking on the beach; it is her husband who grieves the loss of their son.

Ben Ames Williams, author of the 1944 best-selling novel on which this movie is based, clearly does not mean us to identify with Ellen, who ultimately is presented as a narcissistic monster. But one does wonder: would the portrayal of pregnancy loss be more nuanced if it had been written by a woman? Perhaps a woman writer would have known that many mothers-to-be have ambivalence about their pregnancies and fears of parenthood. Are these thoughts unmaternal? Do they cause miscarriages? The male author, male director, and male screenplay writer have every right to bring forth this fascinating, if melodramatic, character study. What is lacking are other Hollywood productions to balance out this portrayal of pregnancy loss.

The early 1960s brought us the British film *A Kind of Loving*, which includes a common use of miscarriage in the movies: the so-called shotgun wedding. Directed by John Schlesinger, the story follows a romance in which the couple marry after the woman discovers she is pregnant. When she miscarries, there is a certain irony because they need not have married after all.

In 1972, Francis Ford Coppola's *The Godfather*, based on a book by Mario Puzzo, famously depicts the life and times of a Mafia family. In the sequel two years later, pregnancy loss plays a role in the relationship of crime boss Michael Corleone and his wife. Abused and embittered, Kay Corleone (played by Diane Keaton) denounces her husband: "Oh, oh, Michael; Michael, you are blind. It wasn't a miscarriage, it was an abortion. An abortion, Michael. Just like our marriage is an abortion – something that's unholy and evil. I didn't want your son, Michael." Kay's words empower her in the face of this controlling family but, powerful as the dialogue may be, the viewer may wonder whether it is written accurately from a woman's point of view. Either way, the film shows us not an authentic miscarriage, but a false one, faked in order to trick her husband.

Even in the 1990s, things had not improved much in Hollywood in the depiction of pregnancy loss. The 1992 thriller *The Hand that Rocks the Cradle* stars Rebecca de Mornay as a nanny with an evil agenda. She becomes the caretaker for the young children of a couple she blames for upending her life and indirectly causing her miscarriage. Her plan includes insinuating herself into the family, undermining their lives, and getting hold of their baby. Ludicrous as the plot may be, it does at least acknowledge the depth of despair, rage, and jealousy that can accompany the loss of a pregnancy, although most of us would stop short of this particular strategy.

From the same decade, the comedic social commentary *Citizen Ruth* (1996) wryly explores the state of abortion politics in America. The unwitting Ruth, played by Laura Dern, is a homeless glue-sniffing pregnant woman who becomes a reluctant symbol of the divisive abortion debate. The film, written and directed by Alexander Payne, makes the point that individual women are overlooked in the fray over the fate of fetuses. Using pregnancy loss as a plot device once again, the film has Ruth's pregnancy end in miscarriage, conveniently making abortion unnecessary. Although this turn of events preserves the delicate balance that allows the movie to ridicule everyone and side with no one, some critics felt it would have been more courageous for the story to unflinching depict a woman choosing to go through with an abortion.

In a final example of mainstream cinema run amok when it comes to pregnancy loss, *The Forgotten* (2004) offers us another silly example of miscarriage as plot device. In this psychological thriller with a tacked-on science-fiction ending, Julianne Moore plays a woman tormented by the memory of her eight-year-old son's death in a plane crash 14 months earlier. Her psychiatrist and her estranged husband try to convince her that her son is in fact a delusion she created to cope with a traumatic miscarriage. Without giving too much away, I can share that the lead character is not persuaded by this story and relentlessly pursues the truth about her son. It seems that in mainstream films, no

one ever has a real miscarriage. Perhaps someday we will see an actress of Moore's caliber portray the actual experience of a woman who suffers a pregnancy loss.

John Sayles' 2003 film *Casa del los Babies* is one of few films that attempt to delve below the surface of pregnancy loss and infertility. Six very different women from the USA, each of whom wants to adopt a baby, are checked into a hotel in South America waiting for the elaborate paperwork to go through. As their wait stretches on for weeks, they begin slowly to reveal their hopes and fears. This pensive film, primarily about what it means to enter motherhood, touches on the wounds these women carry as a result of their infertility and losses.

Skipper, played by Daryl Hannah, is a quietly new-agey and fitness-obsessed woman, who in one scene reveals the cracks in her veneer. As she is ostensibly healing one of the other women with a massage, we learn of Skipper's own losses. In an understated flat voice, she explains that she first had Cody, a non-viable pregnancy which she had to carry to term and deliver. She adds that it was the kind of delivery to which "nobody brings a video camera." Then Joshua, born with malformed lungs, who lived two days, and Gabriel, who "hung on for a whole week."

After a long pause, the other woman asks her: "How…how do you get past that…losing three babies?" Enigmatically, leaving the audience unclear whether she is talking about herself or giving the woman instructions for the massage, Skipper answers: "Imagine that you're made of light and that you're spreading outward into a black sky."

Perhaps the future will present us with more film offerings on pregnancy loss, particularly as the advent of digital technology makes the film-making process dramatically more affordable and accessible. Occasionally, a project by an independent film-maker attempts to do what Hollywood is either reluctant or unable to do. *The Clouds that Touch Us Out of Clear Skies: Stories Surrounding Miscarriage*, a film by Lynn Shelton shown at film festivals around the USA, is one of those projects. This documentary uses personal stories and poetic imagery to convey the almost inexpressible experience of miscarriage. A film of few words, it eloquently uses found visual images, backed by a haunting cello score, to convey the bewildered pain of loss.

Women's ways in the arts

Art historians and critics have long debated whether there is something particular to women's ways of knowing and expressing their truths, and whether this translates into a distinctly female way of making art. Throughout Western

development, women have struggled to have their creative output seen as equal to that of their male counterparts. Women's creative work once was typically described by critics as lacking in historical importance, both in form and content – in other words, women were not seen as being capable of innovative, forceful, or brilliant work. Unlike men, women artists are often forced to choose between having a creative career and having a family.

In response to these hurdles, pioneering modern artists such as Georgia O'Keeffe struggled to be identified simply as artists, not *women* artists. However, by the 1960s, feminist artists such as Judy Chicago began to celebrate gender differences and pride in the female body and spirit. Similar trends developed in writing, with feminist authors forging a movement committed to new forms and styles of writing that better reflected the experiences central to women's lives.

In reviewing artwork about pregnancy loss, one finds a subtle kind of reverse discrimination: are men encouraged to create and submit artwork on miscarriage and infertility? Are we open to seeing their work on this topic? Very few men have participated in the Secret Club Project, for instance, and several of the male inquiries were first posted by their wives on their behalf. In contrast, the body of poetry on pregnancy loss is weighted heavily with the work of male poets.

Because of the trailblazing of both women and men before us, we have more freedom today to use the arts to sing out the truth of our experience. Now, both those who do and those who do not identify as artists see art-making as a right each of us has to express ourselves authentically and without censorship. While some artists seek to transform society by exhibiting their thought-provoking work, others harness quietly the creative process in order to heal themselves. Most of us fall into the latter category – we express ourselves creatively not to be exhibited and critiqued but as part of a process of healing and growth.

Despite the advances made in the arts, there is still a lingering sense of taboo over the frank expression of pregnancy loss. I have encountered more than one artist who has confided, "I made art about my miscarriage, but I never told anyone what it was really about." It still takes a certain kind of daring to break through the silence and tell one's story. Even in the face of these historic challenges, creative expression about pregnancy loss continues to emerge – in arts venues, grassroots community settings, even medical settings – in order to help ease the pain and begin the process of recovery.

5

Art in Therapy

The arts in therapeutic settings

Creative expression has always been a central part of how human beings make sense of their place in the world. In non-industrial societies, the arts were usually seen as inseparable from ritual. Malchiodi (2002, p.172) observes: "In this era of high-priced galleries and competitive celebrity artists, we sometimes forget that art's primary role since the dawn of humanity has been to nourish the sacred dimension of life." The arts have become dissociated from the stream of life as artistic creation has increasingly become the function of the specialist. In our definition of art, we differentiate "professional art" from "folk art," "fine arts" from "crafts." Such distinctions impede the understanding of the arts as a basic expression of human experience.

In traditional communities in India, for example, art is rooted in rituals. The visual and performing arts incorporate rituals to invoke the gods, remove obstacles, celebrate the rites of passage, and mark the turning points in the cycle of death and renewal. In another example, sand paintings are used by the Navajo as part of an interactive healing ceremony including prayers and songs – in effect, as spiritual medicine. The sand paintings and chants are considered holy and invite the patient to enter a state of health. In ceremonies of this kind, art is not seen as an object to be hung in a museum; rather, it is integrated into the life of the community.

Western culture and its reliance on scientific empiricism has separated and compartmentalized the arts, medicine, and spirituality. Only recently has the healthcare establishment begun to rediscover the medicinal potential of creative expression that traditional societies have tapped into for centuries. All over the world, there seems to be a renaissance creating new partnerships between art and medicine.

Some of the seeds of this partnership were sown by early explorations into the nature of the mind. Initial forays into modern psychology were based in part on a fascination with the formation of symbolic imagery and its levels of meaning. Freud and Jung saw humans as symbol-making beings, whose deepest levels of consciousness are experienced as images, not words. In these early stages, psychology employed artwork chiefly as a tool for the assessment and diagnosis of patients, not as treatment. Both Freud and Jung believed that art-making could reveal information that words alone could not.

Beginning in the 1940s, a small movement developed both in the USA and the UK combining the arts and psychology as an innovative therapeutic technique. This field, now known as art therapy, harnesses the creative process to promote healing and insight within a therapeutic relationship. Social workers, nurses, and others in the healing professions are also beginning to integrate the arts into their work.

Organizations such as the Society for the Arts in Healthcare are contributing to this trend, promoting artists-in-residence programs, healing gardens, and traveling exhibits as antidotes to the sometimes oppressive environments we encounter in hospitals and clinics. The arts and rituals are also becoming a more common component of support programs offered to people coping with cancer and other medical illnesses. Using art for healing has become mainstream.

Viewing art and making art are also excellent training tools, offering a sensory, hands-on experience that is not dismissed as easily as a lecture. Christine Jonas-Simpson, affiliated with Sunnybrook and Women's College Health Sciences Centre in Toronto, writes: "The arts have a role to play in healthcare education as powerful vehicles for enhancing understanding of the experience of loss of families whose babies dies prior to birth."

I also use art as a key part of educating professionals. When presenting at training programs for physicians, nurses, counselors, and art therapists, I often share artwork by survivors of pregnancy loss and then invite participants to create their own simple spontaneous drawings. This creative experience allows participants to engage emotionally in the topic and to grapple with their own conscious and unconscious responses.

Progressive medical schools are finding that when they add a creative component to their training, they graduate medical practitioners who are more sensitive and compassionate to their patients' losses. Sandra Bertman, who taught for years at the University of Massachusetts Medical School, is a pioneer in using the arts to instruct healthcare professionals in coping with loss. In her book *Facing Death*, she uses visual and literary images to explore how we understand and react to illness, death, and bereavement (Bertman 1991). Her

approach moves beyond the intellect in order to find the way in which the arts bind us together in the universal experience of death.

Research has begun to back up the intuitive wisdom of artists: art is good medicine. Well-designed studies with both adults and children have found that specific visual art experiences can induce a relaxation response, improve self-esteem, or change the participant's mood. Music is also being employed as a tool for healing, with similar research findings emerging. A study carried out in Bristol, UK, shows that writing poetry can be so effective in reducing anxiety and depression that some participants reported being able to reduce their reliance on medication (Philipp and Robertson 1996). Another well-publicized study provides powerful, measurable findings supporting the use of narrative writing as a therapeutic intervention (Smyth and Pennebaker 1999).

What has been more difficult to pinpoint through research is the connection between the creative process and self-actualization. The psychospiritual transformative power of the arts, although recognized by many, is elusive and hard to quantify. This humanistic movement, which posits that human beings benefit from a holistic approach to healing, is becoming more recognized and respected. Michael Samuels and Mary Rockwood Lane, two pioneers in the art as healing movement, point out: "Research has shown us that a person in prayer, a person making art, and a person healing all have the same physiology, the same brain wave patterns, and the same states of consciousness" (Samuels and Rockwood Lane 1998, p.1).

Practitioners in the fields of psychology and medicine are acknowledging and putting into practice the concept that the mind and the body are not separate: patients require more than medical interventions in order to experience healing and wellbeing. The National Institutes of Health in the USA recently designated art therapy and dance therapy as promising alternative treatments, paving the road for more substantial research into the efficacy of these innovative modalities.

One of the benefits of the creative arts therapies is that they allow the client to be actively engaged and to express the sensations and emotions held in the body. When recovering from trauma, if we use only words we are distanced from our experience – we are observers – while expressive therapies engage the body, supporting "embodied resolution" (Fabre-Lewin 1997, p.119).

"Many clinicians have acknowledged art expression as a way to work through the grief process," observes Malchiodi (1992, p.114). "Art (as well as creative writing, poetry or other art forms) seems to appear spontaneously in the attempt to express the deep suffering one experiences when confronted with a significant loss." Mental health practitioners find that the expressive arts can provide access to clients' emotions and memories and help them open up to new

Healing with the arts

As a tool for transformation, the creative arts offer a powerful form of expression when words are not enough:

- a bridge between the conscious and the unconscious, helping to identify and work through layers of personal history;
- an active outlet to move feelings up and out of the body;
- a productive way to uncover and process a range of emotions;
- an opportunity to view situations from a new perspective;
- a way for others to better understand the artist's experience of loss;
- a visual record and a lasting memorial.

insights. There is also growing awareness in the field of psychotherapy that certain issues simply do not lend themselves easily to verbal therapy. Art therapy is now being used to treat issues such as eating disorders, addictions, depression, and trauma. The healing potential of the arts has been especially well-received by people in the field of grief counseling – rarely does one find a brochure nowadays for a bereavement conference that does not include workshops and events focusing on the expressive arts.

The art materials used in the healing process need not be restricted to drawing or painting. Art therapy can include almost any medium: photography and video, ceramics, puppetry, quilting, collage, sculpture – these are just some of the creative materials that art therapists offer their clients. Clients may be encouraged to use the materials spontaneously, or they may be given a specific framework in order to help them engage their unique creativity and develop personal imagery.

Although many people still think that art therapy is used only to treat children, it is also an effective form of treatment for adults. One does not need to have "talent" or a background in the arts to benefit from art therapy sessions. It's the process, not the product, that counts: each of us has innate creative potential and the right to express oneself in a safe healing setting.

Visual art is just one of the creative formats that have been employed therapeutically over the past 50 years. Dance therapy, music therapy, drama

therapy, and bibliotherapy (using journaling and poetry) also provide powerful avenues for treatment. Those trained in the discipline of expressive therapy may integrate several modalities into their work, including drumming, role play, and movement. The guidance of a compassionate and experienced practitioner affords the safety required to delve into intense grief.

Some find that a particular form or medium best allows them to express and heal their grief. Susan Fincher shares how she discovered her preferred mode of expression after the death of her child and a painful divorce. She found the nights most difficult – to pass the time, she turned to drawing, something she had enjoyed as a child, and allowed herself to play with the materials spontaneously. Eventually, she felt the urge to draw a circle design.

Although it was simple, she noted that she felt some relief after she finished. Without knowing it, she had stumbled on the mandala form. Since that time in 1976, Susan has become an art therapist herself and authored a book on using the mandala as a healing modality (Fincher 1991). The word *mandala* is Sanskrit for "magic circle" or center (Figure 5.1). The modern use of mandalas, pioneered by Jung, focuses on psychospiritual growth and does not need to be employed within the context of a specific religious practice. Art therapist Cathy Malchiodi explains: "Self-created mandalas are reflections of your inner self and are symbolic of your potential for change and transformation" (Malchiodi 2002, p.165).

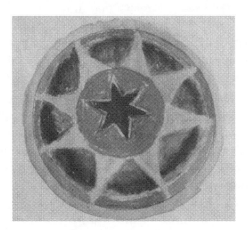

Figure 5.1: Mandala, oil pastel, Laura Seftel

While traditional mandalas often have a balanced or symmetrical design, personal designs may emerge as less symmetrical and more expressive. Making mandalas can help us express polarities: "The circle we draw contains – even

invites – conflicting parts of our nature to appear" (Fincher 1991, p.24). Although it is an age-old practice, drawing mandalas – as confirmed in a recent study – actually induces a relaxation response (Malchiodi 1999). Today, art therapists frequently encourage their clients to make mandalas; one can even find mandala coloring books that can be relaxing and healing to fill in. Artists exploring the themes of motherhood, birthing, and loss turn intuitively to the mandala, the "magic circle, sacred ritual, reflection of self" (Fincher 1991, p.183).

Mandalas are just one example of a specific format that may give shape to and support the recovery process. Some find comfort using fabric and fibers; others may require movement or ritual acts or need to be immersed in the liquid colors of paint. Be alert to messages from your creative process that point towards your unique language of self-expression. Nurture these impulses, even if they seem strange, impractical, or irrelevant. Trust your own symbolic needs to construct and deconstruct, to hide and reveal, to rage and to soothe, with the understanding that any medium is valid if it helps you speak your emotional truth.

It is interesting to note that art therapy seems to have a particular draw for women, both as practitioners and clients. This is certainly not to say that men do not have an important place in the field or cannot benefit from art therapy. It does raise questions, however, about why it is that the arts provide such a powerful healing experience for women.

Psychotherapy practitioner Miche Fabre-Lewin writes that through art therapy, "women have the chance to make their mark, release painful emotion, exercise their imagination and re-vision themselves" (Fabre-Lewin 1997, p.122). She posits that a woman is empowered when she uses the arts to explore her sense of self in relation to a culture that may not value her or her body. In her feminist piece "Liberation and the Art of Embodiment," she quotes M. L. Ellis: "Traces and marks, layers and shapes reflecting a woman's conscious and unconscious bodily gestures hold meaning that is often untranslatable but that mirror back the texture and complexity, the substance and movement of a woman's experience" (Ellis 1989, p.267).

A guide on the journey

Sometimes, the experience of loss feels too perilous to navigate alone – it is easy to become lost in despair or paralyzed in the face of intense unexpected emotions. It is the therapist's job not to rescue us or to provide the answers but to enable us to ask ourselves the best questions, to hold ourselves with compassion, and to tolerate our most difficult feelings. Edward Rynearson, who specializes

in recovery from traumatic grief, believes that individuals seek out therapy when they can no longer struggle with the unfinished narratives and imagery they are carrying around as a result of loss (Rynearson 2001).

During those times when we need a guide on the journey, many people derive great relief from traditional verbal therapy. However, in her article "Choosing a Therapist After Pregnancy Loss," Denise Jess points out: "Not all therapy has to come in the form of talk or psychotherapy. I assessed my own learning style and decided that I wanted to be open to a variety of techniques; including visualization and self-hypnosis, movement, art or music therapy and body work" (Jess 2000).

As an art therapist and mental health counselor, I have witnessed the power of art and ritual to begin to bring resolution to the issue of pregnancy loss. In my private practice, I recall working with a woman whose healing process involved a poignant collage made of wrapping paper saved from her baby shower. By transforming the bits of paper into a memorial of her lost dream, she began to feel less helpless and overwhelmed.

Another client, who was blind, used clay to create a tactile image of a rose to commemorate her three pregnancy losses. Kim Kluger-Bell, who now specializes in the treatment of pregnancy loss after suffering two ectopic pregnancies, has also found it helpful "to construct something tangible which can come to represent your lost baby in your mind's eye. Some people have made hand-sewn dolls or clay figures or wooden statues" (Kluger-Bell 1998). Imagery transcends the awkward words we summon to communicate grief. It speaks to us in a direct and visceral way that bypasses our typical defenses and cliches.

When my client Tabitha (not her real name) was scheduled for a hysterectomy, she found that grief related to two earlier miscarriages was stirred up. Both of these pregnancies were the result of date rapes that occurred when Tabitha had been struggling with alcohol abuse in her early twenties. Complicating the clinical picture further, Tabitha felt intense guilt because she had wished for the first pregnancy to end, going so far as to "make a pact with the devil." She was disturbed that she had not disposed of the miscarriage remains in a way that reflected her current faith and feared that her carelessness had relegated her baby "to Hell."

In our art therapy session, Tabitha first used oil pastels to create an image she called *The Beginning of the End* (Figure 5.2). The image is reminiscent of an embryo and features drops of blood (tear drops?) and a black spiral. Her intention with her second piece, *How It Should Have Been*, was to create an image that felt comforting. She rendered a small image of a mother holding a baby in the softer medium of watercolor. Tabitha explained that each color in this depiction of maternal love had a special meaning for her, such as yellow

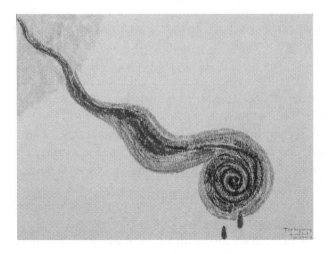

Figure 5.2: Beginning of the End, oil pastel, Tabitha

representing the sacred and green representing healing and growth. It is likely that she would not have been able to access this second image had she not first drawn out a representation of her anger, guilt, and trauma.

When Alexis Faulkner, a recent graduate of an art therapy training program, contacted me about my work in pregnancy loss and the arts, I was excited to hear about her thesis project. Faulkner has designed a healing art process specifically for couples dealing with pregnancy loss. Her work takes into account the tremendous stress that a pregnancy loss can place on a relationship. One exercise encourages the couple to complete drawings expressing their personal experience of the loss.

Faulkner also relies on three-dimensional art materials in several of her suggested art exercises. "Through the art process, parents are given the opportunity to create an object together which represents their lost child. The art task allows for a tangible object to be made that can be seen and held by the couple" (Faulkner 2003). In a related exercise, she provides the couple with a box to decorate and embellish, in which they can place meaningful objects. The box provides a symbolic kind of containment and embodiment for their feelings. They can also choose to co-create a ritual. Through this interactive process, the couple has opportunities to enhance their communication and give tangible form to their grieving process.

Dance/movement therapist Rachelle Smith-Stallman, from Albany, New York state, used movement to heal her own grief following the stillbirth of her baby boy. Many years later, she designed a dance therapy program called Moving Through Your Loss. Her goal is to provide a safe place for women "to

regain balance after suffering the unbearable sadness, confusion, guilt, anger, rage, emptiness, and loneliness of child loss." Because the loss of a pregnancy is in many ways a body-based loss, it makes sense that this grief can be accessed and released through facilitated movement. As Smith-Stallman explains, her knowledge of the healing quality of dance/movement therapy was confirmed by her own experience of recovery.

Groupwork: integrating art and writing

One of the first forays into group therapy for survivors of pregnancy loss was led by psychiatrist Rochelle Friedman. In 1976 she conducted a landmark study to better understand how individuals experience pregnancy loss and how best to meet their needs (Friedman and Gradstein 1992, p.xii). Five women attended her pilot support group. The study's organizers learned that in contrast to the belief prevalent at that time, most women did in fact develop an early attachment to their fetus and did grieve its loss. This small but important study also discovered the healing potential of groups as a response to pregnancy loss. The women who participated felt their feelings were finally validated; they were able to overcome the message that they were overreacting to a "trivial loss."

Nowadays, families have access to a range of group settings, including therapy groups, informal support groups, and art therapy groups. In her article surveying art therapy bereavement groups, Melinda Ann Hill reports: "In recent years, professionals in the fields of grief counseling and art therapy have done much to address the value of non-verbal therapeutic approaches, such as drawing and guided visualization, to deal with the emotional stress arising from terminal illness and grief... The number of articles about art therapy with the dying and bereaved has steadily risen in the hospice and art therapy literature over the past ten years" (Hill 1998). Engaging in an activity such as art-making, writing, or ritual, rather than relying only on verbal interactions, adds another dimension to group work. By making art in a supportive group setting, participants have opportunities to deepen their understanding of their challenges and strengths.

Art therapist Ellen Speert developed a short-term workshop for women who had experienced pregnancy loss in California. By enlisting their own creativity, the women found ways to wrestle with their grief and transform it. In the group, the participants found symbolic release in the use of paint, clay, tissue paper, and other media. The three-dimensional materials allowed the powerful expression of their rage, grief, and emptiness. The women often spoke of the need to have a tangible and lasting part of their lost child.

Speert found that working in a group was a particularly helpful format for supporting grieving women and ultimately creating a new sense of connection with themselves and others. Speert observed: "Art expressions created at the time of loss, and for months afterwards, often graphically express a lost sense of self. In a group, the individual could express her loss and, in seeing similar symbols created by others, reduce her sense of isolation. Although alone in the art-making, the woman has allies in reviewing the art expression and can try out new ideas with the encouragement of others in the group" (Speert 1992, p.123).

In my groups and workshops, I have also seen simple art materials transformed into symbols of healing. A woman was directed by her friend to one of my introductory art therapy workshops at a local community college. She and her husband were reeling from the death of their baby daughter. Already a participant in verbal therapy and monthly support groups, she had been advised to incorporate art into her recovery process. Although slightly skeptical, she was open enough to try anything that might provide some relief.

When she picked up the clay during the first exercise in the workshop, a small hand formed; as she looked at it, it seemed to her that it was just the size of her daughter's hand. Held within it, she began to model the form of a baby, curled up like a fetus going through its phases of development. And then, almost imperceptibly, a tiny image appeared on top of that baby – another infant.

In sharing this small impromptu sculpture with the group, she was amazed at how the images had just come to her and at the relief she felt in giving form to them. She told us that they came from a place deeper than her words, deeper than her rational explanations of what had happened to her baby. At the end of the workshop, she expressed her hope that her husband could also have an opportunity to use the creative process to wrestle with their loss.

Groups can be designed just for women, can be open to all, or can focus on couples. When forming a group, keep in mind the background of the partici-pants. Group facilitators must take into account whether the woman or couple is experiencing primary infertility (i.e. they have not been able to give birth to a healthy child) or secondary infertility (i.e. they have a child but currently are unable to have another). Some group leaders prefer not to mix these two groups, because participants who do not have a baby may find themselves feeling intense anger and envy directed at women who do have children. In mixed groups, the facilitator should consider addressing this issue early in the life of the group.

Unlike the open-ended psychodynamic groups of the past, today's groups often focus on a specific theme or task. Groups for bereaved parents who have experienced a reproductive loss generally offer support and psychoeducation

about the grieving process. More focused groups are sometimes offered for infertile couples considering their next step, such as adoption or coming to terms with living childless. Other groups have formed around the issue of parenting the children a person or couple already has following a pregnancy loss. Some therapists report difficulty in attracting enough members to pregnancy-loss support groups, either because it is still a taboo subject or because families are finding relief in other venues.

Domar and Dreher (2000, p.263) remind us that women dealing with infertility and pregnancy loss may also be wrestling with their connection to the divine: "Some wish to rebuild their shattered faith, others are searching for a faith they've never had, while still others are seeking answers to difficult spiritual questions." They cite the case of a Catholic woman who was "sure that her inability to conceive was divine punishment for her 'sins'" (Domar and Dreher 2000, p.270). Others may feel a deep rage that God would let this happen to them or lose faith that the world is a benevolent place. Nourishing each participant's unique spiritual needs and gently reframing guilt-inducing thoughts can be an important healing component of group work. Zucker (2005) warns against jumping to dismantle personal narratives that seem to promote guilt or anger without first exploring the important role those feelings and beliefs play for the individual.

Special attention must be given to the diversity of beliefs in the group, including those of atheists and agnostics, and creating space for each participant's definition of spirituality or faith. For participants who do not have a spiritual belief system, it might be meaningful to ask clarifying questions such as, "If you don't believe in God, what do you believe in? What gives you hope?" It is crucial that the facilitator and the group bring a stance of profound non-judgment to issues of faith, with no pressure for individuals to solve their spiritual dilemmas prematurely or in a prescribed manner. Lastly, it can be helpful to refer individuals who are struggling with questions of faith to pastoral care or an elder in their spiritual community.

These are some basic ideas to consider when developing groups for pregnancy loss, but how do the arts fit in? "Making art within a group arouses special energy that extends the dimensions of the creative process," explains Malchiodi (2002, p.196). "When I make art alongside others, I find myself having a whole new set of experiences, inspirations, and awakenings that don't occur when I am alone in my studio." And what about those group members who staunchly label themselves "non-artists?" While the idea of making art in front of others may initially bring up self-consciousness and resistance, there are simple guidelines for groups that make self-expression feel safe:

- Agree that there is no right or wrong way to express oneself creatively.

- Emphasize the process – the participant's experience – not the finished product.

- Discourage judgments, positive or negative, by simply witnessing and honoring the creative output of the group.

- Avoid analyzing or interpreting others' creative expressions.

- Sharing one's work is always optional.

In my experience, groups that agree to this format learn quickly to witness and support one another's unique creative expressions. They learn that the creative process is often a surprising and mysterious one and take delight in "happy accidents" that turn out to be unexpectedly meaningful. The paradox is that once participants have carte blanche to play freely and de-emphasize the product, work of great impact often emerges.

One of the benefits of working in a group setting is the framework it provides, a set time and place where participants can focus on healing. Many of my individual clients report to me how challenging it is for them to carve out time to make art or to journal. Often, there seems to be an ineffable resistance to sitting down and focusing – we fear diving in, we want to avoid strong emotions, we wonder whether we will be able to convey what needs to be expressed. A group format offers the structure to overcome many of these blocks.

The group supports the creative process and, in turn, the participants' creative expressions support the work of the group. The symbolic imagery that blossoms in the art and writing of group members reveals levels of experience that are difficult to access through traditional talk therapy. The arts have the ability to express ambivalent feelings and to unearth hidden beliefs and memories, and they help us to envision new ways of being. In this way, the arts not only allow the group to share the superficial but also invite members to a deeper level of authenticity and intimacy.

Another benefit of the more active modalities, such as painting, sculpting, movement, and drama, is that they involve the body. For a woman, pregnancy loss is an event experienced by the body; allowing an outlet for the body to tell its story can enhance the process of recovery. For both men and women, an active versus a more passive stance seems to be an important element of healing: "doing something (symbolic action) is crucial to the mourning process" (Gantt 1991, p.16). Many creative modalities also provide a tangible permanent object – a talisman, a poem, a shrine – which many bereaved parents find especially helpful.

Expressive group activities often invite each participant to create his or her own artwork, but group settings also offer an ideal opportunity to collaborate on a project. Murals and "quilts" (even if not made of fabric) are classic group activities that work well for pregnancy loss. When creating a group quilt, each participant begins by working on a square commemorating his or her particular loss. Then the group comes together, arranging the squares next to one another to create a quilt-like finished product. Seeing one's individual story represented visually in the company of others can be a powerful way to break isolation. Activities such as this can enhance the group's sense of camaraderie and cohesion.

Groups also lend themselves naturally to rituals, which can be as basic as sharing healing wishes for group members or as elaborate as a fully developed ceremony. Simple rituals can be used to warm up the group or to help provide closure at the end. Often, to provide a warm-up and help the group begin sharing, I offer a basket filled with interesting bits of natural elements – shells, stones, pieces of bark, beach glass, even a bird's nest. Members are invited to select one or two objects that speak to them on some level, perhaps helping them connect with their feelings or their story. Rituals like the nature basket also serve to wake up the senses in preparation for creative expression.

It is important for the therapist or facilitator to follow the lead of the bereaved when designing a ritual. Gantt (1991, p.16) points out: "Knowing that virtually all rites of passage require a special place for their conduct, the art therapist can encourage the construction or selection of such a place... All details of the ritual can be tailor-made to the situation, shaped by the participants and supported by the therapist."

Coming together to heal through writing is a wonderful way in which to address pregnancy loss. Kluger-Bell (1998, p.27) shares her own experience of denying and then uncovering her grief: "It was only when I began to give voice to my experiences, to speak of them first in journal writing and then out loud, that I was able to identify what I felt and what it meant to me." Journaling independently can be healing for those who have the discipline to write fairly regularly, but for many people, a group provides the much needed time and space to focus on writing. Writing in a group setting also has the added benefit of breaking the awful isolation that can pervade the life of a bereaved parent.

Rob Zucker, a social worker and former director of a pediatric bereavement counseling program in Massachusetts, developed groups for grieving parents called Writing in Community. He and his wife had participated in a writing group; after experiencing firsthand the power of writing for healing and insight, he was inspired to offer a similar format to the bereaved parents he worked with at the hospital. The groups were based on a model developed by

Pat Schneider, founder of Amherst Artists and Writers (AAW). The simple but powerful method first provides the group a writing prompt, such as a poem or a basket full of evocative objects. Then participants are invited to write spontaneously for a set amount of time. The directions are to write freely, without stopping to edit or critique.

The method of sharing the work is important for the group's success. Sharing is always optional – this allows members to write authentically without fear. The role of the group is chiefly to witness the writer's experience and to offer appreciative responses. Group members are asked not to question or advise but simply to offer their authentic responses about how the work touched them and what, specifically, they appreciated about the writing. This supportive, positive, and honest feedback is received by the writer with a simple "Thank you."

Through this process, participants come to trust one another as witnesses to their experience and learn to trust the creative process. Often, group members will begin by denigrating their own writing skills, only to discover after a few sessions that they too have something to say and the means to say it. "The point is never to write 'well,' although surprisingly 'good' writing often surfaces when permission is given to simply write without expectation" (vanMeenan and Rossiter 2002, p.48).

Spontaneous writing has a way of bypassing our limited ways of thinking, and participants often find that they stumble upon a more playful, wiser, or more authentic voice, allowing them to see their situation from a different angle. Process-oriented writing can give voice to powerful words that the writer needs to say but has been unable to until putting pen to paper. Julia Cameron reminds us: "We should write because it is human nature to write. Writing claims our world. It makes it directly and specifically our own... We should write because writing brings clarity and passion to the act of living" (Cameron 1998, p.xvi).

Whatever creative methods they use, all groups at their best serve to break the participants' isolation. We come to realize that it is normal and acceptable to grieve, whether it is the loss of a pregnancy, a stillborn baby, or one's fertility. By witnessing the struggles and triumphs of others, we develop more compassion for our own experience. Kluger-Bell (1998, p.27) writes: "Hearing others say what they experienced helped to bring me out of the isolation and shame that our culture's silence promotes."

Most of the creative activities found in Chapter 10 can be adapted for group work.

6

Art in the Studio

Creative healing

Healing through the arts does not take place only in the context of support groups and therapists' offices. Healing occurs, whether intentionally or not, in the studio as well. "You can heal yourself with writing, poetry, journals, essays, stories, storytelling, or theater. Music, songs, tones, chanting, silence, sounds of nature, and dance, movement, ritual, circle dancing, and ecstatic dance are all deeply healing" (Samuels and Rockwood Lane 1998, p.2). Some artists, writers, and performers are quite open about the healing nature of their work, while others dislike thinking about their art as "therapeutic" and prefer to keep the focus on the finished product. Of course, those of us who are not professional artists can also tap into creative expression to heal ourselves.

Why might we choose to work independently with our creative process, rather than with a therapist or support group? Some people simply feel more comfortable working privately. Perhaps they have not had positive experiences in therapeutic settings in the past, or they may already have a clear sense of the creative work they need to engage in for their recovery. For some individuals, the creative process itself may provide enough structure for them to make a solo foray into the heart of their feelings. Others may not even think of what they do as healing or therapeutic; they just follow their urge to make something to commemorate a loss.

Artists of all kinds often understand intuitively the transformational process that creativity allows; they use the metaphorical spinning out and re-knitting of their stories to heal their grief and trauma. Many participants in the Secret Club Project, both professional artists and those who are not, have reported deep healing experiences through making art on their own.

Kohner and Henley (1995, p.92) observe: "Creating a way of remembering a baby can itself be comforting because it means concentrating on the baby and

giving him or her time… Mementos can also be helpful in getting others to recognize and talk about the baby." Jen Primack, director of adult education at a college in Pittsburgh, endured two miscarriages in close succession. In a note to me, she shared:

> After the miscarriage I struggled with: why didn't I know the baby's heart stopped beating, was it in pain, I wish I could have been there for it, does the baby have a spirit…the list goes on and on. I also struggled with what to do with the ultrasound picture, the positive pregnancy test and all of the other tangible things I was saving for a baby book. I wound up using art as a way to express myself and heal. I used pretty paper, ribbon, fabric, and a poem to create a book to say good-bye. It helped me tell others what I was feeling and made me comfortable with putting the baby's things away.

When engaging the creative process for healing, we must sometimes delve into the darkness, honestly and deeply, before moving back into the light. An artist specializing in print-making, Jami Taback from New York state explains her own experience with pregnancy loss: "My creative process is my salvation. Working on these prints was a catharsis, helping to erase the immediate pain. Taking the time to explore a darker side ultimately freed me from many of the emotions I was familiar with."

Writer and storyteller Jennifer Jacobson has used her creative process to artfully heal several traumatic events in her life. In a piece entitled *Cartography*, she uses the location of her parents' summer home to map out her celebrations and losses. In this excerpt, she evokes her miscarriage experience:

> On this porch it felt like I was sitting in a tree house and I could see love and danger from every angle, in every light. I was on this porch on a hot day in July when my miscarriage began. I did not know then that 29 hours later an EMS worker standing on 10th Street in New York City would ask me to step up into the ambulance – an ambulance that had been called because I did not understand what was happening to me and that this excruciating wave after wave of pain was labor, labor although it was only the second trimester. But it was then, when I stepped up on to that high step of the ambulance that my daughter was born and died.

Playwright Nancy White from Columbia, MO, also used writing to navigate the bereavement process. She wrote and produced a theater piece inspired by the loss of her stillborn baby, Rayn: "My husband and I lost our baby boy July 10th, 1996 – two days before my due date," shares Nancy. "During the first six months after his death, I was so sad I wasn't sure I could go on."

When Nancy learned about the Secret Club Project a few years later, she contacted me to let me know about her play. She explained her creative approach: "After much sadness and desperation, I put pen to paper in the hope of discovering my way through the grieving process." Throwing herself into the project gave her a kind of purpose and focus and, at times, a sense of calm she had never experienced before.

The play was directed by her husband David White, director of the Missouri Theatre. Entitled *Still as Rain*, the play is based on the Greek myth of Demeter and Persephone in which the goddess of fertility loses her daughter to the underworld. As the play opens, Demeter, described as a visual artist in her mid-thirties, is standing at an easel with a paintbrush in her hand. She whispers cryptically to herself:

> It was really hot night in July when I first realized... When I first learned...that everything...had become so quiet. All the people... there...called it being...still... *(holds the brush to her belly)* I laid there on that table and the woman...she wore white...and she whispered, "Just give me a second." And I counted. In my head I counted "1...2...3..." She stood above me and her hand was shaking. I could feel it move...but I...we...were perfectly still. With one clean sweep of her sweeping hand the whole world just stopped...dead. (White 1997, p.2)

After the performance, audience members were invited to share their reactions and questions. David felt that having the audience respond was an essential part of the project and of his own healing process. Nancy admits: "I've always been pretty much of a loner and sharing my heart with strangers was never one of my strong suits. But the play changed all of that. I found myself hungry to connect with others in sharing the story, and in hearing theirs." In the process of sharing her "secret" with the world, she was healed in a way she had not imagined possible.

Another artist, Diane Savino of Massachusetts, speaks of her creative process following a horrible birth experience during which she almost died: "Finally, I could no longer be alone with my nightmares and memories of being caught in a vacuum, feeling as though I was drifting away from all that I loved... I gave myself permission to talk, to paint pictures of the labor scenario, making it a tangible experience." Her piece *Curtain Call* (Figure 6.1) depicts ostriches in "see no, speak no, hear no evil" positions to call attention to the silence that surrounds women's authentic birth experiences. Savino speaks for many of us who have found creative expression to be the central act that releases us from unresolved grief or trauma.

An art therapist who has lived much of her adult life suffering from severe, at times crippling, endometriosis, Jane Berstein also used visual art to record and

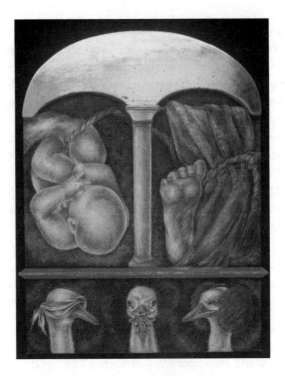

Figure 6.1: Curtain Call, egg tempera and gold leaf, Diane Savino

cope with her condition. "The importance of documenting my symptoms (i.e. the pain) through my artwork was so necessary for me – knowing that it validated my suffering and knowing that there was something wrong with my body even though the doctors missed the diagnosis" (Berstein 1995, p.56). Over the course of a 12-year period, Berstein created approximately 450 spontaneous drawings reflecting her physical and emotional experiences. On occasion, she even shared them with her more open-minded doctors to help them "see" what her pain felt like and where she felt it.

Some families who have survived a stillbirth or neonatal death commission a piece of artwork to memorialize their loss. At the website www.aplacetoremember.com, grieving parents can order an original drawing of their infant based on a photograph. Another website suggests that artists can make pleasing sketches or paintings even if the photographs are of poor quality or disturbing in some way. My colleague Lucy Mueller White was asked to create a piece of art commemorating a stillborn baby who had been one of a set of twins. In the artwork, photographs of the infants are woven into images of green leaves and a buckeye tree that are meaningful to the family who commissioned the piece.

A piece of art also became important to Suzanne and Wayne Cordes of Massachusetts in their healing process. The couple had received hundreds of condolence cards following the stillbirth of their daughter Lilliana. They were particularly taken with one card that had a painting of a little girl among flowers entitled *Angel Girl with Lilies*. An article in their local newspaper explains: "Suzanne fell in love with the painting and tracked down the artist. After hearing Suzanne's story, the artist sent her a copy of the painting as a gift" (Lorie 2003). The artwork now hangs in their living room.

Kara and Hawk's story

I want to share the experience of Kara Jones and her husband Hawk, not because their story is a typical one but because the way the arts buoyed them and continue to play a central role in their lives is an extraordinary one. Kara and I found each other, even though she lives on an island in Puget Sound near Seattle and I reside all the way across the USA on the east coast. The couple lost their son Dakota when he was stillborn in March 1999. At that moment, their whole world changed. Kara describes her experience of the stillbirth as being incorporated in "every fiber of my being." Suddenly, her life turned upside-down, two weeks in a sedated fog, sleeping all day and surfing the Web at night, buffeted by unbearable waves of anguish.

Although both she and Hawk already led lives rooted in the arts, reconnecting with her creative voice was not easy. In her poem "Anger I" Kara pulls no punches:

> *"You can write out your grief,*
> *Perform out your grief," they all tell me.*
> *"Fuck you," I answer.*

Jones (1999, p.46)

Once Kara did open to art again, she held tenaciously to the creative process, as a shipwreck survivor might cling to a raft:

> While I was still in the hospital, a good friend brought me a new writing journal and a pen. And I began to write immediately. I wrote, "3/11/99, 4:47pm, your baby is dead." And I wrote and wrote and wrote and wrote. I wrote poems, I wrote a short story, I wrote letters and emails to friends. And with everything I wrote, I was voicing the story.

But as a poet who had been on an academic career path, Kara found the loss impacted her writing in a way that didn't jive with the expectations of her

professors. "Too emotional," they said, "different audience – try poetry therapy if you want to write poems like this." Within half a year, she had churned out three collections of new poems about her loss of Dakota. She couldn't bear to hand them over to a publisher to be edited and critiqued – it would have felt like handing over her child. So she and Hawk, an artist and photographer, took the major step of starting their own small publishing house, Kotapress.

Although managing their own press is a Herculean effort in itself, they continue their intense relationship with the arts in many other avenues. Kara explains: "The crippling grief left me able to do nothing but make art... Regardless of the medium, every time I create a piece of art and put it out into the world, I defy grief's isolation." One of Kara's creative projects was jumpstarted by a class she took on making handmade books. Kara and a local group of women who had participated in the workshop decided to meet regularly to continue working on their books. Kara developed her own series called Womb Books (Figure 6.2).

Kara and Hawk call one of their projects Overflow of Prayers. Through the Internet, they invited the worldwide community to participate. Each participant in the project is asked to write a prayer on a single piece of paper. The paper is then folded into a small square; when Kara and Hawk receive it, they place the paper in a large prayer basket. When the basket is overflowing, Kara and Hawk envision traveling with the project to diverse places of worship. Kara has on occasion incorporated some of the prayers into her handmade books, honoring the messages and blessings, which helps her to feel less isolated in her grief.

Through their own difficult recovery, Kara and Hawk have also learned to create a safe space for others to engage in the creative process. Through a series of workshops called Body Writes, they teach participants to engage their five senses, tune into their present experience, and express themselves in the here and now. They offer their workshops at pregnancy-loss conferences, learning more about the healing process from each experience.

Kara has also enlisted the tradition of henna. Henna painting, also called *menhdi*, is the traditional art of temporary tattoo, common in India and northern Africa. Henna designs are often applied to the hands, feet, and belly. Although beautifully decorative, the process is also used within the context of sacredness, blessings, and healing, often as a part of wedding celebrations. Experiencing henna body painting allows some women to get back in touch with their body following a stillbirth or other reproductive trauma. Kara, who offers healing henna sessions, explains: "many bereaved parents find very physical and tangible expressions help during the bereavement process."

Hearing their story, I was struck by how Kara and Hawk maintained a strong connection throughout their traumatic loss and how Hawk was "100

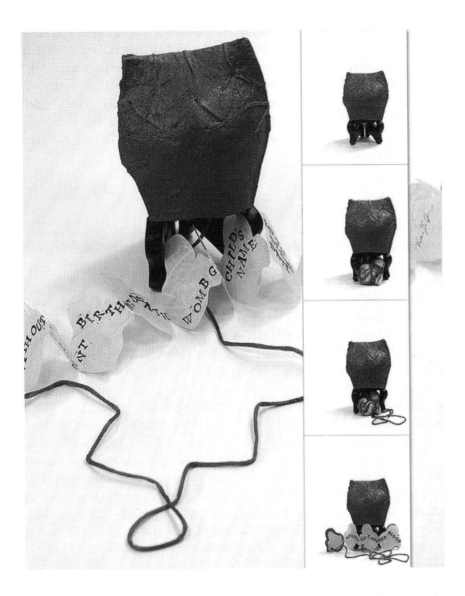

Figure 6.2: Womb Book, mixed media, Kara L. Jones (photograph by Hawk Jones / kotapress.com)

percent involved" in the grieving process. "We teach classes together, manage the press together, even hide under the bed together." It was only when they began interfacing with other families that they realized how rare it was for the male partner to be as fully engaged as Hawk.

Kara also found tremendous comfort from her own mother's words, which she shares in the introduction to one of her poetry collections: "You will always be Dakota's mom, and Hawk will always be Dakota's dad. Nothing, not even death, can change that" (Jones 1999, p.vi).

Is creativity enough?

For every story of a loss that opened up a wellspring of creativity, there is a story of creative shutdown. A traumatic loss, particularly early on, can easily leave us in shock, numb, or in a state of paralysis. Most individuals are not able to jump into the studio at such a time. In essence, we often require time to digest the reality and the meaning of the loss. An intense loss can leave us disconnected from our creative selves for a prolonged period of time.

Tracey Emin, provocative British installation artist, challenges her audience by including details of her sexual and reproductive life in her work. In one interview, she explains the negative impact of some of her reproductive losses on her creative process: "I am frightened because I am 35 and I want a baby, and I can't see it happening... I have had two abortions and a miscarriage. That's what changed my attitude to my work and stopped me from making art for a few years" (Gisbourne 1998).

Some of us will naturally re-establish a connection with our creative process when the time is right. For others, it may be helpful to collaborate with a creativity coach, psychotherapist, or expressive therapy group in order to address obstacles to creativity. There are also many books on the creative process, such as *The Artist's Way* (Cameron 1992) and *The Woman's Book of Creativity* (Ealy 1995), which can guide us back to our innate ability to express ourselves.

There are moments following the loss of a baby when making art can seem like a pale, watered-down remedy. The parallel between creation and procreation can feel too close sometimes, as if this creative product is somehow supposed to replace the baby. Emin echoes this sentiment when she compares her art-making with the desire to bear a child: "This is why I have regrets about my art, because it is nothing in comparison" (Gisbourne 1998). When Kara Jones first lost her son, she was skeptical about the possibility of healing through art or writing: "Write out my grief, what a joke," she intoned. "Poems are a poor substitute for a baby" (Jones 1999, pp.48–9).

Yet for both Emin and Jones, there came a time when the creative process fired up again, its embers waiting to be reignited. For Jones, this happened very quickly after her loss. Art-making can never replace the baby that is lost; instead, it serves as a conduit to bring us home to ourselves, to reconnect with life, and as Jones puts it, to "defy grief's isolation." Judith van Praag writes about her own healing journey after stillbirth: "Recreation of what was lost proves to be impossible, what remains is the option to create something new" (van Praag 1999).

We often forget that incubation is a crucial part of the creative process. Letting an idea or project "cook" – sometimes for years – is not the same as having a creative block. Honoring that these cycles of activity and downtime are essential for many creative people takes the pressure off rushing a project to completion before it and the artist are ready.

This is not to say that bringing a creative endeavor to completion is easy. For Misa Tupou, born in Tonga and now residing in New Zealand, funding was one of the hurdles that prevented completion of his performance piece exploring pregnancy loss. Trained in the tradition of physical theater – a style relying primarily on the physical presence of the actors to communicate with the audience – Misa developed a narrative performance after he and his wife lost a pregnancy. An experienced performer, he knew that bringing it to an audience would have entailed an overwhelming amount of work to organize, fund, and publicize. However, even incomplete creative projects serve their purpose and do not always need to become polished performances or exhibits in order for the artist to reap the healing benefits.

In my work as an art therapist and creativity coach, I have come to have enormous respect for the creative process and its mysteries. Sometimes it feels like pulling teeth to make something happen; other times, it feels inexplicably magical. I do know this: when a client finally, tentatively picks up that paintbrush or pen, they are more than halfway to saving themselves.

Exhibits on pregnancy loss

Incite Art – Create Community. (Bumper sticker)

An art exhibit about miscarriage? The idea for the Secret Club Project emerged in 2000, six years after my miscarriage, when I could talk about the loss without a sensation of drowning. I was finally ready to expand my private process into a public project. I wondered whether there might be other women artists who had found their own artwork crowded with symbols of pregnancy loss. I proposed the idea of a group exhibition to the local arts council in Northampton, MA,

where I initially met with some skepticism but ultimately won a small grant. I called the project the "Secret Club" after reading a newspaper article with the same title about pregnancy loss and the taboo that still surrounds it.

It seemed unlikely that I would receive many submissions for what was considered to be an obscure and morbid theme. When I first began seeking artists for the exhibit, I was not yet aware that approximately one in five pregnancies ends in miscarriage. At the time, the arts council that funded the show was wondering how I would ever find enough artists focused on this topic. Determined to succeed, I went through the council's entire database and wrote down the addresses of all the women artists on their mailing list. I sent out a simple straightforward announcement calling for "artwork on miscarriage." I placed announcements on a few Internet listings for artists.

Calls started coming in from local women and a few from out of state. Would I consider a quilt? Yes. Could I include artwork about abortion? Not in this exhibit, but what an incredible show that would be (perhaps the Top Secret Club?). Could a man submit artwork? Definitely. Nine artists agreed to join me in an exhibit at a gallery in downtown Northampton.

Pulling together an exhibit of this nature proved challenging – making it public broke an unspoken rule that we are not to speak too much about miscarriage. Although this was an art exhibit, not a therapy group, a dynamic developed in which the women artists shared their needs, fears, and hopes. Initially, I made studio visits to view quilts, drawings, photographs, and paintings. The artists then met as a group several times to plan the show. It was during these meetings that we found that there were many unexplored pockets of pain and potential divisiveness. For instance, who among us had children, and who was still struggling with infertility? Whose loss was experienced decades ago, and whose was fresh and raw? Would we survive the upheaval of emotions stirred up by taking this profoundly private artwork to the public?

Our opening event, which included speakers, poetry, and a brief ritual of acknowledgment of our losses, was a moving experience for the artists as well as the audience. Most of the artists were from western Massachusetts, but some traveled from as far away as Philadelphia, Pennsylvania, and St Paul, MN, to attend this event.

The opening event was designed to be interactive on several levels. Many of the 80 people who attended the reception wrote surprisingly personal entries in the journals we left around the gallery. Viewers were also invited to become artists by responding visually to Margaret Carver's installation (Figure 6.3). She provided silver crayon for inspired attendees to express themselves on a wall lined with black paper. Finally, at the end of our presentation, we included audience members who considered themselves part of the "secret club" in a simple ritual using a basket of river rocks to represent our pregnancy losses.

Figure 6.3: Response to gallery installation

The Secret Club show stimulated a flurry of articles and reviews in the press, raising awareness about the issue in our community. In response to the articles in the newspapers, we received a letter from a 75-year-old woman retelling the loss of her pregnancy in 1956. Her interest in the project is another reminder of the longevity of the grief that can accompany miscarriage. She looked forward to the day when she would be reunited with her lost baby whose gender she was never allowed to know. Jean and Michael Morrisey, political advocates for the rights of parents who have experienced pregnancy loss, also wrote to me after the exhibit's opening night: "We've attended many emotional conferences, services and lectures about pregnancy loss from Maine to Australia, but even without a spoken word we both found the Secret Club Project exhibit to be the most emotionally powerful experience we've yet encountered."

Following the impact of the first exhibit, I continued to seek submissions from artists from a broader geographical and cultural range. As the call for artists went out, I began receiving emails and phone calls from all over the country: New Mexico, Kansas, Hawai'i, Texas, Ohio, New York. Women – and a few men – retrieved artwork from under their beds, from their archives, from their

basements. This was work they were aching to show but had never found the right venue for. Each packet I opened felt like another revelation, another secret shared. More than one artist confided "I made art about my miscarriage, but I never told anyone what it was really about."

Somehow, our announcement got picked up by an international network. In my mailbox, I discovered an envelope from Ghent, Belgium, with flowing script – a Belgian artist, Lieve van Stappen, had researched and created an installation about pregnancy loss with haunting blown-glass christening dresses displayed in a former church (Figure 6.4).

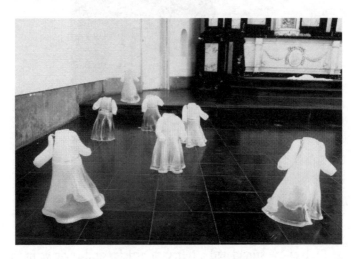

Figure 6.4: Christening Dresses, blown glass, Lieve van Stappen

Currently, the collected artwork represents a breathtaking variety of forms: charcoal drawings, oil paintings, quilts, ceramic teapots, prints, photographs, computer art, blown glass, collage, and found-object sculptures. The work of artists who are fervently pro-life coexists with work by women who are pro-choice. Although the majority of the artists have experienced some form of pregnancy loss directly, there are also pieces in the project created by those who have been touched by pregnancy loss, whether as relatives, medical practitioners, or simply keen observers of the society around them.

The truth remains that a good portion of artwork about reproductive crises is disturbing, capturing the blood and the messiness of miscarriage and other traumatic losses. The experience of miscarriage is above all a physical one. The power of art is that it allows women to bring forth what is so difficult to articulate with words: the flowing out, the emptiness, the sense that your own

body has betrayed you. Some pieces can be described only as images of angry or wounded vaginas and wombs. Other works of art challenge and mesmerize us with images of skeletons, coffins, and ghostly figures. These are symbols that we are loath to associate with the sweetness and innocence of babies. The anguished expressions of women wracked with grief confront the viewer, asking: can we bear to witness their pain? Despite the sometimes challenging nature of the imagery, all of the artwork represents the resilience of the artists who have created it.

The artists in the Secret Club Project conjure their grief into something personal and mysterious and, at the same time, universal. Not satisfied with simply outlining their circumstances, they create a door for the audience to jump into their visceral experience and move beyond platitudes and predictable responses. One visitor remarked: "As I viewed the works, I was moved and starkly reminded of the importance of giving attention to early pregnancy losses. Feeling alone in one's grief or having feelings dismissed is sadly the more common experience." The artists dare to ask and begin to answer the question: what can happen when the loss of a pregnancy no longer has to be secret? One viewer of the exhibit, who survived two of her own miscarriages, wrote: "These artists educate us, help speak the unspeakable and convey the depth and intensity of pain. They don't offer platitudes and superficial images."

Creating an exhibit about pregnancy loss allows a community to break open a dialogue about it. There is no limit to the kinds of organization that can serve as sponsors for the event – one does not need to think only in terms of galleries. In fact, working with agencies outside of the art world can result in a more grassroots audience. For instance, when the Secret Club Project toured Washington state, its first stop was Olympia's Planned Parenthood; the artwork was later showcased at a regional Planned Parenthood meeting. Healthcare providers and others interested in the topic found the show, the first of its kind in the area, to be compelling and controversial. One local doctor was pleased to see the topic of pregnancy loss finally being covered, citing the callousness of some of her colleagues in medical school.

Kristine Sogn, who was instrumental in bringing the Secret Club to Olympia, describes the rest of the exhibit's journey: "It traveled north to a Pregnancy Loss Memorial event in Bellevue, then went on tour with Parent Support, a large group that coordinates support groups through the Seattle area hospitals." At tour's end, the work was viewed by a group of artists and at one point just missed being caught in a fire at a clinic in Olympia. This last bit of news highlights the unpredictability and serendipity that come along with creating a thematic exhibition and putting it out into the world – security issues,

controversy, unexpected expenses, and miraculous coincidences are all part of the experience.

The publicity and educational material supporting the exhibit are crucial. The show's coordinator has an opportunity to use carefully chosen words to inform the community about alternative ways in which to view and make sense of pregnancy loss. Kristin Sogn observed one powerful reaction to the exhibit:

> One woman had two tubal pregancies over 20 years ago and this show was about the first time her grief was openly validated. She read your Secret Club introduction which mentioned ectopic pregnancies and said, "I'm on that list! It wasn't just miscarriages – I'm on that list." Her relief at that validation seemed to completely wash over her. She and I have been colleagues for years, yet I never knew. She loved the inclusiveness of your words, relaying that losses occur through many ways and are united.

With regard to the Secret Club presentation, and other thematic exhibits I have viewed over the years, one of the most moving and inviting aspects was the artists' own words. Prominently displaying the artists' statements gives viewers a way in which to engage with the exhibit in a more personal and meaningful way.

When participating in an exhibit titled *Women's Bodies: Violence and Healing*, Kara Jones displayed her Womb Books. Her decision to show a specific number of books was particularly meaningful and served to educate the viewer to the realities of pregnancy loss. The opening night of the exhibit was scheduled to last two hours. According to statistics Kara had gathered, approximately seven babies are stillborn every two hours in the USA. "So I created seven Wombs," she explains, "to honor the seven children who would die of stillbirth while we all stood around in the luxury of art."

Art exhibits focused on healing bring up both aesthetic and ethical questions, particularly when the artwork is the product of psychotherapy. "In moving the work from the private to the public domain the question is no longer one of individual therapeutic resolution, but rather whether the images, selected out from the hundreds created in the process, have the power to communicate to a broad audience" (Martin 1997, p.164). Edith Kramer, the legendary grandmother of art therapy in the USA, posited that the therapeutic cycle is not complete until the artwork is seen by the community. On the other hand, she did not believe that every cathartic expression should be deemed "art" and encouraged her clients to move towards a more sublimated and complete expression of their personal imagery. Anyone who hopes to mount a show on pregnancy loss must weigh these two ideas and arrive at their own equation.

Martin (1997, p.163) also raises the point that it is inappropriate to exhibit artwork until the "pain, trauma, have been worked through." This matter is

highly subjective and lends itself to a sensitive discussion of the artist's experience, both in making the piece and her current relationship to it, and of the viewer's response. It is also key for therapists to remember that, legally and ethically, images created within the context of a therapeutic setting should never be made public without the written consent of the artist.

In pulling together the Secret Club exhibit, I was confronted with artwork that was so raw and challenging that I questioned whether I dared include it in a very public show at a downtown shopping center. Ultimately, I did choose to go with an inclusive approach, avoiding censorship in favor of speaking the truth, even if the artist's truth seemed to be a harsh one. But we did discuss as a group whether we, as artists, were ready to go public and whether the public was ready to see our work.

A similar process of soul-searching and negotiating accompanies other kinds of public presentations, whether poetry-reading, performance, or publication. Combining traditional art exhibits with computer technology allows us to display artwork in cyber-galleries. These Internet exhibitions create new questions about who owns the work, whether it is copyrighted, and whether posting an image online means it has been "published."

Regardless of the venue, it seems that when we give women and their partners an arena to present the truth about their reproductive losses in all their permutations, it provides a unique opportunity for them to heal not only themselves but also their communities. As Diane Savino, who participated in the first Secret Club exhibit, explains: "It has taken me a long time to be ready to exhibit this painting. It has remained shrouded in a black garbage bag and buried beneath my bed, as well as in my subconscious." By coming out with their powerful and challenging artwork, artists invite us to see through their eyes and to imagine a more open and compassionate response to their hidden losses.

Perhaps Terri Campeau, who helped organize the show in Olympia, sums it up best: "If it validates even one woman's loss who comes to see it, it'll be worth it" (Gilmore-Baldwin 2004).

Lost Traditions

Butter, Toads, and Miracles

Bridging old and new

Modern society seems to have lost the ability to respond coherently to child-bearing crises. "There's little acknowledgment in Western culture of miscar-riage, no ritual to cleanse the grief" (Orenstein 2002, p.38). For today's families, the lack of meaningful rituals to mark the loss leaves an emotional vacuum.

Throughout my exploration of healing through the arts, I wondered how other cultures, both past and present, responded to pregnancy loss. What kinds of rituals did they develop? What sculptures did they carve? What songs of grief did they sing? I imagined that present-day artists might be reinventing (with a modern twist) the practices of our ancestors. Are the new rituals and images being developed by artists, clergy, and counselors filling the void once held by these lost traditions? Are, as many authors have theorized, today's creative arts therapists filling the role of yesterday's shaman?

To uncover the answers, I started reading. I tracked down out-of-print books in order to research how people once understood and coped with pregnancy loss and what, if anything, these practices have to do with today's art-making and rituals. Many of these rituals were collected in the books *Mothers of Thyme* (Sha 1990) and *The Anthropology of Miscarriage* (Cecil 1996). I have included rituals related to both infertility and pregnancy loss because in many customs these two issues are woven together and become inseparable.

Traditional rites and symbols help us place the work of contemporary artists and healers within a meaningful context. Art therapist Linda Gantt advises, "through careful study of other cultures we can learn the general forms such ceremonies take and thus can help our clients in devising their own" (1991,

p.15). Some traditional beliefs and ceremonies may seem strange or antiquated to us, while others jump out as still relevant to our modern lives. Some of the rituals presented here have an almost dreamy or poetic sensibility and speak to the heart of the artist. Others possess a kind of psychological wisdom, albeit couched in ancient terms.

It is important that we tread lightly when encountering traditions and cultures with which we are not fully familiar. Although it is easy to romanticize traditional cultures, it is best to remember that they do vary widely in their treatment and empowerment of women. It must also be understood that what follows is not an in-depth study of these rituals in the full context of their cultures; rather, it is a survey of images and practices that might in some way inform our use of art and ritual today. Dance therapist Claire Schmais envisions thoughtfully uniting the rich traditions of the past with modern knowledge in order to create a new framework for using the creative arts for healing (1988, p.284).

Ultimately, the differences between cultural practices are not so great when we consider that all people are responding to the same basic challenges that life presents. "Flowers, fire, ashes, precious possessions, symbolic acts (for example communication sent in the direction of heaven), leave-taking, and radical transformation of objects are features commonly found around the world, not just in funerals but in ceremonies of all types" (Gantt 1991, p.16). These universal forms and symbols unite us in our humanity.

The following exploration of cultural practices offers insight into how and why humans create sacred symbols about the mysteries of fertility, birth, and miscarriage. Janet Sha reminds us, "women and men who experience infertility and miscarriage belong to a tremendously large and ancient fellowship" (1990, p.113). I hope that these brief examples may serve to reconnect us to our own spiritual sources and the innate urge to heal through creative acts. You may notice, as I have, that the line separating art and ritual begins to disappear. Fabric artist Lynne Marie of New York, describes this blending well: "Offering my art as a transcendent language of my hands, the work itself is prayer…"

Symbols and amulets

One apparently universal response to pregnancy loss and infertility is the wide-spread use of "surrogate babies." These dolls or sculptures, which generally represent children, were incorporated into rituals reflecting each culture's beliefs. Variations of these symbolic dolls were used all over the world, including New Zealand, Mexico, Indonesia, Japan, South Africa, and North America (Sha 1990, p.34).

Many African traditions incorporate the use of carved dolls and statuettes to influence states of infertility and respond to miscarriage. Dolls carved of wood are carried by the Asante women of Ghana if they wish to conceive. A story from the Asante tradition tells of a young woman, Akua, who was infertile. "In her despair she went to a diviner and asked for his help. He told her to bind the small wooden doll she had played with as a child on her back in the folds of her wrapper, where it would soon be replaced by a real child." Akua followed these directions, despite the teasing of her neighbors. "They stopped laughing when Akua bore a beautiful little girl. Since that time, all such fertility dolls are called *akua ba* by the Asante" (Herling 1998).

A doll's power comes through consecration to a deity, and it is hoped that the beauty of the doll will translate into an attractive child. It is treated tenderly as one would a living child: dressed, held, and adorned with jewelry. According to an exhibit at the Museum of Fine Arts in Boston, a woman of the Lulua people from the Congo who lost a pregnancy received from a shaman a small wooden sculpture. She was instructed to place it in a basket by her bed and "feed" it with oil or clay in order to maintain its spiritual viability. After the successful birth of a baby, these dolls retain great value and may be placed on a shrine. Some fertility dolls can even be worn as part of a woman's coiffure or headdress.

In Mexico and other parts of Latin America, *milagros* are still used to aid prayers for fertility. A *milagro* (Spanish "miracle") is a small charm, most often made of metal, used to petition saints for help or to thank them for an answered prayer. Each devotional charm represents an individual's specific illness or need. *Milagros* petitioning for a woman's increased fertility are usually in the form of a swollen belly, a breast, or buttocks (Figure 7.1). Ancient Etruscan sites in Italy have yielded *milagro*-like images of wombs and other parts of the human body. It is also said that *milagros* of horses, sheep, and goats can represent fertility (Egan 1991). The tradition of *milagros* dates back to ancient Roman times, when similar amulets were used to ask the gods for their healing interventions. In the Americas, these customs brought over by the Spanish and Portuguese colonists were combined with indigenous and African cultures in the New World.

The custom of offering votives similar to *milagros* was once common in Catholic southern Germany. Votives shaped like keys were offered to specific saints by women concerned about pregnancy and birth. Jewish folk tradition also used the symbol of a key as an amulet for healthy conception and delivery. Although not a familiar symbol to us today, the image of a toad, or occasionally a turtle, salamander, or crocodile, was used to denote the uterus (Egan 1991, p.13). These toad ex-votos were offered to saints in order to express concerns about infertility or miscarriage or to offer gratitude for a successful pregnancy. Native Americans from the south-west used images of frogs and turtles to

Figure 7.1: Mexican fertility milagros, pencil drawing, Laura Seftel

symbolize fertility, while the ancient Egyptians used frog-shaped beads for the same purpose. The frog's metamorphosis from egg to tadpole to four-legged creature helped establish it as a symbol of genesis and reproduction. In China, the symbol of the dragon welcomes fertility.

One also finds symbols associated with fruitfulness and growth – such as water or rivers, fruit trees, and seeds – woven into traditional rites for pregnancy loss. The Onge people of the Adaman Islands in Burma believe that babies waiting to be born live in ficus trees. If the infant dies before weaning, then it returns to its place in this tree (Fontanel and d'Harcourt 1998, p.60). In China, the apple, and the pomegranate with its many juicy seeds, represent fertility, while in eastern Africa the fig serves the same symbolic function. To enhance fertility, Asian women rolled on the ground beneath an apple tree or washed their hands and face in water mixed with apple-tree sap (Sha 1990, p.23). In the contemporary form of Wiccan or Pagan tradition, a woman who wants to conceive might eat seeds and nuts while concentrating on their purpose: to germinate life. In the European Jewish tradition, an age-old custom encourages a woman to bite the stem of an *etrog* (a fruit central to the harvest holiday of *Sukkot*) in order to enhance fertility and conception.

In some traditional cultures, stones were believed to transmit their powers to infertile women. A woman from the Onge society seeking to become pregnant may go down to a shore where a large number of stones are found. "According to legend, these were once children. At low tide, she climbs on to one of these stones and the soul of the baby then enters into her body to be reincarnated" (Fontanel and d'Harcourt 1998, p.60). A similar perspective is seen in ancient British traditions, where childless women would slide over stones in

order to acquire the fertility found in the "bones of Mother Earth" (Biedermann 1994, p.327).

Music and song were also important elements of traditional cultures. Buddhist author Jack Kornfeld (1993) offers an example of how song is employed to aid in conception and used as a motif throughout the child's life. Kornfeld describes a community in east Africa that attributes a "song of the spirit" to each member of the tribe. When a woman becomes aware of her intention to conceive a baby, she sits alone under a tree and waits until she hears the song of the child to whom she hopes to give birth. The birth date of the baby is counted not from the date of conception or physical birth but from the first time the mother thinks of this potential child. Once she hears its unique song, she returns to the village and shares it with her man so that they can sing it together as they make love and invite the child to join their family. If she becomes pregnant, she sings this spirit song to the baby in her womb. Kornfeld describes how the village sings the song of the spirit when the individual faces times of initiation, injury, marriage, and other milestones. Coming full circle, the song is sung one last time at the individual's deathbed.

Beliefs and rituals

One of the most fundamental questions of belief centers on when a pregnancy becomes a person (Figure 7.2). How a religion answers this question has a direct impact on how a pregnancy is regarded when it ends prematurely and what kinds of rituals will accompany the loss.

In the Jewish tradition, customs responding to pregnancy loss vary according to different communities. For instance, Orthodox guidelines consider early pregnancies to be "watery tissue," with no burial warranted. Beginning 40 days after conception, it was traditional to bury a miscarried fetus, but without a ceremony. There is currently some debate about what observances are appropriate for stillborn babies. Updated rituals related to pregnancy loss are being refined and developed by present-day rabbis, offering comfort and support to the Jewish woman and her partner. For a more in-depth exploration of a Jewish approach, read Rabbi Nina Beth Cardin's publication, *Tears of Sorrow, Seeds of Hope* (Cardin 1999).

In the Koran, it is written: "To God belongs the dominion of heavens and earth. He creates what He wills. He bestows females upon whom He wills and bestows the males upon whom He wills. Or He couples them in males and females and He leaves barren whom He wills. For He is All-Knowledgeable All-Powerful" (42: 49–50). Islamic traditions vary from country to country, but in general it is believed that the soul is breathed into a baby 120 days after

Figure 7.2: Womb, alkyd on canvas, Jennifer Shafer

conception. If the parents wish, a funeral ceremony may be performed at any gestational age. In some cultures, women are not allowed at graveside rituals, but this is not considered Islamic law and does not reflect more contemporary thinking about the status of women.

Hinduism holds the belief that the human soul (*atman*) is divine and passes from one life to the next at conception. Thus, there is no time when the human fetus/embryo is not en-souled and thus sacred. Within the framework of rein-carnation central to Hinduism, each life is one of a great number of rebirths for that self until the achievement of its final state of liberation from the birth-and-death cycle. Traditionally in Hinduism, there is no discussion about degrees of humanity or any attempt to put higher value on the embryo at a later stage.

On the fourth night after the marriage and before first intercourse, the Hindu groom addresses the bride with the verse: "May Vishnu prepare the womb, may Tvashtar mould the embryo's form, may Prajapati emit seed, may Dhatar place the embryo. Place the embryo, Sinivali, place the embryo, Sarasvati! May the Ashvins garlanded with lotuses provide the embryo, the Ashvins with their golden fire-churning sticks, the embryo that I now place for you to bear in ten months" (Jaiminiya Grihya Sutra 1.22).

If a pregnancy is lost, the mother may be considered to be at fault in a karmic sense. There are a series of specific injunctions and rituals following any death in the Hindu tradition. This period, called *asaucham* (ritual impurity), requires different kinds of observances based on the circumstances. For instance, if a miscarriage occurs, then the number of days observed is equal to the number of months of pregnancy that occured (e.g. if the mother miscarries in the sixth

month, then the period of *asaucham* is six days). If a baby is stillborn, the period of *asaucham* for both the parents is 24 hours. Up to the age of three years, there is no cremation, only burial without any ritual – offering of sesame seeds and water is optional.

Central to the Catholic faith is the role of infant baptism, a Christian sacrament signifying spiritual cleansing and assuring the child's place in Heaven. When a pregnancy is lost or a baby is stillborn, it presents a situation in which theological questions are raised around the ritual of baptism. According to Kohn and Moffitt (1992, p.138), some members of the Catholic clergy recognize this problem and offer what they call "conditional baptism," in which the rite is offered on the chance that some spark of life exists that is not discernible. Recently, an older concept has been welcomed back – "baptism of desire" – where the baby is considered to have been automatically baptized before it died, based on the parents' faith and intention to have had the child baptized should it have survived.

Catholic mass can also incorporate a prayer to remember a lost pregnancy; however, this practice does not seem to have been adopted until recently. For instance, women who suffered a miscarriage in Northern Ireland traditionally were encouraged to carry on quietly with their duties. The remains of miscarriages or stillbirths were placed in unconsecrated unmarked sites with little ceremony – sometimes they were even buried at night. In contrast, the Catholic church now holds an annual Mass of Remembrance on the Feast of the Holy Innocents and has established a Garden of Remembrance in Belfast (Cecil 1996, p.186).

In Medieval times, church doctrine espoused the notion that unbaptized infants could not gain entry into Heaven. Instead, they lingered in Limbo, a state that was pleasant but did not afford God's direct presence. Paintings often depict scores of cherubs in the sky – these are the spirits of babies who died before baptism. In more recent times, the belief that unbaptized infants are barred from Heaven has been challenged, and the doctrine has evolved in order to provide a more comforting image for bereaved parents.

Rather than depicting images of cherubs in purgatory, today's Christian artist is more likely to depict a lost baby tenderly cradled by God's hands or watched over by Jesus (Figure 7.3). The belief that the baby is cared for in Heaven is often combined with the promise of eventual reunification.

The Native American cultures of the Arapaho and Ojibwa people considered unborn children to be human beings and so "treated the remains of miscarried babies in the same manner as for adults" (Sha 1990, p.72). One Ojibwa woman recounts that when a relative lost a pregnancy, the fetus was lovingly wrapped, buried, and offered a feast in its honor.

Figure 7.3: Heaven Bound, colored pencil, Andrea Picard

The bulk of rituals and remedies for pregnancy loss and infertility in traditional cultures are directed strictly at the woman, as the fault is usually deemed to be hers. Cecil (1996, p.103) points out that in these societies, there is no such thing as an "infertile man," although I did discover a tradition of the Onge people in which a married man who wants to ensure his fertility may wear a band of bark around his shoulders like the one that is used to carry babies (Fontanel and d'Harcourt 1998, p.60). Inhorn and van Balen (2002, p.7) confirm that: "Indeed, women worldwide appear to bear the major burden of infertility, in terms of blame for the reproductive failing; personal anxiety, frustration, grief, and fear; marital duress, dissolution, and abandonment; social stigma and community ostracism…"

The loss of a pregnancy in traditional cultures is often considered to be the result of poor relationships or misconduct on the part of the woman. Many fairytales originating in Europe portray the loss of a child as a punishment for wrongdoing. Rituals around the world are designed primarily to "fix" the woman, to enhance her purity and fertility in preparation for subsequent births. In southern Ghana, an infertile woman of the Aowin people may be considered

a witch. It was traditional for an infertile woman to go into the forest accompanied by a medium in tune with the spiritual world. The woman would bathe in a river for purification and make offerings such as eggs to appease the gods. She was then painted with white clay and dressed in white cloth. Only then was she ready to try to conceive again (Sha 1990, p.31).

Although the idea of placing blame on anyone might feel psychologically unsavvy to modern sensibilities, we need only scratch the surface of a modern woman's psyche to find a stream of guilt and shame following pregnancy loss or infertility. Perhaps by acknowledging feelings of guilt and then providing a route for the symbolic release of that guilt, these stories and rites offer some benefit. Or is this seemingly universal blame of women who are infertile or who miscarry simply a result of misogyny? Thankfully, almost all religions offer a ritual for expiation – for instance, the Catholic confession – providing opportunities to seek forgiveness in God's eyes and in our own, regardless of whether our wrongs are real or imagined.

In the Victorian era in England, pregnant women faced guilt-inducing societal pressure and a daunting list of forbidden activities, lest they instigate a miscarriage through their own misbehavior. Sha (1990, p.78) observes: "Western authorities often could not make up their minds about which behavior and habits caused miscarriage." Pregnant Victorian women were warned against many things, including:

> Overreaching to hang a picture, taking a warm bath, riding a bicycle, sleeping with the arms above the head, having a tooth extracted, being excessively happy, running a sewing machine by foot, lacing a corset too tightly, washing clothes, bathing in the ocean, *not* bathing in the ocean... (Sha 1990, p.80)

Women were also advised against strong surges of emotion and nervous dispositions – even the fear of having a miscarriage was thought to have the power to induce one. And, of course, pregnant Victorian women were never to engage in vigorous sexual intercourse. This latter warning was addressed primarily to men, considered the sole initiators of sex.

Despite this plethora of advice, when a miscarriage did occur, little solace or public ritual was offered. Although the Victorians lavished attention on deathbed scenes and the etiquette of mourning, pregnancy loss was not regarded as a death worthy of public bereavement. Carol T. Christ, a scholar specializing in the Victorian sensibility of death and dying, has found no accounts of miscarriage in her extensive search of literary and visual representations from that era (Christ 2004). Perhaps because a fetus was considered to be a soul that had barely left the other world and did not have a fully formed identity, it did not yet warrant the elaborate response customary

when a member of the family passed away. There is the possibility, however, that women did mark these pregnancy losses and even attempted to document them. But, as Sha (1990, p.x) surmises, women's diaries that touched on reproductive experiences may have been edited to be more "appropriate" before they could be published.

One universal concern is the fear that the vulnerable pregnancy or newborn infant will be lost. Customs to protect the new child are found in traditional and contemporary societies around the globe. French ethnologist Suzanne Lallemand describes these ritual attitudes gleaned from a variety of geographical locations:

> A pregnancy may not be announced, and may even be denied. After birth a baby may be hidden or disguised: a newborn may be blackened with soot to escape the forces that desire his or her death. A boy may be dressed as a girl in order not to arouse the envy of evil spirits… In short, the double solution of deprecation and disguise ensure the infant's survival in the face of invisible threats. (1998, p.21)

Lallemand goes on to relate how customs may also reflect the family's wish to prevent the return of the baby to the spirit world where it dwelled so recently. Bits of metal or hostile-looking items placed by the baby's bedside are thought to prevent spirits from capturing the baby. Babies may be adorned with talismen and charms on bracelets or necklaces in order to protect them and keep them from departing for the other world. Parents may even remove one shoe from a sleeping baby to keep him or her from running off to the other world (1998, p.22). In Nigeria, a mother who has already lost a pregnancy may name her next baby "Do not go again" or "Sit down and stay with us" (Cecil 1996, p.7). In modern societies, the reluctance to celebrate the impending arrival of a baby still lingers. Contemporary Jewish and Chinese families, for example, may still discourage baby showers or setting up the nursery before the birth. They do not want to draw attention to the happy event, just in case such celebrations draw bad luck to the home.

Some glimpses of early life in northern Europe are still available to us. If an Anglo-Saxon women suffered a miscarriage, she could avail herself of many good-luck rituals. In one of them, "A grieving victim of a miscarriage took 'a piece' from her child's grave, wrapped it in wool, and sold it to traders, saying to them, 'I sell it; buy ye it, this black wool, and seed of this sorrow'" (Sha 1990, p.97). Related rituals involved symbols of fertility, including cows and milk.

The common view held by most traditional societies is that the transition from the spirit world to this world happens in stages and is fraught with peril. In some cultures, the death of a baby or the end of a pregnancy is regarded not as an accident or sickness but as the child not being fully committed to an earthly

life with an earthly family. A pregnancy that is lost would be understood as a spirit ambivalent about being born at this time or thwarted by a sorcerer, an evil force, or a displeased ancestor.

The culture of the Tamberma people of Togo fuses notions of death and birth: when an elder dies, he or she must be encouraged to "return and bring forth children" to the remaining family members (Blier 1981, p.289). The expressive and elaborate funeral performances developed by the Tamberma to honor their dead include choreographed movement, drama, music, and symbolic actions. The ritual performance spans several days, with the last section stressing the rebirth of the ancestor's spirit.

To assure future fertility, the deceased's married daughters are asked to participate in one small part of the funeral ritual: a family aunt smoothes butter (symbolic of fatness and fertility) on their small toes (symbolic of children) (Blier 1993, p.290). Some of the songs included in these rituals emphasize that a family might be at fault if they have fertility problems. For instance, "the metaphor of a poorly kept house suggests the plight of families who are without offspring because of the failure of ancestors to return and sponsor young…" (p.289).

Some societies in Polynesia thought of their lost babies as deities. In Hawai'i, a miscarried fetus would be placed in a running stream or the sea, to be cared for by ancestral gods. Over the years, these spirits were honored by offerings of drinks. A well-tended spirit would visit and perhaps communicate with a family member. It was also believed that the spirit could transform into a reptile, bird, fish, or human at any time (Sha 1990, p.163).

In the Himalaya, a miscarriage was thought to be caused by the demon Sor Moong. To prevent another loss, the fetus was carried to a river, after which a holy man blessed the couple with a bundle of grass tied with colorful threads and trinkets (Sha 1990, p.92). Unlike many other cultures, in this tradition the man is included in the ritual. In rural Jamaica, folk tradition purports that miscarriages are often the result of "false bellies" (an unnatural condition mimicking pregnancy caused by an intruding ghost). A traditional healer can be consulted to perform a purifying ceremony, which may include colored candles, special oils, and banners to wave away evil spirits (Cecil 1996, p.53).

Traditional communities in China regard an infant who dies as a "ghost baby" – not a real child but the work of a disgruntled spirit. Mothers are instructed by elders not to mourn these losses (Fontanel and d'Harcourt 1998, p.183). In other areas of traditional China, infertile women may appeal to the goddess Guanyin, also known as the Goddess of Mercy, who is considered the bestower of children. She is often depicted holding a male child as a gift to

childless women (Elinor 2000, p.54). In Tibet and India, this same deity was originally called Avalokitesvara, and was male, not female.

Some cultures believe that the spirit of a lost pregnancy returns to the same mother in her next pregnancy and so is not truly lost. Similarly, to the Aborigines of Australia, when a woman miscarried it was a sure sign that a spirit child had mistakenly entered the wrong mother or that the young spirit of another animal, such as a kangaroo, had temporarily taken up residence in her womb. In the context of this understanding, a "miscarriage was nothing to be concerned about" (Sha 1990, p.65). One can see how these beliefs could have a psychologically protective function in societies with high rates of infant mortality, allowing parents to detach from the lost pregnancy or infant and to transfer their hopes to a future child.

In traditional Japan, grieving women wrote the name of a lost pregnancy or lost child on paper and set it on the river. It was believed to float to the mythical River of Souls, where the lost spirit would be watched over by Jizo, a deity regarded as a kind of guardian angel for children. Often portrayed as a simple beggar wearing a red woolen cap and sweater, Jizo is a benevolent and nurturing caretaker who tends to these lost children (Sha 1990, p.74). Stones are often placed on statues of Jizo to serve as "stepping stones when he guides the souls of children who have died young across the river between this world and the next" (Biedermann 1994, p.190).

In present-day Japan, Jizo ceremonies are still conducted in Buddhist temples, honoring the souls of those lost through miscarriage, abortion, stillbirth, or early infant death. Wendy Ponte writes of her first experience encountering this tradition near Tokyo, where she stood in a temple gazing at hundreds of Buddha statues:

> Ranging in size from around 4 to 12 inches, they lined walkways, went up steps, and edged paths. Some were adorned with beads and flowers or wore little hand-knit caps; others had bibs with cartoons and white, ruffled baby hats. They stood silently amid the rock arrangements and soft bamboo trees. Their sheer numbers were breathtaking. (Ponte 2002, p.54).

Although the Jizo ritual has existed for centuries, its practice has grown dramatically since the 1980s. Within Japanese tradition, little distinction is made between pregnancies lost to miscarriage and those lost to abortion. The Japanese appear to have avoided the abortion debate by viewing a pregnancy as "liquid life" with the potential to form a child, but not yet a baby. Kluger-Bell (1998, p.122) explains: "The life that exists during pregnancy, then, is a 'liquid life:' a life that is in the process of taking on its own distinctly human form but

that could just as easily revert to its former state of pure liquidity." In Japanese, this being is called a *mizuko* ("child of the waters").

The Jizo ritual acknowledges the need for both abortion and miscarriage to be resolved emotionally and spiritually. It allows the woman to offer an apology for whatever guilt she may be carrying about the loss of the pregnancy. The woman can make offerings, light a candle, or tie a red knitted bonnet or bib on a designated small stone statue. These rounded temple statues may remind one of a silent stone baby. Some families select a specific statue to attend to. The Buddhist view also holds open the possibility that the potential that this lost pregnancy held may return to the family in the form of another pregnancy.

This use of figurative statues in Japan and around the world – the way in which women are encouraged to care for them, dress them, and rub them with oil – provides an ingenious way to symbolically fill the empty arms of a mother who finds herself with no baby to hold. As Ascher (1992, p.63) notes, "Grieving is physical as well as spiritual. It is an inner journey, but its restlessness demands movement." Many families appreciate not only the connection that rituals provide to their community and a sense of the sacred but also the outlet to do something.

As I learn more about pregnancy-loss practices, I am intrigued by the ways in which traditional societies develop rituals and objects to express, contain, and redirect grief. These ceremonies offer a way to actively mark the frequently unseen but universal milestone of pregnancy loss. Artist Allie Alden sums it up in her observation: "Grief is easier to heal from with something to hold onto and look at and shed tears over" (Alden 2003).

What I find especially relevant about rituals, both modern and ancient, is that they almost always include a sensory component, something to see, to hear, to hold, to exchange. Ritual leaders, past and present, understand the power that visual imagery, song, movement, and storytelling bring to a sacred moment. Performance art, like ritual, may incorporate several of these modalities combined in innovative ways. Modern-day visual artists employ the tactile qualities of painting and sculpting, mirroring aspects of the ritual process. In response to pregnancy loss, artists draw upon both personal and universal symbols in order to give form to their formless grief, to purge their lingering guilt and anger, and to make meaning and reconnect with the world around them.

8

New Rituals

The Creative Response to Loss

Rites of passage

"Pregnancy is a rite of passage in our culture, and when you complete it, rituals of reincorporation bring you back into the world with a new identity," author Linda L. Layne explains in an interview in the *Boston Globe*. "With pregnancy loss, it's an incomplete rite of passage, and society solves it by trying to pretend that nothing ever happened" (Hartigan 2002, p.19). Thus, there are surprisingly few opportunities for meaningful rituals, even though approximately one in four pregnancies ends in miscarriage or a related loss. Artist Margaret Carver of Massachusetts gives us a sense of her utter disorientation and disconnection after her miscarriage: "invisibility, fragmentation, silenced or muffled expression and experience, grief unseen and uncounted, no time or space for this non-event to take place."

"Until recently in Western society, pregnancy was hidden as much as possible, acknowledged only upon the birth of a live child" (Sha 1990, p.63). In smaller, more traditional societies, pregnancy was more difficult to disguise and there was generally some way in which a miscarriage would be acknowledged. These responses to pregnancy loss were not always rooted in compassion for the woman, but at least it was not a hidden loss. "Fortunately, we live in a time when many people have begun to think about creating new rituals for previously unmarked and uncelebrated life-cycle changes" (Imber-Black and Roberts 1992, p. 283).

One of the challenges of grief associated with losses such as miscarriage, failed IVF, and ectopic pregnancy is that there is no body to mourn. These losses are often referred to as hidden or invisible losses. Malchiodi (1992, p.117)

reminds us: "the most well-known ritual involving death is the funeral where the bereaved are allowed a public forum to express grief." Yet a burial or a funeral is often not possible or appropriate in the case of pregnancy loss. Tammy Gross, an artist who endured an ectopic pregnancy, reflects on "the inability to find closure, the need to have a final resting place to visit, place flowers in honor of my baby... This type of closure is very important and unfortunately many who have experienced pregnancy loss do not have this."

Families are hungry for ways to commemorate and acknowledge their lost pregnancies and stillborn babies. Lieve van Stappen, an artist who explored the issue of pregnancy loss in her work, shares a new development in her native Belgium. Until recently, a child who did not live to be born or who died soon after birth did not officially exist and therefore was not entitled to documentation or a gravesite. In 1999, a new law was passed recognizing these children and giving their parents the right to place the name of the stillborn child in their "matrimony book." This book is the official document issued by the state when a couple marries; the children's names and dates of birth are written in it by an official. Van Stappen reports that some parents came to have the name of their stillborn child written in their matrimony book 35 years after he or she was born.

Grief counselors know that this lack of a body to mourn can lead to "delayed grief," a kind of emotional holding pattern in which we are waiting for tangible proof of the loss. For instance, after the devastation of the World Trade Center attacks on September 11, 2001, in which many of the lost were never recovered, the city of New York issued bereaved families special urns containing debris from the site. These ritual objects became profoundly important for the families who received them.

In a similar fashion, a woman who has carried a pregnancy may have a deep need to commemorate her loss physically. In response to this need, support groups in the USA have begun to integrate symbolic ceremonies into their format, and a growing number of progressive hospitals offer annual memorial services or ceremonies that are designed specifically for families grieving the loss of a pregnancy. These ceremonies often incorporate the arts into their programs. "In recent years, there is a growing movement to redefine the mission of the arts," writes Malchiodi, "transforming it from its position in Western culture as a commodity to a sacred and communal activity" (2002, p.196).

In Honolulu, Hawai'i, the Perinatal Bereavement Network organizes a service each year at which participants are invited to light a candle and place a poem or photograph in a communal scrapbook to honor and remember "a baby lost." St Francis Hospital in Hartford, Connecticut, offers interdenominational memorial services at which parents can mourn a pregnancy loss or an infant

death. The service includes a holiday tree decorated with ribbons bearing the family name of each pregnancy-related loss in the past year. Along the same lines, a recent conference of the International Stillbirth Alliance offered activity stations for bereaved families to "create memories" through journaling, scrapbooking, and memory kits.

Zucker (2005) supports this approach, pointing out that traumatic grief responds well to treatments that integrate movement, such as walking, expressive arts, and ritual. Author and art therapist Lucy Mueller White speaks of a resurgence in the use of ritual in modern society and how the arts can be an integral part of our healing: "In developing therapeutic rituals, the inclusion of the expressive arts into the ritual process adds the important function of engaging the client's creativity and individuality" (White 1992, p.43).

When creative rituals are encouraged, the arts allow us to make a contribution and then integrate a deeper understanding of our experience. These therapeutic rituals can be used in solitude, in a therapeutic relationship, with family members, or in a support group. Linda Gantt, an art therapist, reminds us of "the necessity of giving full voice and responsibility of the direction and content of the ritual to the chief mourners so that the elements of the process and the symbolic props are consonant with the survivors' needs" (Gantt 1991, p.15).

The authors of *A Silent Sorrow*, a comprehensive pregnancy-loss guide, see art and ritual as going hand-in-hand in creating an outlet for grief. Their suggestions for meaningful items to be placed in a memory basket include: "artwork created by family and friends in honor of the baby, such as drawings made by an older sibling or embroidery done by a loving grandmother" (Kohn and Moffitt 2000, p.228).

Some families create symbols and rituals such as planting a tree or a garden in memory of the loss. One miscarriage support group in New Jersey collaborated on a quilt and released balloons as part of a ceremony they designed in order to cope with their collective grief. Sister Jane Marie Lamb offers the idea of helium balloons to symbolize the release of grief and the return of a spirit to God (Lamb 1989). She also suggests the lighting and extinguishing of candles, representing the flame of life and the loss of that potential. Cardin (1999) also uses candles in her own rituals to help herself and her family move through the loss of her pregnancy. New liturgy is being developed by progressive clergy from a variety of religious backgrounds in order to provide solace and structure to bereaved families.

Today, many women, regardless of the tradition they were raised in, are drawn to spiritual practices based on honoring the goddess/mother earth. The underpinning of their beliefs and rituals may combine Native American, Wiccan

and other nature-based, non-hierarchical traditions. Drawing from these traditions, women come together to create rituals to mark spiritual passages.

In her book *Dancing Up the Moon*, Robin Heerens Lysne provides a glimpse of a modern-day ritual designed by a group to support a woman who had a miscarriage. This rite uses a doll as a means of making sense of pregnancy loss:

> Sheila spoke of her loss and of her sorrow. As she stated each feeling, the rest of us repeated Sheila's words back to her. It sounded a little like an echo, but it was very helpful for Sheila to hear her feelings affirmed. Then she spoke to a doll wrapped in a blanket, as though it were the lost child, and told it all her regrets and sorrow about the loss. As she cried and expressed her feelings, she began to affirm her desire for the future, too, when the child could come through her. Then each woman shared insights and feelings from her own experience, and the ritual was over. (Lysne (1995, p.157)

Kara Jones, who survived a stillbirth, employed the tradition of henna as one of her healing practices. Staining the skin with temporary henna tattoos has a long history. In using henna, Jones reclaims a ritualized form of art that provides a tangible image painted directly on the body. "The tradition of henna gives us a sense of time outside the present hideous moments of grief." She calls these tattoos "memorial henna pieces," and she now designs them for bereaved parents to honor a lost child.

The role of ritual

What is the role of ritual? Rituals provide a focal point of awareness that we are moving through an obstacle, transitioning to a new sense of self, or letting go of something lost. Without such focal points, we can feel unbalanced, without a clear vision of where we are on our life path. Lysne (1995, p.6) explains: "When we create a meaningful sacred event, assisting ourselves through a transitional phase, it is a self-loving action. We companion ourselves. We listen to our hearts and act on what is called for." Rituals allow us to move from the personal to the transpersonal – to create connections with ourselves, each other, and our experience of the sacred.

Objects used in one's own creative rituals need not be considered religious or exotic – simple symbols, photographs, and objects that hold personal significance can add meaning to the experience. Ben Ford, who lived through the stillbirth of his son Thomas, knew it was crucial to face his grief, not cover it over. Interviewed in the *Washington Post*, he explained his healing process: "I created rituals to make myself deal with the loss. Literally every night before I went to bed I would smell Thomas's hospital gown and look at his memory

book. I made myself look at his picture and I kept a journal for a year – now his birth and death have become a comfortable part of my life. I can think about him, talk about him" (Phalen 2000, p.15).

Another family, interviewed in the same story, created a special site in their yard to remember the three-and-a-half-week-old baby they lost. Each member of the family selected a rock and placed it at the base of a tree. At night, baby Anne Marie's brothers mention her in their prayers. Anne Marie's mother, B.J. Perkins shares: "I feel if I put her memory in a box and sealed it up there's no healing – I like feeling her presence with us" (p.14).

Commemorating a loss by creating a shrine or altar is a custom found in many traditional cultures around the world. Malchiodi (2002, p.159) explains how the intentional arrangement of objects creates a special place for reflection and healing and how simple it is to develop one's own shrine: "Anything displayed or arranged with reverence or evoking mystery can become a shrine. Shrine-making is a form of art-making that reflects the human urge to assemble and arrange things in meaningful ways." Candles or flowers can add to a home altar, particularly on special days or anniversaries. Poems or small pieces of art can also be included.

Sari Koppens, a Dutch art therapist, found the use of creative rituals to be essential to her own healing process from multiple miscarriages:

> When I suffered my first loss, my partner and I did a symbolic funeral. There was nothing to bury...so I did something else. I made a small pouch of leather in which I put some things to remember my baby. I made a small drawing of the embryo, I wrote a letter, which basically said "I love you – your mommy," I put a precious stone in it that I had worn around my neck when I was pregnant, and I put a toy in it: a little teddy bear. Also, I added some flower seeds in the hope that they might bloom one day. This we buried in a beautiful place in the forest, where friends of ours live. It's a safe and friendly place and I felt like we could make a new start again.

This loss was only the first of eight that Sari would endure. Over time, she created many small rituals in order to remember her lost pregnancies. She planted flowering bushes, she burned a candle for a child on its due date or the date of the loss, she glued a glow-in-the-dark star on the ceiling of her bedroom for each baby she lost. She wrote poems and letters to her babies. She prayed.

After her eighth miscarriage, Sari began to see a counselor who specialized in helping women recover from such losses. During one session, Sari was introduced to a technique called "visualizing:" the therapist told an open story and invited Sari to fill in the blanks in her own way. "It helped me to get in touch

Figure 8.1: Found My Stars, watercolor, Sari Koppens

with my hurt feelings and I started to make paintings of fairy-tale-like images which came right out of my heart" (Figure 8.1).

For Kara Jones, simple acts reflect not only the sacred but also the sense that she is still a mother to her lost child. With little tender rituals, she continues to parent and maintain a connection to him. In her newsletter *A Different Kind of Parenting*, she writes:

> Maybe I write him a letter for his baby book. Or I send an email to another bereaved parent to let them know that what they are experiencing is normal. Maybe I buy a little Eyore toy and put it on an *ofrenda* for him during Day of the Dead. Maybe I clean off the shelf we have in our house for him and add new photos or cool rocks I've found by the ocean. Maybe I make donations in his name. Maybe I try extra hard to do a small kindness for someone rather than just bustle off to my next appointment…

In their stories, many families mention using meaningful pieces of nature, such as rocks and shells, and planting gardens or trees to commemorate their losses. Going to a natural setting that nurtures you, such as a wood, beach, or riverside, can be refreshing and healing. Creating rituals in these settings can add a deeper connection to nature and to spirit; at the very least, they may serve to ground us and give perspective to our loss.

Gabrielle Strong, an artist living in Pittsburgh, shares her experience of combining art and ritual in a wooded setting during a class she was taking at the time:

We each created some type of environmental reflection of an idea, mood… Without knowing it until I explained the piece for the group, I had created a nut and leaf memorial to the life I had just let pass. I had very recently had a menstrual extraction. It was the most positive of all my abortion experiences and I think in creating this outdoor shrine I was healing all past circumstances surrounding the abortions.

Figure 8.2: Womb of Its Own Accord, environmental installation, Gabrielle Strong

Strong later went on to create other environmental installations related to pregnancy loss, such as her piece *Womb of its Own Accord* (Figure 8.2).

How do we go about the process of creating a ritual? Kluger-Bell (1998) outlines three elements of ritual for early reproductive losses that seem to meet most family's needs: "These elements are expressing the hopes and dreams held for the baby who was lost, making an offering of some kind in honor of the lost being, and doing something which signifies one's readiness to let go of him or her." Rituals that symbolize one's readiness to let go might include dropping a note in water, burying mementos, or burning medical records. "All can serve as ways of both caring for and releasing the being who is gone." This paradox of letting go and holding on simultaneously is part of the process that bereaved parents encounter in their journey towards comfort and hope.

Many rituals developed by traditional societies utilize the four elements, earth, air, fire, and water. Gantt (1991, p.16) points out that fire and its opposite, water, are often connected with the idea of transition. Traditional rituals may also incorporate the directions, the seasons, or a wheel symbolizing the circle of

life. When teaching women to create personal rituals, Lysne instructs that every ritual is based on nature. Rituals in the Judeo-Christian tradition also include natural elements, but often they are so familiar to us that we forget their original connection to nature. Sabbath candles welcome fire, wine and bread represent fruit and grain from the earth, and baptism submerges in water.

Lita Lundeen, a performance artist who lost her six-year-old son Diego in a car accident, sought the cleansing power of fire to help her heal. As part of her recovery, she moved to the Big Island of Hawai'i and studied the art of fire spinning. When she returned to Massachusetts, she wove these fire rituals into an outdoor performance piece titled *Ashes and Sparks: A Ritual of Remembrance*. The performance included dance, drumming, giant puppets and, of course, dramatic fire dances.

Most of us will not follow such an exotic path in our search for healing. However, whether you create your rituals online, in your studio, in a therapist's office, or with a support group, you are tapping into a universal and natural form of human expression. Often, today's society promotes an unobtrusive demure response to our saddest milestones and challenges. But by forfeiting our innate ability to engage in creative rituals, we risk losing an essential tool for making meaning in our lives. As Robinson (1980, p.35) writes in a discussion of artistic rituals, we have "given up our right to dance, to sing, to build, play and celebrate together, as well as our need to mourn and grieve, to rage and shout incantations of our misfortunes and loss." Yet each of us can use simple rituals to see our lives more clearly, restore a sense of balance and well-being, and welcome the transformative power of creative expression.

Cyber-rituals

In this age of virtual communication, many turn to the Internet to share our secrets and relieve grief. The *Boston Globe* reported on the role of the Internet in providing the emotional support that survivors of miscarriage often find lacking in their personal lives (Hartigan 2002). The Internet has become a major source of connection and self-expression for pregnancy-loss survivors. This tool combines cutting-edge technology with the ancient human imperative to connect.

Online chat rooms, listserves, and bulletin boards are sponsored by national and international organizations such as SHARE (www.nationalshareoffice.com) for miscarriage and the International Council on Infertility Information Dissemination (INCIID, www.inciid.org) for infertility. These sites are not for the occasional computer geek – INCIID, for instance, receives more than 20,000 visitors a day. These virtual communities are filled with heartbreaking

messages and loving responses from women who, in Hartigan's words, are "desperately seeking comfort in the keystrokes of strangers." She goes on to describe how the Internet "provides an alternative universe, a place where you can be that grieving character who rants and raves or who simply asks for a little TLC. It's a place where, at long last, the silence has been broken, where, for once, you don't feel so terribly alone" (Hartigan 2002, p.11).

Smaller websites, of a more homegrown variety, are also sprouting up. One such site called Our Tiny Stars in Heaven (http://home.hetnet.nl/~sterretjes/frameUS.html) is based in the Netherlands. Hosted by art therapist Sari Koppens, this site shares the rituals she developed in order to cope with her multiple miscarriages. She offers visitors to the site an opportunity to place a twinkling star in a virtual heaven to commemorate their own losses. Many sites hosted by individuals or small regional organizations offer space for visitors to make entries in online memory books.

In my research, I also found a veritable cottage industry on the Internet offering consolation to grieving families. You can purchase prints depicting Jesus holding a lost baby in his arms as a desolate mother pines over an empty crib. You can buy customized memorabilia, such as hearts and angel pendants, imprinted with a name or date. One website offers for sale a "baby memory box," a special place in which to save mementos related to a lost pregnancy or neonatal loss.

Through this electronic web that loosely binds us, women are creating new kinds of rites of passage and expressions of their loss within a cyber-community. In her article on Internet support for miscarriage, Hartigan (2002, p.11) relates how the kindness of a woman, a stranger from another part of the country, helped her through a particularly difficult night: The woman "has made a string of wooden stars to hang on her Christmas tree, and she has asked the other women to send her the names of their children or the dates of the loss; she promises to paint those names or dates on the stars and hang them on her tree." This long-distance connection somehow provided the comfort that eluded her in her everyday life.

Tefilat Chana (www.tefilatchana.com), a website dedicated to Jewish women struggling with infertility or pregnancy loss, explains the appeal of the Internet: "You are not part of a specific town, city or country. You are part of a community that understands your pain. Here, you may speak freely without identifying yourself. You may express yourself to others who offer support. Your prayer may be silent, but you are not alone."

How to Create Your Own Ritual

Regardless of your spiritual beliefs or religious affiliations, you can develop a ritual that suits you. You may choose to design a ritual that can be integrated into your religious tradition or a rite that expresses your own unique and personal relationship with the divine. These suggestions can help you unfold your own process to commemorate the life-altering passage of pregnancy loss:

- Clarify your intention for this ritual. What is the milestone you want to honor or transition through? What effect do you hope the ritual will have?

- Decide who should be present at your ritual and what their roles will be. You may ask participants to silently witness, reflect back your experience, or contribute words and symbols of their own.

- Create a sacred space. You can do this, for instance, by forming a circle, saying a prayer, lighting a candle, or observing a moment of silence.

- Design a beginning, middle, and end for your ritual. How will you open and close the ritual?

- What elements support the intention of this ritual? Will you include elements of nature: fire, air, water, earth? What objects and actions evoke these elements?

- Bring your personal symbols. Consider creating a simple altar as a focal point. You can also create artwork to enhance your ritual.

- Tell your story. This may be a simple narration, or it may involve a poem, song, dance, or other forms of creative expression.

- Consider including an act of release or closure that helps with transitioning or letting go, while still honoring and remembering.

- Consider documenting the ritual through photography or videography.

9

Creating Your Own Healing Practice Through the Arts

Getting started with art-making

You will find gentle and supportive activities including making art, writing, and creating rituals. These creative exercises are designed to help you open the door to non-verbal expression and healing. You need no special ability or training in the arts in order to engage in these activities. These ideas can be used equally well by both individuals and by groups. They need not be done in any specific order – give yourself permission to develop a process that mirrors and heals your own experience of loss.

Having facilitated creativity groups for almost 20 years, I have learned that everyone has the power to retrieve their real feelings and true voice through writing and art-making. I have also learned that almost everyone has a critical internal voice that can block these creative efforts. In my workshops, I encourage participants to identify the "inner critics" that may be sabotaging their natural urge to express themselves.

Typically, inner critics are wily and shape-shifting – just when you catch hold of one, it pops up somewhere else. An internal critic may also masquerade as a helper or a protector ("don't make a painting, you'll only embarrass yourself"). Often it resembles the voice of a teacher or parent; however, if it stands in the way of authentic self-expression, it is not likely to be of any real help. It is rarely possible to eradicate internal critics, but we can learn to dance with them in a new way. By gently observing your own critical internal voices, over time you can begin to shift your relationship to these barriers to creative freedom. "It is also important in releasing the inner critic to realize that healing art is not about success, aesthetics, or making art that another person likes. It is about healing" (Samuels and Rockwood Lane 1998, p.160).

Trusting the process and working spontaneously and without judgment are the key to finding your own creative voice. Leave behind doubts about artistic ability, training, or familiarity with the materials, and give yourself permission to dive in. Your hands and heart will tell you where to go next. In return, the creative process will buoy you and allow you to travel to new, perhaps unexpected places.

Finding time and space for your creative practice may be the most challenging aspect of all. Often, people hear from their inner critic on this issue – it encourages them to prioritize everything and anything before creativity. If you can locate a small area of your home where you can leave out your supplies for easy access, it can make the transition into making artwork much easier. Turn off the television, ignore the phone, and carve out a nurturing and safe world where you can come home to yourself. Large chunks of time are not necessary – even just 20 minutes can be enough to engage in the process.

Timing is important in another way too. This is a process that cannot be rushed, controlled, or second-guessed. Trusting the creative process means allowing it to unfold in its own time. Most people who suffer loss or trauma are not ready to dive into the creative process immediately. In the initial stage of shock and denial, one has not had the opportunity to adequately digest the news that life has changed dramatically. The healing process may also take longer than initially imagined. When you are ready to use creative media to begin to make sense of the loss, it is wise to remember not to overdo it. Generally, our own creative intelligence helps us pace ourselves so that we do not feel flooded or overwhelmed. Often, our poems, paintings, and songs convey layers of metaphor and meaning, revealing themselves only when we are ready to see them.

It is crucial not to judge your personal expressions. When a piece feels complete, take a step back from your artwork and look at it without preconceived ideas. What do you see? What does it say to you? What mood does it convey? Is there anything about it that surprises you? Is there something you would like to change or add? If you like, you can write in your journal about your art-making experience.

Your everyday rational mind may not always understand what your creative source offers you. Your imagery may appear mysterious or hard to interpret. Remember that it is not necessary to immediately comprehend what your artwork is about for it to be healing. Perhaps this is what visionary writer Kahlil Gibran meant when he wrote "Inspiration will always sing; inspiration will never explain…" Like dreams, our artwork speaks to us in another language, reflecting not only our mundane experiences but also stories mined from a deep and sacred place.

Creation, destruction, and re-creation are all part of the art-making process. For instance, sometimes a painting that initially feels like a failed effort gets a second chance when it is torn up to create an unexpected collage. When I had a terrifying automobile accident several years ago, I knew I had to make something out of the shattered pieces of my car. Too traumatized to return to the scene myself, I sent a friend to collect shards of reflective plastic from my tail light. I incorporated a few of the pieces into a mosaic I created.

Why did it feel so important to make artwork out of something so bad? I just knew I had to transform that experience in a palpable way. Artist Klaus Boegel describes these acts of doing and undoing this way: "In the creative process old structures are broken open in such a way that something new may be created. In this process healing may take place." (1991, p.14). It is the same impulse that a woman has when she uses the wrapping paper from her baby shower – remainders of a hopeful time, now tinged with sorrow – or small items retrieved from the hospital to create a collage, a new image reflecting where she is now in her recovery process.

The creative process allows us to touch something greater than ourselves. Many people believe that our creative acts channel a life force that is universal and sacred. "Artistic expression is far more than self-expression and has much more astonishing power," explains Malchiodi (2002, p.x) "Artistic creativity offers a source of inner wisdom that can provide guidance, soothe emotional pain, and revitalize your being." Whether you experience this inner wisdom as the voice of your authentic creative self or a divine energy, it is a welcome guide on the path to healing.

Writing for healing

Julia Cameron, well-known for her books on creativity, sees writing and other forms of expression as essential tools for tapping our connection to the divine. "We should write because humans are spiritual beings and writing is a powerful form of prayer and meditation, connecting us both to our own insights and a higher and deeper level of inner guidance as well" (Cameron 1998, p.xvi). Some people might liken this energy to a wiser self that is given voice when we put pen to paper.

To tap into this voice, you must learn to get out of your own way. When writing for personal growth, avoid editing while you are writing and forget about things like proper grammar and spelling. Tell your inner critic – whether it sounds like a critical parent, an overenthusiastic coach, or your second-grade teacher – to take a break. Like art therapy, the focus in writing for healing is not on the product but on the process.

Judith van Praag shares how she trusted her own creative process to carry her through the shattering stillbirth of her daughter. Among other modalities, she turned to writing:

> Writing about loss is good therapy. You can buy a notebook for a buck, a fancy journal, or use your calendar. Write at the spur of the moment, on the doily of a pastry you just ate, on a brown paper bag, on a coaster. Start with a doodle, start with the name of your lost love, or just words that come up in your mind. Write the syllables stuck in your throat, write the words weighing on your shoulders, write the same thing over and over. (Van Praag, 1999, p.72)

Several of the activities in this book suggest using poetry to explore your experience. The term "poetry" is used loosely, leaving room for you to make it whatever it needs to be. VanMeenen and Rossiter (2002, p.48) remind us that when writing for healing, "you don't need to be a poet. You don't even need to frame your writing in the shape of a poem. Write paragraphs or lists if that feels good to you." Including specific sensory details, such as images, sounds, or smells, can help you convey your feelings and memories.

Often, beginning with a simple prompt or directive can jumpstart the writing process. In my writing groups, we often use objects such as seashells, old picture postcards, and bottles of spices or fragrances to awaken the senses and spark a memory or visceral response. Beginning with a question or incomplete phrase can stimulate the urge to write. These prompts do not need to be related directly to your grief – once you begin writing, your creative process will take you where you need to go. Here are a few examples of writing prompts:

> The first person I saw this morning...
> These things I have loved...
> Write about "interruptions"...
> I never thought I would...

The idea is to let the prompt take you on a trip without knowing where you will end up. Natalie Goldberg's (1986) classic, *Writing Down the Bones*, is full of wise and wonderful writing directives and hints on writing spontaneously and authentically.

Tools for creative healing

To work with the creative activities in this book, you need some very simple tools: a journal for writing (I prefer a journal without lines so I can draw too) and a few basic art supplies. You can use the art materials you have around the house or you can go to an art or craft store and buy a box of inexpensive oil pastels and

a pad of decent paper. I think of oil pastels as crayons for grown-ups, but richer and more expressive with their vivid colors and ability to blend. If you prefer a finer point and a more controlled medium, you may choose colored pencils. I like colored pencils that can be used with water, offering the flexibility of pencil and paint together.

Along with your journal, you may want to purchase larger paper for artwork that feels more expansive. Try paper that is 11" × 14" and make sure it is not so thin that it will fall apart or tear. The thickness of paper is designated by pounds – I recommend paper that is at least 50lbs. You may also find a pad of student-grade watercolor paper that handles wet media nicely.

For making collages, you will need scissors, a glue stick, and paper or cardboard that is a bit stiffer than usual so it won't curl or bend. For gluing objects, white glue works well, as does a glue gun if you have one. I like to collect images torn from magazines, catalogs, and anything else that catches my eye. Set aside a box or basket to collect these images, along with findings like buttons, lace, and beads.

As you become more familiar with your own creative urges, you may decide to add additional materials to this list. If you want to express yourself with paint, I recommend watercolors or tempera paint. A basic box of semi-moist watercolors is fine, or you can splurge on a set of watercolors in tubes. Either way, you don't need to know any painting techniques to play with them. Tempera paints, also called poster paints, are more opaque than watercolors; they allow you to build up layers of color and cover over images if you choose. Tempera paints are inexpensive, go a long way, and clean up easily with water. In my groups, I lay the colors out in ice-cube trays for easy access and wrap the trays in a plastic bag for next time.

If you wish to paint on something like a box or a piece of wood, I recommend acrylic paint. Traditional tubes of acrylic are expensive, but most craft stores now offer sets of cheaper paints in smaller containers. Another option is to use leftover latex paint that you used to paint the interior or exterior of your home.

The bottom line is to use whatever materials or methods feel right. Creative solutions often happen when the artist runs out of the usual materials and grabs something unexpected instead. If the exercise recommends writing a poem and you feel inspired to sing a song or make a collage instead, trust your own process. Some readers may feel inspired to knit, quilt, or weave. These are wonderful materials with which to address pregnancy loss.

Simple warm-up activities like scribbling with your eyes closed or dipping a string in ink and dragging it on the paper can provide enough playfulness to begin a free-flowing process that bypasses your intellect and your inner critic.

Sometimes, my most powerful art experiences arise when least expected, when I am relaxed and have no particular intentions or expectations.

Rosanne Cecil writes: "The feelings concerning simultaneous birth and death, the death of one who never was, may be virtually impossible to convey" (1996, p.2). Through the arts, we may be able to do the impossible: to capture and portray an experience that is otherwise invisible.

Suggested art materials for creative expression

- Journal with unlined paper
- Box of oil pastels (student grade)
- Colored pencils (or watercolor pencils)
- Box of watercolor paints (student grade)
- Tempera paints in a range of colors plus white (optional)
- A few soft brushes of various thickness
- Drawing pad, 11" × 14" (at least 50lbs weight) or student-grade watercolor pad
- Glue stick for collage; white glue for objects
- Scissors
- Poster board or cardboard for collage
- Basket of found images (magazine photos and other imagery)
- Basket of findings (buttons, ribbons, pebbles, shells)

10

Creative Activities

Creative activities to do any time

Journaling

There are many myths about journaling: you have to write everyday, you must be a good writer, you should always write at a certain time of day. Most people find that these rules don't work for them and have better luck developing their own journaling rhythm. The most important myth to debunk is the one about writing ability. If you can think and talk, then you can write. The secret is to trust the process and put pen to paper without judgment.

If you are a computer-lover, you may prefer the keyboard to the pen, but I encourage trying the old-fashioned blank book. There is something lovely about the object-hood of a journal, being able to hold it, doodle in its margins, and flip through its pages. If you are more of a visual person, you might try keeping a journal that focuses more on imagery than on writing or combines the two.

Write at any time you want to check in with yourself, express your feelings, recall a meaningful moment, capture a dream, or simply record your healing process. You can write spontaneously or use writing prompts found in this book or other books on journaling. Often, it's helpful to start from exactly where you are in that moment: "Not sure what to write – feeling a bit lethargic and clouded. Need to do laundry today…" Trust me: if you keep writing without stopping to edit or think too much, you will find yourself in a zone where the words simply come without effort. Be sure to date each journal entry, even if it's just a few sentences.

Mandalas

Making mandalas is an excellent exercise whenever you are not sure what else to do or you are in need of a relaxing, calming activity (see pp.99–100 for

more). Fincher (1991, p.32) reminds us: "drawing mandalas can serve as a centering device to bring clarity out of confusion." Psychologist C.G. Jung, who was instrumental in reintroducing mandalas to Westerners, made a mandala everyday for a period of time. You might try this, creating a daily mandala and noting how each one has its own form and energy.

Although you can employ almost any medium to create a mandala, pastels, watercolors, and colored pencils are the most readily available and the simplest to use. Some people like to use pastels on black paper, as the colors appear luminous against the dark background. It can be helpful to cut the paper you choose into a square and then draw or trace a circle in the center.

Without planning or thinking too much, trust your spontaneous impulses concerning where to begin and which colors feel right. Allow the forms and patterns to emerge without judgment, knowing that each mandala takes on a life of its own and becomes a reflection of where you are in this moment. Sometimes it feels right to begin in the center; other times you may feel inspired to divide your mandala into sections. Your imagery can be completely abstract or may incorporate recognizable images. Play within the circle until you feel a sense of completion. Take a moment to regard the image and drink it in. Put the date on the back. You may also want to write down whatever feelings or thoughts you associate with your mandala.

Creative activities to address specific issues

Harbored hopes

Our response to a lost pregnancy is wedded to our individual understanding of when and how life begins. The creative expressions that emerge following a reproductive loss provide a tour through the hearts of the artists who made them. Each brings to his or her work a unique understanding of what befell that particular pregnancy physically, emotionally, and spiritually. To begin to understand how a woman and her family imagine her pregnancy, and the hopes they harbored for the future, is to begin to understand the nature of the loss.

Each of us has particular ideas and images of what we believe is created and what is lost when a pregnancy ends.

ART: A HIDDEN EXPERIENCE

This activity provides an opportunity to explore your personal experience and understanding of pregnancy. If you are working with infertility and have never been pregnant, you can adapt this exercise to fit your own experience. If you have a partner, doing this exercise together may help you to understand each other's experience of the loss and accept that your beliefs may differ.

With paper and pastels, begin to explore how you envisioned your pregnancy or pregnancy in general. Intuitively choose a color to get started. You can simply begin with a doodle and allow the drawing to develop as you go along. Feel free to make more than one drawing. Remember to date and, if inspired, title each sketch.

- What do you see?

- Does anything about the drawing surprise you?

- How did you envision your pregnancy?

- Does this exercise connect you to any specific feelings?

- What did you lose?

WRITING: WHAT WAS LOST

Begin a poem or journal entry with the phrase "What I lost…" You may choose to repeat the phrase in your writing. Write spontaneously, without censoring or judging.

WRITING: JOURNALING ON YOUR CONNECTION TO SPIRITUALITY

It is not unusual for a traumatic loss to challenge your faith. Neimeyer (1998), in his work on meaning reconstruction in the face of loss, has developed some powerful questions to help you in your journaling on this topic:

- "What philosophical/spiritual beliefs contribute to how you live with this loss?"

- "What lessons about life and/or loving has this loss taught you?"

A physical loss: body grief

After three months
Of silent stitching…
What finger let slip
What growing row of cells
Unravelled, loosing life and
Leaving the lap empty?

Olson Binder (1993, p.168)

Perhaps what is most difficult to convey about miscarriage is the visceral experience itself. Unlike other losses, pregnancy loss is literally experienced within the body. It is first and foremost a physical wrenching that can be painful,

frightening, and traumatic. Often there is a copious amount of blood, for which the woman may be totally unprepared, and an overwhelming sense of helplessness – like Humpty Dumpty, it can't be put back together again.

Some women receive the news of the demise of their pregnancy during a routine ultrasound. They leave the session in shock. A woman diagnosed with an ectopic pregnancy may suddenly face emergency surgery to save her life. This is the stuff of nightmares, seared into our sensory memory – no wonder we have such difficulty describing our experiences and our loved ones have difficulty locating the right words to comfort us. After the loss of a pregnancy or a failed IVF procedure, a woman may feel that her body has betrayed her or that she is somehow defective. She may feel physically wounded or scarred.

What surprises many people who encounter any kind of loss is the physicality of grief, often experienced as pain or heaviness in the region of the heart and chest. Women who have lost a baby describe a sensation of numbness or pain in their arms. In the novel *The Wholeness of a Broken Heart*, the character Channa loses a pregnancy that she has already named. She remembers how she "ached and felt lost from the rest of my body when I couldn't hold my baby Vitl" (Singer 1999, p.89).

Women may also experience what might be thought of as an imagined memory of the baby they carried. A fragment from a poem by Gennet Emery captures the sense of already knowing this baby, through sensations woven by "heart and mind." She feels her loss all the more deeply because her imagined memories of having touched and held her infant in her arms are so visceral: "As real as if my arms had felt your weight / and sensed your body's warmth / close pressed to mine" (Emery 1997, p.23).

In the following excerpt from a poem by Maya Charlton, we hear the truth her body expresses. Maya, my colleague, sent this to me shortly after she moved to England with her husband and her young son. She had just endured a second miscarriage:

Moon Knows

Body
knows, weather
knows, dreams
know, moon
knows

Body lives it
weather reflects it
dreams tell it

and moon humbles herself,
reaches in
and reveals it.

Words alone may not be adequate to express and soothe the loss experienced on a primal level. In art therapy groups for pregnancy loss, Ellen Speert observed that pounding and forming clay offered some relief to the ache that women experienced in their bodies. One artist, in a compassionate response to a friend's relentless feelings of empty arms, created a weighted doll for her: "Until her body was ready to put down that lost baby, it gave her something to hold on to" (Alden 2003).

Pregnancy loss is a physical loss, and you may experience your grief as physical sensations. Massage and other forms of bodywork may be particularly helpful following your loss. Making images, expressing the self through movement and voice, and enacting rituals all channel our energies and move feelings up and out of the body. Engaging the body and nurturing it can be an important part of the healing process.

GUIDED IMAGERY: COMING HOME TO THE BODY

Read these directions slowly, with plenty of pauses to allow you to check in with your sensations. If you like, you can record yourself reading these instructions aloud or invite a friend to read them to you so that you can relax into the guided experience:

Begin by positioning yourself comfortably, allowing your body to be supported by whatever you are sitting on. Close your eyes and take in a long, slow breath through your nose and release it slowly through your mouth. This first breath may feel constricted or ragged. On the next breath, allow your belly to drink in the nurturing air, pause briefly, and then slowly release the breath. For the third breath, follow the same instructions, this time allowing your body to relax more deeply as you exhale. Sometimes it feels good to allow an audible sigh to accompany your exhale.

Now, breathing normally, turn your attention to areas that feel tight or uncomfortable or that draw your awareness in some way. Gently explore those parts of your body that you are drawn to – what sensations do you feel in each area: tightness, numbness, tingling, heaviness, spaciousness? Are there particular colors, images, or sounds associated with this area?

You may want to do a simple inventory of your body. Beginning with your head, survey where you feel tight or clenched. Check in with your forehead, eyes, jaw, and back of the skull, and then move your awareness to the inside of your head and any sensations you have there.

Move down to your neck and shoulders, just noting any feelings you discover here. Now focus gently on your chest, breathing naturally, and move your awareness to the area around your heart. Allow yourself to become aware of sensations or feelings in this area. Move your attention down your arms and into the hands, noting any sensations along the way.

Now turn your awareness to the abdomen and to the belly. What do you feel here? And move your attention down to your pelvis, to your pelvic floor, and allow yourself to be aware of any sensations here. Now bring your awareness to your lower back, down the length of the tail bone. And now moving into your legs, feeling sensations you find along the way, down to your feet and toes.

Having done this gentle inventory, take a slow, deep breath and invite the cleansing, nurturing energy of this breath into the places that feel uncomfortable in your body. And, if you like, you may take in another breath directed towards these areas of discomfort, inviting them to soften, unfurl, or melt into relaxation. And finally, allow yourself a moment to just inhabit this body of yours, to feel your breath filling it – to simply be in your body.

And, when you are ready, return to the room by slowly and gently opening your eyes.

Following this guided experience, you may want to briefly journal about your inner journey or draw any imagery that arose for you during this tour of your body.

MOVEMENT: LETTING THE BODY SPEAK

Approaches, old and new, such as t'ai chi, yoga, body–mind centering, and authentic movement provide ways to move energy through the body and to listen to the body. There are also simple, spontaneous ways to tap into the body's story. Try these activities with a spirit of openness and non-judgment:

1. Lie on the floor. Sprawl, roll, breathe, stretch. Feel the ground supporting you.

2. Stand in bare feet. Gently begin to sway your hips or move your arms. Where do these movements take you? Follow whatever impulses emerge, repeating movements and exaggerating them. Do sounds or words accompany these motions?

3. Put on music that moves you, helps you cry, or soothes you. Don't let it be in the background – really attend to the sounds, allowing the music to inspire emotions and movements.

After each activity, ask yourself the following questions:

- What sensations and emotions arise when you allow yourself to move?

- Did your movements begin to tell a story?

- Did your body feel different after your movement experience?

ART: FEELING AND HEALING (TWO DRAWINGS)

First, draw a simple body outline on your paper – it does not need to be realistic or anatomically correct. This figure can represent you. With pastels or watercolors, use lines, shapes, and colors to fill in areas of your body where you experience numbness, discomfort, pain, or other sensations, especially those that may be related to your pregnancy loss.

On a second piece of paper, draw another body outline. Visualize or imagine a metaphor that is comforting to you, such as cool, flowing water, a warm quilt, or a sense of being held by loving arms. Now fill your second figure with colors and images that speak to you of comfort.

An alternative exercise, developed by art therapist Ellen Speert, uses torn colored paper. Tear a shape representing yourself from a color that feels right. Next, choose a color to represent your loss and tear it into an appropriate shape. Glue the forms on a piece of heavy paper, placing them where they belong in relation to one another. Finally, draw with oil pastels "what is needed to bring comfort, wholeness, or peace to the torn-paper images" (Speert 1992, p.127).

- In what ways was this exercise comforting or discomforting for you?

- If you developed a comforting image or metaphor, could you visualize it when you want to soothe yourself?

WRITING: LISTENING TO THE BODY

If your body could speak, what would it tell you? Begin a poem giving voice to different parts of your body. You can use phrases such as:

> I am your arms...
> I am your belly...
> I am your heart...

RITUAL: NURTURING YOUR BODY

Elements of a healing ritual can include taking a bath with special fragrance or candles, having a massage, or going for a walk in the woods. Inviting a group of

important women in your life to help you create the ritual can be very healing. Select one or two participants to help lead the ritual, so that you can relax and soak in the experience. A group ritual might include taking a hot tub together or having each woman offer you a hand or foot massage. You can invite participants to bring a flower and, one by one, place the flowers in a vase while offering a healing wish. All of these examples are designed to invite the body, not just the mind, to be present.

Empty arms: the ache of the irreplaceable

Rabbi Nina Cardin, who suffered a pregnancy loss, writes: "Feelings of loss and emptiness are our most constant companions. They go with us wherever we go; color the air around us…" (Cardin 1999). When a pregnancy ends, the normal outcome ensures the mother receives a baby. When the process is interrupted, the mother is left with empty arms, and the parents long not for a generic baby but for the very special baby they lost. It is this longing that is often so difficult to articulate to others. As Dan Barry of the *New York Times* explains, "The phrases we rely on to make sense of grief have always failed to convey the ache of the irreplaceable" (Barry 2003, p.141).

Often, we come away from a pregnancy loss with more questions than answers. Even when clear facts are provided about the loss, it does not always feel like enough to help us make sense of the loss. Andrea from Minnesota wrote to me in response to the Secret Club Project. She said: "It took me about five years to be able to find out what the pregnancy had meant to me and why it was so emotionally devastating to lose such an early and non-viable pregnancy. Although we had a very good outcome in terms of the other two pregnancies that I did carry, the one I lost in 1986 stays with me now and I suspect forever."

Bereaved parents derive scant comfort from the ubiquitous phrase that follows them: "You can have another." Instead, they long to express their unique love for the specific child they lost. "She was not no one. / She had a given name, / a drawer of knitted things, / a crib under the window / where the sun could look" (Petrie 1984, p.172).

Fabric artist and aspiring midwife Allie Alden found a unique way to fill her empty arms following her miscarriage: she created what she calls a "grieving bag." Here, in an excerpt from her website, she describes her creative process following her pregnancy loss:

> I used my art to heal my grief. I made a mourning quilt to hang on my wall. It wasn't enough. I needed a baby to hold. I made a tiny fabric fetus at the developmental stage mine had been lost. I dyed fabric to look like a placenta and quilted the baby onto it. I dyed more fabric to look like a uterus, and made a bag from it and tied it at the top with a blue thread

blotched with red to symbolize the umbilical cord. Inside the bag I placed healing herbs including sage and cedar, which would smell soothing and comforting. (Alden 2003)

Alden describes how she wore the "baby" inside her bra, against the place where it would have been nurtured and nourished. Her use of fabric makes sense, as it offers a kind of softness and flexibility not so far removed from our own bodies. Inside the baby's fabric bag, she placed objects with special meaning to her. It was not just the wearing and touching of this baby that soothed her – the healing was also in the making of it. She writes: "With every passing of the needle the pain of loss bit and began to ease".

ART: A HEALING OBJECT

Create your own small grieving pillow using fabric, yarn, embroidery thread, buttons, beads – anything you find around your house or at the craft store is fair game. One simple method is to cut out two pieces of cloth or felt into the same shape and sew the edges together, leaving an opening for stuffing. Turn the whole thing inside out if you don't want the seams to show, then fill with stuffing, fragrant herbs, sand, or rice. After your form is stuffed, you can add a prayer or poem inside before you hand stitch it completely closed. If it feels right, create a container or bag to hold your talisman.

If you know how to knit, sew, weave, or crochet, you may consider creating a small quilt, tapestry, or blanket that not only memorializes your loss but also provides a physical warmth and softness. Or perhaps you can commission a friend or relative to make something that you design together.

ART: HEALING MANDALA

If you could picture a sense of healing, what would it look and feel like? Using oil pastels or watercolors, depict images that feel healing to you. Do more than one if you like – it may take a few attempts to create something that resonates for you. Let there be room in your mandala for the dark as well as the light.

WRITING: WHAT I KNOW

Begin a journal entry or a poem beginning with one of these phrases:

What I know is…
I never saw you…
In my dreams…

You can use one of these phrases or a phrase of your own repetitively in your writing, creating a rhythmic cadence to your work.

Good medicine: women as patients

> Because it is not yet born, the loss of the baby through miscarriage is somehow supposed to be not as "bad." As bad as what I wonder? The loss is a loss just the same (Marion K. Flanary, Secret Club artist).

Many women report that the circumstances of their pregnancy loss were made more difficult by their interactions with their medical providers. Because of the nature of the system, women may feel left in limbo by the obstetrician whose job is complete and the pediatrician who has no infant to treat. Artist Tammy Gross writes: "I received no compassion on an emotional level while in the hospital for my ectopic pregnancy. The closest I got was a brief visit from a woman who gave me a copy of information about ectopic pregnancy." Sherokee Ilse, author and pioneer in the pregnancy-loss advocacy movement, had a similar experience. Ilse shared with me that following her stillbirth in 1981, she received "no packets, no materials, books, blankets, mementos…nothing was given."

Our relationships with institutions can be complex and maddening. The care you received at the time of your pregnancy loss may have felt less than ideal. It can be helpful to clarify your experience visually – your imagery may offer up unexpected information and details.

ART: THE MEDICAL PICTURE

With oil pastels, portray your experience in the hospital or your doctor's office. You may focus on the time of your loss or moments before or after. You can use abstract shapes and colors or more realistic images. Create images or symbols to represent the doctors, the other staff, your family, yourself. Add any other details that help you tell your story.

- How large are you compared with the rest of the people in the picture?

- Are you represented as being isolated, constricted, connected to others?

- Do the colors you use speak to you of comfort or discomfort?

- How would you describe the relationships you see on the paper?

WRITING: A LETTER NEVER SENT

Is there something you wish you could have said to your medical providers? If so, you may want to try this writing exercise:

In a mock letter, write to a healthcare practitioner who you feel misunderstood your needs during your pregnancy loss. Because this letter is

never mailed, it liberates you to express your authentic feelings. If you want to, you can write several drafts. Often the first letter is angry (that's OK, let it out!), while a few drafts later you may notice yourself moving towards a new perspective or shifting your feelings. Let the process unfold spontaneously.

Remember: this series of letters is for you alone, not your practitioner. If at some point in the future you decide to send a *real* letter to your practitioner, be clear about the points you want to make and keep your prose purposeful and professional. It may be wise to have a trusted friend read it over before you send it out. And, of course, you may wish to send a letter thanking those practitioners who were particularly helpful or supportive.

ART: MEDICAL COLLAGE

If you have saved medical paraphernalia (ID bracelets, sonograms, reports, prescriptions), create a collage using these items or photocopies of them (remember that you may want to save some special items for the memento box exercise). You can collage these items on to stiff paper or cardboard using glue. Feel free to cut up or alter the objects and to add paint, colored paper, or other materials to help you express your feelings. Don't forget to date and title your piece.

- Did your collage come out the way you imagined it would?

- Does seeing these objects together in a new way shift your relationship to them or to the experience of your loss?

Sorrow, anger, shame, and other unmentionables

You will most likely be mistaken if you try to measure grief by the length of a pregnancy, for what is really lost is the dream of a child. How do you begin to measure that? The overlay of depression, shame, and rage that sometimes follow a lost pregnancy can be unpredictable and multilayered, making it confounding to try to communicate this morass of emotion in words. Because of the secrecy that still blankets miscarriage and other losses, most women do not have an opportunity to normalize their feelings, to learn that their strong reactions are not crazy, overly negative, or pathological. Ascher (1992, p.i), in discussing her struggle with grief, writes: "I did not know that it is unpredictable, with a life of its own. I hadn't known that rage, guilt and remorse are sorrow's companions."

If we stonewall our feelings, they have a bad habit of emerging when they are least welcome or showing up as headaches, back pain, or other somatic symptoms. Opportunities to explore our full range of feelings help us to identify undelivered communications – things that need to be acknowledged in order for healing to take place.

The arts provide a powerful way to express the inexpressible and provide a safe harbor for emotions that may be unwelcome or unacceptable. Artwork can capture the rage (how could God do this to me?), the guilt (what did I do wrong?), and the fear (will I ever be able to have a healthy child?). Many women feel that their right to grieve was denied. The message is usually to hurry up, regain one's composure, and get back to normal. But the emotions following a pregnancy loss are not neat and easily packaged; they don't conform to what others expect of us. People don't want to hear about the horrible night spent in the bathroom, so most women don't tell. But the Secret Club artists dared to, and you can too. In telling the truth, we make room for true healing to begin.

WRITING: HONORING EMOTIONS

Although we think of anger, sadness, guilt, and fear as negative emotions to be avoided, it is often more helpful to honor these emotions, work with them, and learn to move through them.

Write a poem or journal entry addressed to a particularly difficult or painful emotion, acknowledging it and dialoguing with it. You can do this exercise for several different emotions. Below is an example:

> *Dear guilt,*
> *I know that you are the shadow*
> *following me through my day.*
> *I am afraid of you,*
> *afraid to turn and face you.*
> *You whisper that I must have done*
> *something wrong*
> *and sometimes I believe you.*
> *But people lose babies*
> *and it's no one's fault.*

VOCALIZATION: SINGING FROM THE SPIRIT

Your own voice can be a healing instrument. Not only does the expression of feelings and stories through song do us good, but also, as ancient cultures and modern scientists have discovered, the actual vibrations of the tones may have healing qualities as well. Try humming or singing spontaneously around the house, taking a shower, or chilling out on the meditation cushion – it doesn't matter where. Lullabies, cries, chants, prayers, nonsense syllables all allow for open expression of the voice.

For a less improvisational experience, put on music that speaks to you and sing along.

ART: MEMENTO BOX

Boxes are wonderful to work with because they provide a kind of containment for our feelings and memories. You may have saved wrapping paper, cards, photographs, and other bits and pieces related to your pregnancy and your loss. Create a memory box using these items, or photocopies of them. You can also augment the project with additional images gleaned from magazines. You will need a box (try a shoe box, a cigar box, or a wooden or cardboard box purchased from a craft store), scissors, glue, and a basketful of mementos.

The box format provides an outside and an inside with which to work. It may be helpful to think of the outside of the box as your more public, visible self and the inside as your more private, hidden self. You can paint and collage the box as well as put meaningful objects inside. You may also choose to place a written wish in your box.

The ways in which these separate pieces come together will speak to you about your unique experience of pregnancy and loss. If you are tempted to censure yourself or to make the box "pretty," give yourself permission to allow images and creative impulses to arise as they need to, allowing them to be as messy or contradictory as they need to be.

- How are the inside and the outside of the box similar or different?

- Where would you like to keep this box?

- Did you choose to place items inside the box? Why?

RITUAL: BALLOON RITUAL

This ritual, adapted from Lysne (1995), works well with groups and families. To prepare for the ritual, you need a bag of different-colored balloons. Write brief notes on slips of paper about your memories and feelings about your pregnancy loss. Place one note inside each balloon before you inflate it. Gather the group, create a sacred space (see box on p.148), and one by one pop the balloons – a pin is practical, but stamping may be more satisfying. Read aloud each note that is revealed when a balloon is popped. The role of the group is to witness and acknowledge each experience that is shared. Group members should refrain from giving advice. When all of the balloons are popped, each participant in the group can make a wish or offer a prayer.

Making meaning/making peace

Although initially we are afraid of grief and make maneuvers to avoid it, it is much more likely that real healing is found when we turn around and face grief full on. In my own healing process, I located the courage to wrestle with my loss

through creative expression. But one can draw courage from many other sources: grief counseling, friendship, ritual, late-night online chat sessions, spiritual connection to something bigger and deeper than we are alone. Sometimes, just reading someone else's story can bring that rush of relief that other people like you exist in the world. As Hartigan (2002, p.24) shares, "Over time, I've learned that hope is other people. Hope is harnessed every day through the strength of women who fight the same demons and weather the same pain. Hope manages to thrive when the silence is broken."

Recovery from pregnancy loss includes opportunities to explore and express the regrets, wishes, and ambivalence that each of us feel in relationships – even a relationship as new and as unknown as a pregnancy. "In order to resolve an emotionally incomplete loss, we must complete it. If you complete your emotional relationship, it does not mean you'll have to forget your loved one" (James and Cherry 1988, p.107). When, step by step, we are able to move down this path, our experience shifts. What initially felt intense, traumatic, and unbearable is gradually replaced with positive associations, acceptance, and the ability to remember and talk about the loss without feeling overwhelmed.

Resolution of grief may also entail forgiveness: forgiving our partner, our family, our medical providers, but, most importantly, forgiving ourselves for mistakes (real or imagined) that could leave us forever feeling guilty or incomplete. Some people who specialize in bereavement counseling posit that the process of mourning can result in coming out of the experience better than we went in: more compassionate, more focused, and, ultimately, more alive. In her book about her stillbirth, Beth Powning writes, "I never thought that the most important path I would walk would be the one that taught me how to love, or that I had to lose the chance to love in order to find my way, stumbling, tear-blind, onto it" (1999, p.7).

For some people, coping with pregnancy loss is less about letting go and more about the art of remembering. There are those who lose a child, whether by early miscarriage or stillbirth, who want their parenthood recognized, not just as a past event but as an ongoing identity. Terri Campeau, quoted in her local newspaper, points out: "When my father died, I was still considered a daughter, but when my daughter died, I was no longer considered a mother because I didn't have a baby" (Gilmore-Baldwin 2004). Kara Jones calls the experience of remembering and loving her son Dakota, who is no longer with her, "a different kind of parenting." She continually strives to be recognized and to help other bereaved families be recognized as parents.

Suzanne and Wayne Cordes of Massachusetts, lost a full-term baby girl to a rare condition called *vasa previa*, which involves a defect in the umbilical cord. Their baby, Lilliana, died in the womb after Suzanne's waters broke. When

Lilliana died, they chose to spend all the time they could with her in the hospital. They dressed her, held her, and had her baptized. A year later, on the anniversary of her birth, they released balloons as a way of remembering and celebrating their daughter. A card attached to the balloons read: "We love you and miss you, Lilliana. Mommy and Dad" (Lorie 2003). They plan to continue the ceremony annually for the rest of their lives.

To memorialize, to celebrate, adds a sweet melody to our saddest song. Remembering and at the same time letting go – this is the paradoxical work of grief recovery. It seems that the more deeply we affirm that this is a true loss, a real loss, the closer we come to healing and acceptance. The many creative ways that families devise to honor their lost dreams acknowledge and ennoble their experience. Van Praag (1999) describes her reliance on her hands to speak for her heart:

> Grieving is a never-ending process. But along the way trust in one's self and in care givers will be restored. Mourning is tearing clothes, sheets and fabrics related to the lost loved one. Grief is holding on to the shreds and arranging them. Healing lies in patching the pieces together. Recovery is found stitch by stitch.

Despite societal pressures to move on and relinquish sorrow in a timely fashion, Ascher (1992, p.4) reminds us: "Grief doesn't read time tables." Acceptance, if it arrives, comes in its own time.

WRITING: POEM IN DIFFERENT VOICES

Poet and workshop leader Kara Jones offers this exercise: try writing a poem with several stanzas. Let the first stanza be in the voice you would have had on the day your loss occurred. Write the second stanza in the voice you had a week later. Third stanza, a month. Fourth stanza, a year.

If you have been keeping a journal during your recovery period, an alternative activity could be to piece together excerpts from it over time.

- How do the voices differ from one another?

- Does the passing of time change our relationship to loss?

- What remains the same?

WRITING: INVITING THE LOST ONE TO SPEAK

If the spirit of your lost one could speak to you at this point in your healing, what would he or she advise? Begin your journal entry as if your loved one is writing you a letter. Whether you consider your loss a pregnancy, a spirit, or a child, it may have words of wisdom to offer.

ART: PERSONAL ICON

One definition of an icon is a sacred image. This activity offers a chance to create a personal icon related to your pregnancy loss. As you prepare, you may want to take a moment to identify your intention for making this object: it may be to commemorate your loss, to honor the spirit of your baby, or to express your hopes for the future.

To begin, find a small block of wood. In my studio, clients have also used small wooden boxes from the craft store for this project. What colors, images, and symbols will you include to support your intention? You can paint and collage the wood block or nail or tack beads, charms, and small items to it. Acrylic paint, which is permanent when dry, is best for painting wood.

- How does your spiritual practice or sense of the divine support this process?

- Would you like to use this personal icon as part of a shrine, or will you keep it some place else?

ART AND RITUAL: CREATE A HEALING SHRINE

Many spiritual traditions use shrines to remember and honor a loved one (Figure 10.1). You can develop your own healing shrine to commemorate your lost pregnancy and what it represents in your life. Let your intentions for this project focus not only on your sadness but also on welcoming peace of mind and healing. To develop a commemorative shrine, you and your family can display meaningful objects together on a shelf, or you can arrange items in a special container or box.

Consider including photographs, bits of poems or prayers, rocks, shells, candles, and your personal icon if you have done the previous activity. Give yourself permission to include anything that feels right; don't be limited by rules about what is "sacred."

If you work on this project together with your partner or family, make sure each person has an opportunity to contribute something and to help decide on the arrangement. Each person may also want to say a few words about what the shrine means to them.

RITUAL: REMEMBERING AND LETTING GO

Design a simple ritual that helps you express your need to commemorate and your need to let go. Kluger-Bell (1998) suggests various ways to let go, such as dropping a note in moving water, burying mementos, and burning medical records. One outdoor fire ritual I attended invited participants to write down their burdens on a strip of white cloth and tie them to one large stick. Later, the

Figure 10.1: Healing Shrine, mixed media, Laura Seftel

stick and all its messages were burned in a cleansing ritual. The Japanese tradition of writing the name of a lost pregnancy and setting it down in a river might inspire a water ritual. You can create artwork or poetry that is then transformed through the natural elements of water, earth or fire.

This may be a private ritual or you may choose to invite special people in your life to witness and support your process. Only engage in these types of rituals if you feel ready – there is no pressure to include "letting go" into your healing process if it does not feel right for you.

Special days

Due dates, Mothers' Day, Fathers' Day, Christmas, and birthdays of other children can be torture for families who have lost a pregnancy or experienced a stillbirth. You can rely on your creative process to help move you through these difficult times and perhaps even to reconnect with a joyous spirit.

WRITING: WHAT YOU STILL HAVE

Journal or write a poem that begins "What I didn't lose..."

ART: MANDALA

Begin with an intention for your mandala. This may include exploring and expressing your feelings, inviting a sense of peace or calm, or honoring the importance of the day. Working within a circle, create your mandala with whatever materials appeal to you. Do not concern yourself with whether you are fulfilling your initial intention; simply allow yourself to trust the process and relax into the mandala experience.

Remember to date and title your work. You may also choose to write around your mandala image or on the back of the paper an affirmation or anything you learned about yourself in the process.

RITUAL: GIVING

Although it is important to take care of ourselves in difficult times, we can also heal ourselves when we give to others. Identify a non-profit project or organization to which you would like to donate your time or money. It may be a group or agency related to pregnancy loss or something else close to your heart. Write a note accompanying your donation, explaining the inspiration for your contribution.

Conclusion

The sudden and sometimes traumatic loss of a pregnancy can linger just below the surface for years as a chronic sorrow. The gift of the artist, or anyone embracing their own creative process, is the willingness to explore "a grief without a shape" and the dark beauty of one's own original imagery.

On your own journey of healing yourself or others, perhaps the most important thing to take with you is this: remember what you know. If you loved a pregnancy as if it was a child, then you must grieve it like a lost child. If your arms ache with the emptiness, then you must honor the emptiness. If your doctor's words "You can have another" make you cry out for the one you lost, then cry. Your body knows, your spirit knows, and your heart knows that something precious has been lost. To pretend otherwise, some women tell me, has left subtle but lasting scars.

What you must not do is also simple: you cannot blame yourself, you cannot hate God, or the goddess, or the universe forever (well, maybe just for a little while, but then you must return to trust, to creativity, to reconnection), and you cannot stay silent. In that spirit, this book offers a path to healing that embraces a deep trust in our innate ability to return home to ourselves, even when we fear that a vital piece of us has been forever lost.

My own process, and that of my clients, has taught me that the creative self and the authentic self are inseparable. I have also learned that the creative process touches on the divine sometimes, allowing us to tap into something greater than ourselves, helping us to heal the spiritual crisis that we may suffer after a traumatic loss. We may not return to exactly who we were before, but we can hope to find our way to a new identity that incorporates the loss.

Ultimately, whether we produce an accomplished work of art, develop a simple ritual between family members, or share a symbolic act between supportive strangers on the Internet, we are moving into the realm of creative healing. No matter what the expressive medium, when we give form to this

invisible grief, even if it is difficult to gaze upon, these images invite us beyond the state of overwhelming or frozen emotions. And if we put forth our images and tell our true stories, we break the isolation that too often surrounds us when we need connections the most.

Journalist Peggy Orenstein observed "it is only if your pregnancy is among the unlucky ones that fail that you begin to hear the stories, spoken in confidence, almost whispered" (2002, p.38). I hope that some day soon this will not be the reality for those who lose pregnancies. Author Dave Eggers writes in relation to his own traumatic losses: "We share things for the obvious reasons: it makes us feel un-alone" (2000). Secret Club artist Karen Ricciuti echoes these words in her observation: "I have been to the secret places of the heart and have realized we are not always in control, yet we are not alone in our suffering."

I end this book as I began it, with a poem. Ellen Bass, perhaps best known for co-writing the classic *The Courage To Heal*, is also an accomplished poet. She gave special permission to use her poem, offering it as a gift to this project.

The Thing Is

*To love life, to love it even
when you have no stomach for it
and everything you've held dear
crumbles like burnt paper in your hands,
your throat filled with the silt of it.
When grief sits with you, its tropical heat
thickening the air, heavy as water
More fit for gills than lungs;
When grief weights you like your own flesh
Only more of it, an obesity of grief,
you think,* how can a body withstand this?
*Then you hold life like a face
between your palms, a plain face,
no charming smile, no violet eyes,
and you say, yes, I will take you
I will love you, again.*

References

Alden, A. (2003) "Sewing Comfort out of Grief." www.midwiferytoday.com/
friends/alliealden.

Amos, T. (1998) "Spark." On CD *From the Choirgirl Hotel.* New York: Atlantic Records.

Ascher, B.L. (1992) *Landscape Without Gravity: A Memoir of Grief.* Harrison, NY: Delphinium
Books.

Barry, D. (2003) "For One 9/11 Family, Five Waves of Grief." *New York Times,* September 10,
2003.

Bass, E. (1998) "The Thing Is." *Mules of Love.* Rochester, NY: BOA Editions.

Berman, M.R. (2001) *Parenthood Lost: Healing the Pain After Miscarriage, Stillbirth and Infant Death.*
Westport, CT: Bergin and Garvey.

Berstein, J.C. (1995) "Art and Endometriosis (from an artist's sketchbook)." *Art Therapy:
Journal of the American Art Therapy Association 12,* 1, 56–61.

Bertman, S.L. (1991) *Facing Death: Images, Insights and Interventions.* New York: Hemisphere
Publishing.

Bertman, S.L. (1999) *Grief and the Healing Arts.* Amityville, NY: Baywood.

Beutel, M., Willner, H., Deckardt, R., Von Rad, M. and Weiner, H. (1994) "Similarities and
Differences in Couples' Grief Reactions Following a Miscarriage: Results from a
Longitudinal Study." *Journal of Psychosomatic Research 40,* 3, 245–253.

Biedermann, H. (translated by James Hulbert) (1994) Dictionary of Symbolism. New York:
Meridian.

Blier, S.P. (1993) "The Dance of Death: Notes on the Architecture and Staging of Tamberma
Funeral Performances." In J.C. Berlo and L.A. Wilson (eds) (1993) *Arts of Africa, Oceania,
and the Americas.* Englewood Cliffs, NJ: Prentice Hall.

Boegel, K. and van Marissing, L. (1991) "The Healing Qualities of Art." *Art Therapy: Journal of
the American Art Therapy Association 8,* 1, 12–16.

Brody, J. (2003) "After Ending Pregnancy, Ripples of Pain." *New York Times,* August 14,
2003, p.F6.

Brooks, G. (1991) "The Mother." *Blacks.* Chicago: Third World Press.

Burke, K.J. (1999) "Mothers of Miscarriage." CBC Radio One, broadcast September 20, 1999.

Cameron, J. (1992) *The Artist's Way: A Spiritual Path to Higher Creativity.* New York, NY: Jeremy
P. Tarcher/Putnam.

Cameron, J. (1998) *The Right to Write.* New York: Jeremy P. Tarcher/Putnam.

Cardin, N.B. (1999) *Tears of Sorrow, Seeds of Hope: A Jewish Spiritual Companion for Infertility and
Pregnancy Loss.* Woodstock, VT: Jewish Lights Publishing.

Cecil, R. (ed.) (1996) *The Anthropology of Miscarriage.* Washington, DC: Berg.

Chadwick, W. (1990) *Women, Art, and Society.* London: Thames and Hudson.

Chicago, J. (1985) *The Birth Project.* Garden City, NY: Doubleday.

Christ, C.T. (2004) "The Victorian Way of Death." Lecture presented at Smith College,
Northampton, MA, August 2, 2004.

Cooper, S.F. (2001) *The Victorian Woman.* London: V&A Publications.

Corbin, G.A. (1988) *Native Arts of North America, Africa, and the South Pacific.* New York: Harper and Row.

Dick, L. (1988) "Envy." In A. Fell (ed.) *The Seven Deadly Sins.* London: Serpent's Tail.

DiLeo, G.L. (2005) "The Risk of Miscarriage." www.babyzone.com

Doka, K. (1988) *Disenfranchised Grief: Recognizing Hidden Sorrow.* New York: Lexington Books.

Doka, K. and Martin, T. (2000) *Men Don't Cry...Women Do: Transcending Gender Stereotypes of Grief.* Philadelphia, PA: Brunner-Routledge.

Domar, A. and Dreher, H. (2000) *Self-Nurture.* New York: Viking.

Ealy, C.D. (1995) *The Woman's Book of Creativity.* Hillsboro, OR: Beyond Words Publishing.

Egan, M. (1991) *Milagros: Votive Offerings from the Americas.* Santa Fe, NM: Museum of New Mexico Press.

Eggers, D. (2000) *A Heartbreaking Work of Staggering Genius.* New York: Vintage.

Elinor, R. (2000) *Buddha and Christ: Images of Wholeness.* Trumball, CT: Weatherhill.

Eliot, G. [1879] (2003) *Middlemarch.* New York: Penguin.

Ellis, M.L. (1989) "Women: The Mirage of the Perfect Image." *Arts in Psychotherapy 16,* 263–276.

Emery, G. (1997) "Lament for a Child." *Journal of Christian Nursing.* Summer, p.23

Fabre-Lewin, M. (1997) "Liberation and the Art of Embodiment." In S. Hogan (ed.) *Feminist Approaches to Art Therapy.* London: Routledge.

Fallaci, O. (1977) *Letter to a Child Never Born.* Newark, NJ: Simon and Schuster.

Faulkner, A.F. (2003) *Art Therapy with Couples Who Have Lost a Child Through Miscarriage.* Master's thesis, Eastern Virginia Medical School, Norfolk, VA.

Fincher, S. (1991) *Creating Mandalas: For Insight, Healing, and Self-expression.* Boston, MA: Shambhala Publications.

Fontanel, B. and d'Harcourt, C. (1998) *Babies Celebrated.* New York: Harry N. Abrams.

Friedman, R. and Gradstein, B. (1992) *Surviving Pregnancy Loss.* Boston, MA: Little, Brown and Co.

Fritsch, Julie (1992) *The Anguish of Loss: Visual Expressions of Grief and Sorrow.* Maple Plain, MN: Wintergreen Press.

Frost, R. (1914) "Home Burial." In E.C. Lathem (ed.) *The Poetry of Robert Frost.* New York: Henry Holt.

Gantt, L. (1991) "Discussion." In Boegel, K. and van Marissing, L. (eds) "The healing qualities of art." *Art Therapy: Journal of the American Art Therapy Association 8,* 1, 12–16.

Gatta, J.P. (1999) "It's a Free Will Planet." *Magical Blend Magazine 63.* www.magicalblend.com

Gilmore-Baldwin, M. (2004) "Art Offers an Outlet for Loss." *Olympian,* October 1, 2004.

Gimbutas, M. (2001) *Civilization of the Goddess.* London: Thames and Hudson.

Gisbourne, M. (1998) "Life into Art." *Contemporary Magazine,* June.

Glass, R.H. (1992) "Foreword." In Friedman, R. and Gradstein, B. *Surviving Pregnancy Loss.* Boston, MA: Little, Brown and Co.

Goldberg, N. (1986) *Writing Down the Bones: Freeing the Writer Within.* Boston, MA: Shambhala Publications.

Gough, M. (1999) "Remembrance Photographs: A Caregiver's Gift for Families of Infants Who Die." In S.L. Bertman (ed.) *Grief and the Healing Arts: Creativity as Therapy.* Amityville, NY: Baywood.

Hartigan, P. (2002) "The Kindness of Strangers." *Boston Globe Magazine,* August 4, 2004.

Herling, C. (1998) *Art and Life in Africa.* CD-ROM. Iowa City, IA: University of Iowa Press.

Herrera, H. (1991) *Frida Kahlo: The Paintings.* New York: HarperCollins Publishers.

Hill, M.A. (1998) *Healing Grief Through Art: Art Therapy Bereavement Group Workshops.* Master's thesis, College of Notre Dame, Belmont, CA.

Hogan, S. (1997) "A Tasty Drop of Dragon's Blood: Self-identity, Sexuality and Motherhood." In S. Hogan (ed.) *Feminist Approaches to Art Therapy*. London: Routledge.

Ilse, S. (1982) *Empty Arms: Coping with Miscarriage, Stillbirth and Infant Death*. Maple Plain, MN: Wintergreen Press.

Imber-Black, E. and Roberts, J. (1992) *Rituals for our Times: Celebrating, Healing, and Changing our Lives and our Relationships*. New York: HarperCollins Publishers.

Inhorn, M. and van Balen, F. (2002) *Infertility Around the Globe*. Berkeley, CA: University of California Press.

James, J.W. and Cherry, F. (1988) *The Grief Recovery Handbook*. New York: Harper and Row.

Jess, D. (2000) "Considering Therapy? Suggestions for Choosing a Therapist after Pregnancy Loss." www.honoredbabies.org

Jones, K.L.C. (1999) "Anger I." In *Flash of Life*. Vashon Island, WA: KotaPress.

Jones, K.L.C. (2000) *Father, Son, Holy Ghost*. Vashon Island, WA: KotaPress.

Jones, K.L.C. (2005) "His 6th Birthday." *A Different Kind of Parenting, 1*, 5.

Jones, R. (1986) "The Miscarriage." In C. Otten (ed.) *The Virago Book of Birth Poetry*. London: Virago Press.

Kluger-Bell, K. (1998) *Unspeakable Losses: Understanding the Experience of Pregnancy Loss, Miscarriage and Abortion*. New York: WW Norton and Co.

Kohn, I. and Moffitt, P.L. (2000) *A Silent Sorrow: Pregnancy Loss Guidance for You and Your Family*. 2nd Edition. New York: Dell Publishing.

Kohner, N. and Henley, A. (1995) *When a Baby Dies: The Experience of Late Miscarriage, Stillbirth and Neonatal Death*. London: HarperCollins Publishers.

Kornfeld, J. (1993) *A Path With Heart: A Guide Through the Perils and Promises of Spiritual Life*. New York: Bantam.

Kramer, A. (1992) "Poetry and the Dying." *Journal of Poetry Therapy 5*, 3, 153–160.

Kramer, E. (1958) *Art Therapy in a Children's Community*. Springfield, IL: Charles C. Thomas.

Kübler-Ross, E. (1969) *On Death and Dying*. New York: Macmillan.

Lahiri, J. (1999) "A Temporary Matter." In *Interpreter of Maladies*. New York: Mariner Books.

Lallemand, S. (1998) "Introduction." In Fontanel, B. and d'Harcourt, C. (eds) *Babies Celebrated*. New York: Harry N. Abrams.

Lamb, J.M. (1989) *Bittersweet… Hellogoodbye: A Resource in Planning Farewell Rituals when a Baby Dies*. St. Charles, MO: SHARE.

Lorie, C. (2003) "The Sad, Sweet Story of Liliana Marie Cordes." *Hampshire Life*, January 17, 2003.

Lysne, R.H. (1995) *Dancing Up the Moon: A Woman's Guide to Creating Traditions that Bring Sacredness to Daily Life*. Berkeley, CA: Conari Press.

Malchiodi, C. (1999) *Medical Art Therapy with Children*. London: Jessica Kingsley Publishers.

Malchiodi, C. (2002) *The Soul's Palette*. Boston, MA: Shambhala Publications.

Malchiodi, C. (1992) "Art and Loss." *Art Therapy: Journal of the American Art Therapy Association 9*, 3, 114–118.

Martin, R. (1997) "Looking and Reflecting: Returning the Gaze, Re-enacting Memories and Imagining the Future through Phototherapy." In S. Hogan (ed.) *Feminist Approaches to Art Therapy*. London: Routledge.

McCarthy, P. (1993a) "D and C." In C. Otten (ed.) *The Virago Book of Birth Poetry*. London: Virago Press.

McCarthy, P. (1993b) "Ante-natal Clinic." In C. Otten (ed.) *The Virago Book of Birth Poetry*. London: Virago Press.

Minty, J. (1974) "The Babies." *Lake Songs and Other Fears*. Pittsburgh, PA: University of Pittsburgh Press.

Moffatt, A. (2002) "Angel Dust (Poussière d'Ange)." On CD *Aquanaut.* Montreal: Audiogram.

Moffitt, P.L. (2005) 'Pregnancy Loss Support Program Employs Effective Closed Group Format.' *SIDS Alliance 2005 Conference* (Retrieved 11/5, www.sidsalliance.org).

Neimeyer, R. (1998) *Lessons of Loss: A Guide to Coping.* New York: McGraw-Hill.

Neugebauer, R., Kline, J., Shrout, P., Skodol, A., O' Connor, P., Geller, P.A., *et al.* (1997) "Major Depression Disorder in the 6 months after Miscarriage." *Journal of the American Medical Association 277,* 5, 383–386.

Nin, A. (1969) *Diary of Anaïs Nin: Vol. 1 (1931–1934).* New York: Harvest Books.

Olds, S. (1984) "Miscarriage." *The Dead and the Living.* New York: Alfred A. Knopf.

Olson Binder, A. (1993) "Knitting." In C. Otten (ed.) *The Virago Book of Birth Poetry.* London: Virago Press.

Orenstein, P. (2002) "Mourning my Miscarriage." *New York Times Magazine,* April 24.

Otten, C. (1993) *The Virago Book of Birth Poetry.* London: Virago Press.

Parton, D. (2003) "Mountain Angel." On CD *Little Sparrow.* Durham, NC: Sugarhill Records.

Peterson, P. (2004) "Strategies for Coping with a Diagnosis of Infertility." *Pioneer Valley Health Magazine,* winter.

Petrie, P. (1984) "The Lost Child." In C. Otten (ed) *The Virago Book of Birth Poetry.* London: Virago Press.

Phalen, K. (2000) "Losing a Baby." *Washington Post,* health section, February 1, 2000.

Philipp, R. and Robertson, I. (1996) "Poetry Helps Healing." *Lancet 347,* 8997, 332–333.

Plath, S. (1968) *Three Women: A Poem for Three Voices.* London: Turret Books.

Plath, S. (1981) "Parliament Hill Fields." In T. Hughes (ed.) *Sylvia Plath: Collected Poems.* London: Faber and Faber.

Ponte, W. (2002) "Solitary Sadness: The Need to Grieve Miscarriage." *Mothering Magazine 113,* July – August, 54–61

Powning, B. (1999) *Shadow Child: An Apprenticeship in Love and Loss.* New York: Carroll and Graf.

Rivera, D. and March, G. (1960) *My Art, My Life: An Autobiography.* New York: Citadel Press.

Robinson, A. (1980) *Art and the Soul of Man.* Master's thesis, Lesley College, Cambridge, MA.

Rocsi, M. (1976) *Leonardo.* New York: Mayflower Books.

Rukeyser, M. (1968) "Kathe Kollwitz." In *The Speed of Darkness.* New York: Random House.

Rynearson, E. (2001) *Retelling Violent Death.* Philadelphia, PA: Brunner-Routledge.

Samuels, M. and Rockwood Lane, M. (1998) *Creative Healing.* New York, NY: HarperCollins Publishers.

Schmais, C. (1988) "Creative Arts Therapy and Shamanism: A Comparison." *Arts in Psychotherapy 15,* 4, 281–284.

Sexton, A. (1967) "In Celebration of My Uterus." *Love Poems.* New York: Houghton Mifflin.

Sha, J. (1990) *Mothers of Thyme: Customs and Rituals of Infertility and Miscarriage.* Ann Arbor, MI: Lida Rose Press.

Silverman, P. (2000) *Never Too Young to Know: Death in Children's Lives.* New York: Oxford University Press.

Singer, K. (1999) *The Wholeness of a Broken Heart.* New York: Riverhead Books.

Smiley, J. (1991) *A Thousand Acres.* New York: Ballantine Books.

Smolowe, J. and Gold, T. (2003) "Baby, it's You!" *People 60,* 11, 114.

Smyth, J. and Pennebaker, J. (1999) "Telling One's Story: Translating Emotional Experiences into Words as a Coping Tool." In C. Snyder (ed) *Coping: The Psychology of What Works.* New York: Oxford University Press.

Speert, E. (1992) "The Use of Art Therapy Following Perinatal Death." *Art Therapy: Journal of the American Art Therapy 9,* 3, 121–128.

Speraw, S. (2004) "Healing Through Metaphor and Private Rituals in Response to Miscarriage: Four Families." Presented at Making Sense of Health, Illness and Disease, Oxford, UK, 7 July, 2004.

Sterling, S.F. (1995) *Women Artists: The National Museum of Women in the Arts.* New York: Abbeville Press.

Strayed, C. (2002) "The Love of My Life." *The Sun* (Chapel Hill, NC), September.

Sweeney, C. (2004) "Baby Maybe (or Maybe Not) and the Conception Game." *New York Times,* August 19, 2004.

Thesen, S. (1995) "Elegy, the Fertility Specialist." In Gilbert, S.M., Gubar, S. and O'Hehir, D. (eds) *Mothersongs: Poems For, By, and About Mothers.* New York: WW Norton and Co.

Tobey, S.B. (1991) *Art of Motherhood.* New York: Abbeville Press.

Tropper, J. (2005) "Goodbye Too Soon." *New York Times Magazine,* March 6, 2005.

VanMeenen, K. and Rossiter, C. (eds) (2002) *Giving Sorrow Words: Poems of Strength and Solace.* Des Moines, IA: National Association for Poetry Therapy Foundation.

Van Praag, J. (1999) *Creative Acts of Healing: After a Baby Dies.* Seattle, WA: Paseo Press.

Van Zandt, T. (1998) "Marie." On CD *Abnormal.* Bonn, Germany: Normal Records.

White, L.M. (1992) *The Healing Connection: A Healing Mandala.* Master's thesis, Lesley College, Cambridge, MA.

Willard, N. (1971) "For you, Who Didn't Know." In C. Otten (ed) *The Virago Book of Birth Poetry.* London: Virago Press.

Worden, J.W. (1991) *Grief Counseling and Grief Therapy.* London: Routledge.

Zinoman, J. (2004) "A Chilling Account of a Child Never Known." *New York Times,* August 19, 2004.

Zucker, R. (2005) "Grief Counseling: Cutting Edge Strategies and Clinical Interventions." Presentation, Springfield, MA, June 6.

Further Reading

Pregnancy loss

Allen, M. and Marks, S. (1993) *Miscarriage: Women Sharing from the Heart.* Hoboken, NJ: John Wiley and Sons.

Berman, M.R. (2001) *Parenthood Lost: Healing the Pain After Miscarriage, Stillbirth and Infant Death.* Westport, CT: Bergin and Garvey.

Faldet, R. and Fitton, K. (1997) *Our Stories of Miscarriage: Healing With Words.* Minneapolis, MN: Fairview Press.

Friedman, R. and Gradstein, B. (1992) *Surviving Pregnancy Loss.* Boston, MA: Little, Brown and Co.

Fritsch, J. (1992) *The Anguish of Loss: Visual Expressions of Grief and Sorrow.* Maple Plain, MN: Wintergreen Press.

Ilse, S. (1990) *Empty Arms: Coping With Miscarriage, Stillbirth and Infant Death.* Maple Plain, MN: Wintergreen Press.

Ilse, S. (1992) *Miscarriage: A Shattered Dream.* Maple Plain, MN: Wintergreen Press.

Kohn, I. and Moffitt, P.L. (2000) *A Silent Sorrow: Pregnancy Loss Guidance for You and Your Family.* New York: Dell Publishing.

Powning, B. (1999) *Shadow Child: An Apprenticeship in Love and Loss.* New York: Carroll and Graf.

Pregnancy and Infant Loss Center (1984) *Sibling Grief... After Miscarriage, Stillbirth or Infant Death.* Minneapolis, MN: Pregnancy and Infant Loss Center.

Van Praag, J. (1999) *Creative Acts of Healing: After a Baby Dies.* Seattle, WA: Paseo Press.

Books for children

Cohen, J. (1994) *Molly's Rosebush.* Morton Grove, IL: Albert Whitman and Co.
This children's book tells the story of a young girl, Molly, as she remembers the day she found out she wasn't going to be a big sister. A good book for parents to sit and read with their children in order to help them understand and begin to cope with miscarriage, the text allows for incorporation of an individual family's own religious or philosophical beliefs. An introduction for parents is included.

Dodge, N. (1984) *Thumpy's Story: A Story of Love and Grief Shared.* Springfield, IL: Prairie Lark Press.
Thumpy's sister dies and the rabbit family experiences grief and learns to go on living. Through Thumpy's search for answers, we understand the anger, guilt, and fear that children experience and how we might try to reassure them. *Thumpy's Story* is available as a book to read, as a book to color, and as a workbook.

Erling, J. and Erling, S. (1986) *Our Baby Died: Why?* Wayzata, MN: Pregnancy and Infant Loss
 Center.
A bereaved boy shares his feelings and thoughts about his stillborn brother. This is an honest
account of a child's questions, fears, and emotions about loss and death. It is a very good resource
for children between the ages of three and ten, to read, draw, and color.

Gryte, M. (1988) *No New Baby.* Omaha, NE: Centering Corporation.
This book was written for young children whose sibling has died shortly before or after birth. It
provides simple openings for discussion of feelings.

Art and healing

Cameron, J. (1992) *The Artist's Way: A Spiritual Path to Higher Creativity.* New York: Jeremy P.
 Tarcher/Putnam.
De Salvo, L.A. (2000) *Writing as a Way of Healing: How Telling Our Stories Transforms Our Lives.*
 Boston: Beacon Press.
Ealy, C.D. (1995) *The Woman's Book of Creativity.* Hillsboro, OR: Beyond Words.
Fox, J. (1997) *Poetic Medicine: The Art of Poem-Making.* New York: Jeremy P. Tarcher/Putnam.
Ganim, B. and Fox, S. (1999) *Visual Journaling: Going Deeper Than Words.* Wheaton, IL: Quest.
Klüger-Bell, K. (1998) *Unspeakable Losses: Understanding the Experience of Pregnancy Loss,
 Miscarriage and Abortion.* New York: WW Norton and Co.
Malchiodi, C. (2002) *The Soul's Palette.* Boston, MA: Shambhala.
Samuels, M. and Lane, M.R. (1998) *Creative Healing.* New York: HarperCollins.

Reading for helping professionals

Bertman, S.L. (2000) *Grief and the Healing Arts: Creativity as Therapy.* Amityville, NY: Baywood.
Doka, K. and Martin, T. (2000) *Men Don't Cry… Women Do: Transcending Gender Stereotypes of
 Grief.* Philadelphia, PA: Brunner-Routledge.
Goldberg, N. (1986) *Writing Down the Bones: Freeing the Writer Within.* Boston, MA: Shambhala
 Publications.
Imber-Black, E. and Roberts, J. (1992) *Rituals for Our Times: Celebrating, Healing, and Changing
 Our Lives and Our Relationships.* New York: HarperCollins.
Irish, D., Lundquist, K. and Nelson, V. (1993) *Ethnic Variations in Dying, Death and Grief.*
 Washington, DC: Taylor and Francis.
Klass, D., Silverman, P. and Nickman, S. (1996) *Continuing Bonds: New Understandings of Grief.*
 Washington, DC: Taylor and Francis.
Malchiodi, C. (1999) *Medical Art Therapy with Adults.* London: Jessica Kingsley Publishers.
Neimeyer, R. (1998) *Lessons of Loss: A Guide to Coping.* New York: McGraw-Hill.

Useful Organizations

USA

AMEND (Aiding Mothers and Fathers Experiencing Neonatal Death)
PO Box 20260
Wichita KA 67208-1260
www.amendinc.com

CLIMB (Center for Loss in Multiple Birth)
PO Box 1064
Palmer AK 99645
www.climb-support.org

The Compassionate Friends
PO Box 3696
Oak Brook IL 60522-3969
www.compassionatefriends.org

First Candle / SIDS Alliance
1314 Bedford Avenue, Suite 210
Baltimore MD 21208
www.sidsalliance.org

Hygeia
www.hygeia.org
Medical information, poetry, support and other resources.

Pregnancy Loss Support Program
9 East 69th Street
New York NY 10021
www.ncjwny.org/services_plsp.htm

RESOLVE (National Infertility Association)
7910 Woodmont Avenue, Suite 1350
Bethesda MD 20814
www.resolve.org

SHARE *(National Organization for Pregnancy and Infant Loss)*
St Joseph Health Center
300 First Capitol Drive
St Charles MO 63301-2893
www.nationalshareoffice.com
Telephone counseling (English, Spanish, Russian): 212-687-5030 (x28)

INCIID *(International Council on Infertility Information Dissemination)*
PO Box 6836
Arlington VA 22206
www.inciid.org

Canada

Centre for Reproductive Loss
PO Box 282
Station Cote St Luc
Montreal, Quebec H4V 2Y4

The Compassionate Friends
685 Williams Avenue
Winnipeg, Manitoba R3E 0Z2
www.tcfcanada.net

Perinatal Bereavement Services Of Ontario
6060 Highway 7
Suite 205, Markham, Ontario L3P 3A9
www.pbso.ca

UK

The Compassionate Friends
53 North Street
Bristol BS3 1EN
www.tcf.org.uk

Miscarriage Association
c/o Clayton Hospital
Northgate, Wakefield
West Yorkshire WF1 3JS
www.miscarriageassociation.org.uk

Helpline (England): 01924 200799
Helpline (Scotland): 0131 334 8883

SANDS (Stillbirth and Neonatal Death Support)
28 Portland Place
London W1B 1LY
www.uk-sands.org

Australia

Bonnie Babes Foundation
PO Box 2220
Rowville VIC3152
www.bbf.org.au

SANDS (Stillbirth and Neonatal Death Support)
SANDS Australia National Council Inc.
901 Whitehorse Road, Suite 208
Box Hill VIC3128
www.sands.org.au

Support After Fetal Diagnosis of Abnormality (SAFDA)
Royal Hospital for Women
Locked Bag 2000
Randwick NSW 2031

The Secret Club Project

For more information about the Secret Club Project, contact:

Laura Seftel
26 Union Street
Northampton MA 01060
www.secretclubproject.org

Telephone 413-586-7710
laura@secretclubproject.org

The Secret Club can be experienced as an exhibit or a narrated slide presentation and is available to travel to medical centers, colleges, conferences, and community art centers. The project continues to welcome donations and new submissions of artwork in any medium.

Subject Index

Page numbers in italic refer to figures.

Author Index